The New Complete Guide to
WILDLIFE PHOTOGRAPHY

HOW TO GET CLOSE AND CAPTURE ANIMALS ON FILM

JOE McDONALD

AMPHOTO BOOKS
An imprint of Watson-Guptill Publications/New York

Page 1: **COUGAR (CAPTIVE),** Wild Eyes, Montana. 300mm F2.8 lens, 1/125 sec. at *f*/4, Kodachrome 200

Pages 2–3: **SNOWY OWL (CAPTIVE),** Project Raptor, British Columbia, Canada. 500mm F4 lens, 1/1000 sec. at *f*/8, Fujichrome 100

Page 5: **GREAT BLUE HERON AND CHICK,** Venice, Florida. 600mm F4 lens, 1/125 sec. at *f*/4, Fujichrome 100

Pages 6–7: **BIGHORN SHEEP,** Yellowstone National Park, Wyoming. 300mm F2.8 lens, 1/125 sec. at *f*/4, Kodachrome 200

Pages 16–17: **GENTOO PENGUINS,** Volunteer Point, Falkland Islands. 20–35mm F2.8 lens, 1/250 sec. at *f*/11, Fujichrome 100

Pages 44–45: **BISON,** Yellowstone National Park, Wyoming. 80–200mm F2.8 zoom lens, 1/125 sec. at *f*/8, Kodachrome 64

Pages 106–107: **ELK BULLS,** Yellowstone National Park, Wyoming. 80–200mm F2.8 lens, 1/125 sec. at *f*/5.6, Kodachrome 64

Pages 136–137: **BLACK-BROWED ALBATROSS,** Saunders Island, Falkland Islands. 20–35mm F2.8 zoom lens, 1/125 sec. at *f*/9, TTL flash at -1.7, Fuji Velvia

Joe McDonald is a photographer, writer, and lecturer who, along with his wife Mary Ann, leads photographic tours to exotic places around the world and conducts photography workshops throughout the United States.

He is a strong advocate of photographing wildlife without causing undue stress to animals and is a member of NANPA, the North American Nature Photography Association, which promotes ethical behavior, education, conservation, and similar issues as they relate to wildlife and nature photographers.

His photographs have appeared in the calendars of The Audubon Society and The Sierra Club, and his images have also been featured in such national nature magazines as *National Wildlife, International Wildlife, Audubon, Natural History, Ranger Rick,* and *Wildlife Conservation,* as well as in *Newsweek, Time,* and *National Geographic.* He is the author of numerous photography books, the most recent being Amphoto's *Photographing On Safari* (1996). When not traveling, he works on special photography projects near his home in Pennsylvania.

Editorial concept by Robin Simmen
Editors: Liz Harvey, Sue Shefts, Alisa Palazzo (revised edition)
Designer: Areta Buk
Production Manager: Hector Campbell

Revised edition copyright © 1998 Joe McDonald
First edition copyright © 1992 Joe McDonald

Published in 1998 in New York by Amphoto Books,
an imprint of Watson-Guptill Publications,
a division of BPI Communications, Inc., 1515 Broadway, New York, NY 10036

Library of Congress Cataloging-in-Publications Data

McDonald, Joe.
 The new complete guide to wildlife photography : how to
get close and capture animals on film / Joe McDonald.
 p. cm.
 Includes index.
 ISBN 0-8174-5009-2 (pbk.)
 1. Wildlife photography. I. Title.
TR729.W54M334 1998
778.9'32—dc21 98-18559
 CIP

Printed in Hong Kong

1 2 3 4 5 6 7 8 9 / 06 05 04 03 02 01 00 99 98

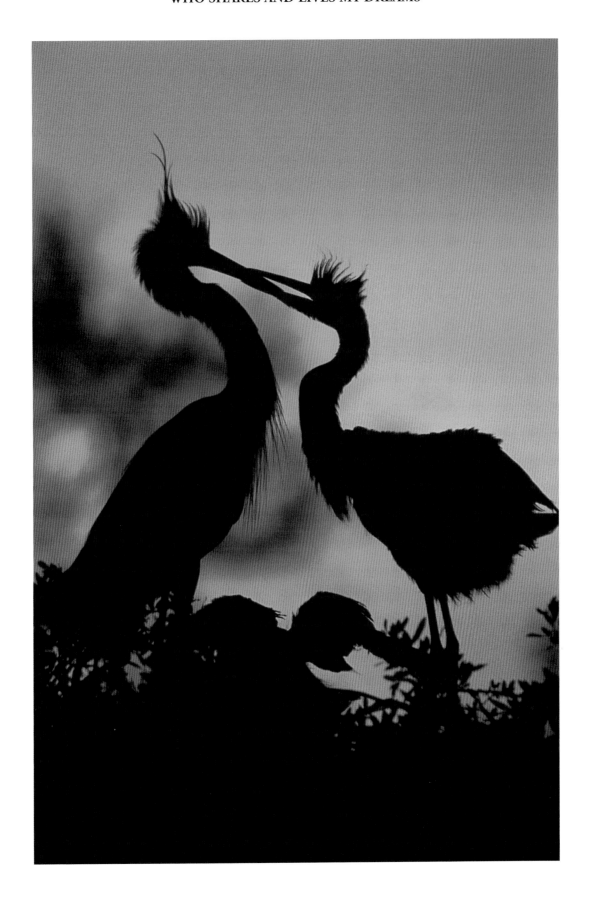

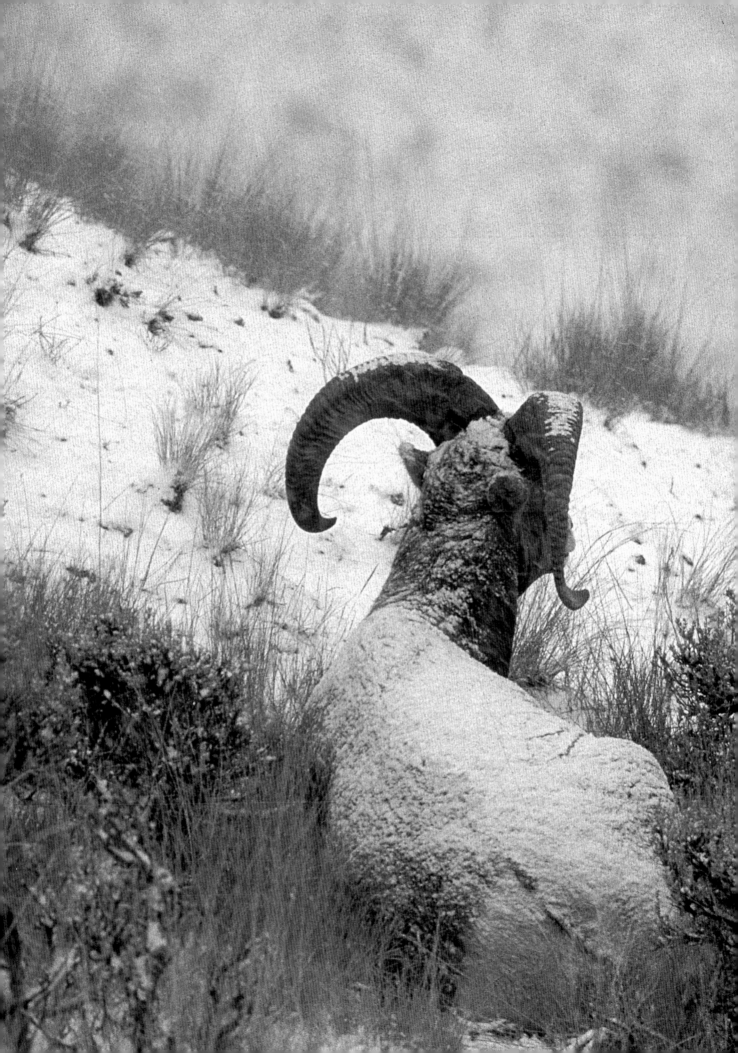

CONTENTS

PREFACE

Time flies by. Sometimes it seems like only yesterday that I wrote the first edition of *The Complete Guide to Wildlife Photography* (Amphoto Books, 1992). When I think about it, what's even more amazing is the length of time I've been involved in taking wildlife and nature photographs—I started in 1966, as a freshman in high school.

So much has changed since those beginning days. Gear certainly has improved. In the sixties, autoexposure was still far in the future and autofocus was the stuff of science fiction. Today, many photographers couldn't conceive of being without either feature. My first telephoto lens was a 400mm preset, a fairly sophisticated lens at the time with which the user looked through the lens with the aperture wide open and, just prior to snapping the frame, manually turned a ring that closed the lens down to the picture-taking aperture. It is no wonder there were not a lot of action photographs taken back then.

I'd hate to think what I'd be doing today if it weren't for the availability and efficiency of autofocus cameras and lenses. Like many folks when they reach their forties, I lost a lot of my short-vision acuity, and determining critical sharpness in a viewfinder became increasingly difficult. Fortunately, that isn't as much of a hindrance with the latest cameras.

When I was a kid in college, travel to many foreign destinations was very difficult and very expensive. Relatively speaking, today, many once-remote locales are now affordable shooting destinations for wildlife and nature photographers. That fact is certainly reflected in this book, as approximately 25 percent of the images were made in destinations outside of North America.

On the other hand, more than that number were made within six miles of my home at Hoot Hollow. I find this gratifying, because it shows that quality work can be done quite close to home. Some of those images, as well as others made in Montana, Canada, and southern Africa, were made with animals I've identified in this book as captive. This label encompasses a wide variety of circumstances. For example, some of these animals were pets; others, such as frogs or snakes, I captured in order to photograph and released after a few minutes or hours. A few were falconer's birds, and others were being rehabilitated, like the orphaned screech owls I filmed until they were released back to the wilds. Some—particularly the North American predators—were raised and husbanded solely for use as photography or cinematography models.

As you go through this book, you will, at times, encounter a string of captions identifying captive animals. Please don't despair or be discouraged; my point in honestly labeling this material is to illustrate the realities of wildlife photography. Sometimes it is difficult, if not impossible, to film an animal in the wild; yet, a good—if not a wonderful—photograph of that species can still be obtained by using a captive or controlled creature.

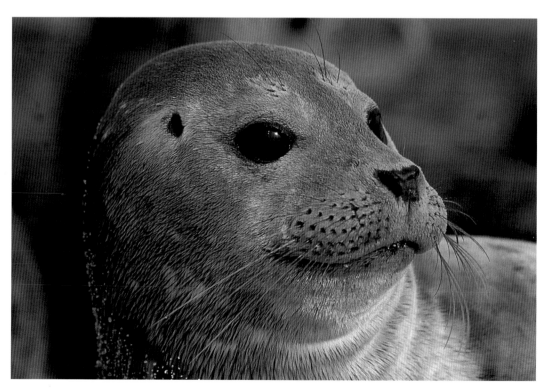

HARBOR SEAL, La Jolla, California. 600mm F4 lens, 1/250 sec. at *f*/9, Ektachrome 100

Although tourists and scuba divers often walk within feet of the herds of resting seals on this California beach, it is wise for photographers to maintain some distance between the camera and the subject.

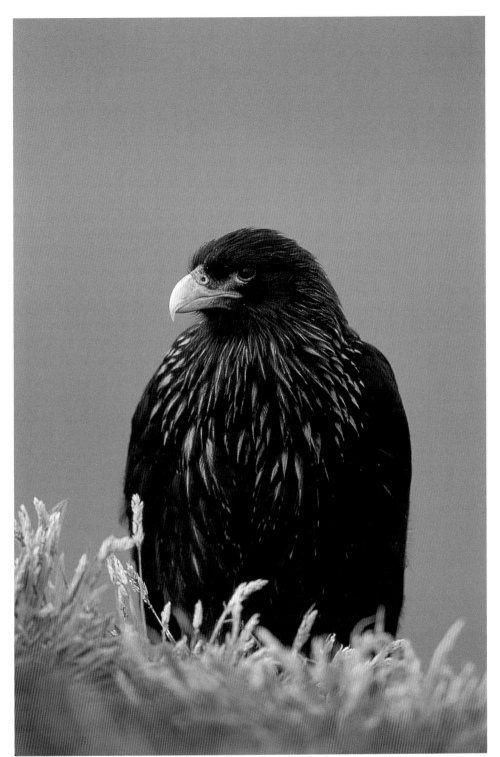

Frankly, I have to laugh when I look at many nature or photography books, magazines, or calendars that clearly label a photograph's origin when it is a national park or wildlife refuge, but vaguely cite "Montana" or "outside Glacier National Park" or "North Fork of the Flathead River" when the image depicts a wolf, cougar, grizzly, or lesser predator. You'll see so many images like this that if you read the captions, you might worry about visiting Montana—too many wolves, too many cougars! Surely, you could get eaten there! In truth, many of these wolves, cougars, bobcats, lynx, and other predators were indeed photographed along the North Fork or just outside Glacier, but the captions sidestep the truth: that these were "wildlife models" filmed under very controlled conditions.

This practice has created a tremendous amount of controversy, with some people maintaining that this fosters an unrealistic impression of the natural world. Viewers might believe these animals are more common and certainly far more accessible than they actually are.

Critics argue that uninformed photographers might get themselves into serious trouble by trying to approach a wild grizzly bear for the type of frame-filling images they have seen in magazines or books. They may have a point.

On the other hand, I think wildlife models, captives, falconry birds, and even wild pets have a very real and valuable role in wildlife photography. There can be no argument that these subjects make compelling images, and I'd disagree with many who claim they just don't look wild. The "wild" look these critics refer to might be that adopted by animals that are just nervous or stressed by a photographer's presence.

At any rate, captives provide photographers and the viewing public with images quite likely unobtainable any other way, and they are still extremely useful and meaningful. I question whether Yellowstone's wolf recovery program would have enjoyed its tremendous public support without images—mostly of captives—that depicted the hidden world of the wolf in books, calendars, posters, and magazines. Would people care as much about the destruction of the rainforest if they didn't have a visual sense of its inhabitants—made

with captive ocelots, jaguars, boas, venomous snakes, and other creatures that are so rarely filmed or seen in the wild?

When I started taking photographs, there were very few images of wild North American predators. By the time I graduated college, a few photographers were publishing outstanding images of wolves or cougars, and I wondered whether they were just better field naturalists than I, or if I was missing something. As I learned more, I discovered the "tricks" of this profession, learning of, and using, game farms (where wildlife models could be rented for the day), or using a falconer's birds or a herpetologist's collection for images. It wasn't an issue; it was just the way things were done.

Today, this has changed, and there has been a growing concern for accuracy and honesty. For this reason, I've labeled as captive all of the images in this book that do not depict truly "wild" animals, animals with total freedom to come and go as they please. In a book of this nature, intended to teach wildlife photographers the how-to's of successful shooting, doing anything less would be a grievous disservice to the reader.

Right: **GRAY WOLF (CAPTIVE)**, Wild Eyes, Montana. 500mm F4 lens, 1/250 sec. at *f*/4, Fujichrome 100

While not impossible, it is very difficult to make a close-up image of a wild wolf. By using captive subjects, photographers can create portraits and capture animal behavior that conveys a sense of the hidden world of elusive, oft persecuted predators.

Opposite: **MOUNTAIN GORILLA**, Bwindi Impenetrable Forest, Uganda. 300mm F2.8 lens, 1/125 sec. at *f*/4, Fujichrome 100

Long-term and patient habituation of selected groups of mountain gorillas has resulted in wonderful photographic opportunities of real wildlife models. The tourism generated by the gorillas has provided economies with needed cash and governments with a real incentive to preserve wildlands and wildlife.

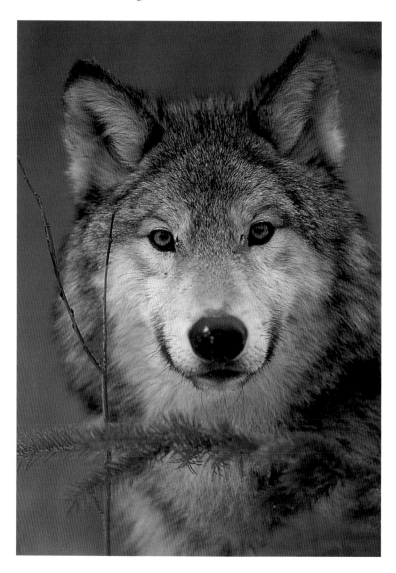

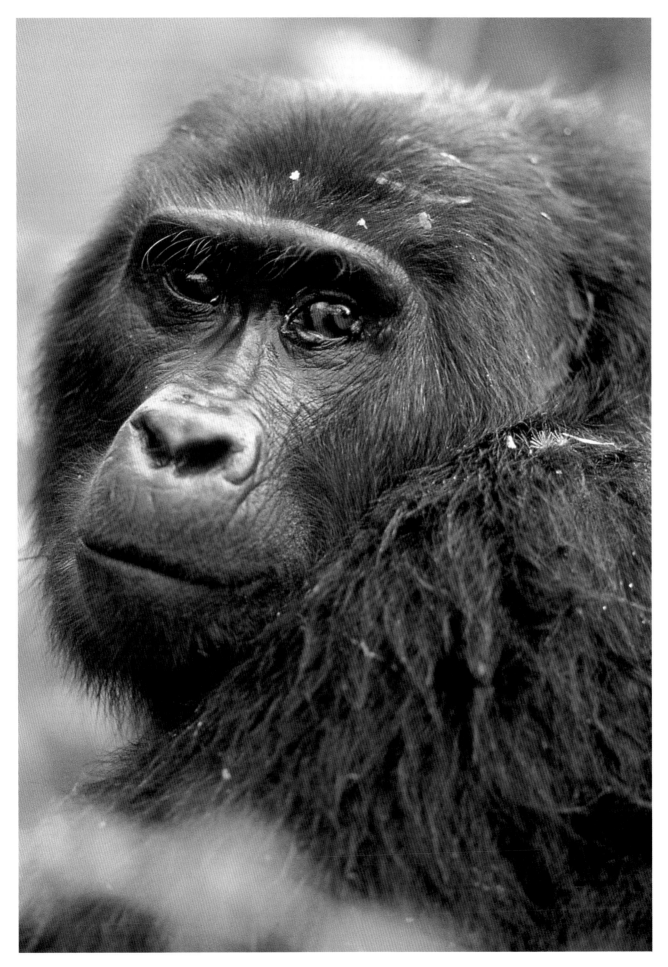

INTRODUCTION

One hundred queasy feet below me, the South Atlantic smashed in a white froth against steep, wave-polished, vertical ledges, and in the 30-knot blasts that punctuated a constant, driving wind I worried I'd be blown off my ridge and into the sea. Except for the bright sun to my back, conditions didn't seem perfect for quality bird photography, yet I fired roll after roll as albatrosses and cormorants sailed passed just yards before me toward their nesting sites. And I shot with confidence, expecting my gear to meet the challenges the wind and flying birds presented.

When I saw the photographs weeks later, I wasn't disappointed. With autofocus, most of the flying birds were sharp, unless an exceptionally powerful gust had jerked my lens sideways or operator error (read: wind, please) had ruined the image. Just a few years ago, this type of shooting would not have been possible.

As this little anecdote illustrates, in some ways we're living in a golden age of photography. The latest advances in camera technology—incorporating autofocus, through-the-lens flash metering, automatic exposure control, and more—have made the process of shooting images increasingly easy. Films offer improved color and better grain, and with the help of computers, even flaws or damage to images can be corrected or repaired. Through photo tours and safaris, traveling to ever-more exotic regions of the globe, photographers are certainly not suffering for a lack of subjects. Great gear, plenty of subjects—what more could a photographer hope for?

Not much, I suspect. But despite all this, the basic elements that make great images are still the same as they were 30-some years ago when single-lens-reflex cameras became readily available to the average nature photographer. These elements—accurate exposures, pleasing compositions, and sharpness—are not 100-percent guaranteed by technological advancements.

That shouldn't come as a surprise, really. In the workshops my wife, Mary Ann, and I teach, we frequently see that even the best and most modern equipment does not the photographer make. A machine can only do so much, and it is kind of nice to know that the art of photography is still a human-controlled event. And indeed, wildlife photography is a type of art. There is art in the process of getting close to and interacting with wildlife, in "seeing" images, and in composing a photograph in a manner that is pleasing to the eye. These processes are not controlled by a machine, they are driven by the operator, the photographer.

The same problems that plagued photographers 10 years ago are still troublesome today. Challenging exposures, extreme contrast, the nuances of flash, as well as the seemingly mundane task of simply choosing the correct gear for your needs, are the same concerns that they always have been for the wildlife photographer.

The second edition of this book addresses these contemporary needs. For example, when I revised the text, I read with amusement my original lukewarm comments regarding autofocus, a development that has

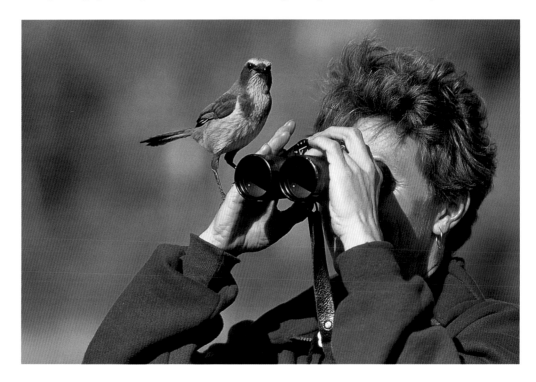

MARY ANN AND SCRUB JAY, Florida. 300mm F2.8 lens with 1.4X teleconverter, 1/500 sec. at *f*/8, Fujichrome 100

Habituated subjects are a joy to work with. Mary Ann had a peanut in her hand when a hungry jay impatiently perched on her shoulder.

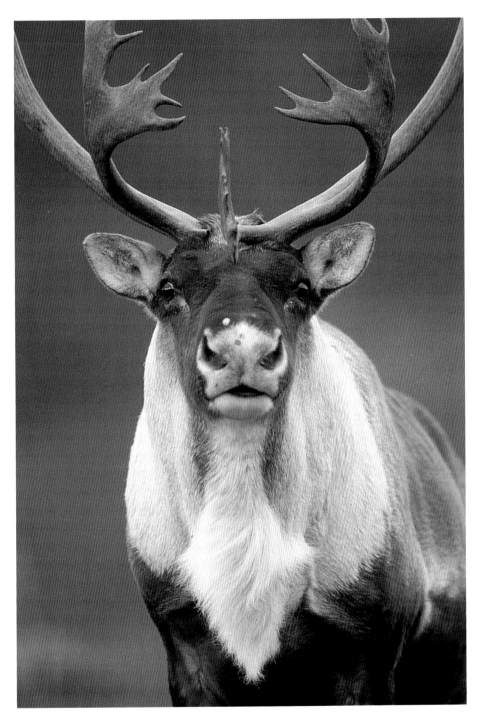

BARREN GROUND CARIBOU,
Denali National Park, Alaska.
600mm F4 lens, 1/250 sec. at *f*/5.6,
Kodachrome 200

*The north slope of Alaska is America's
last and largest wilderness and the
home of caribou, grizzly bear, wolf,
and snowy owl. It may also hold
vast reserves of oil and natural gas.
Photographic images may serve to
preserve this wilderness or, at worst,
document what is slowly vanishing.*

truly come of age in the last six years. Exposure, the perennial bug-a-boo for the serious shooter, has come an incredibly long way, as well.

Still, even the most advanced system cannot handle every circumstance. Understanding the basics of photography enables me to recognize, for example, when the contrast in a scene is too great for an exposure system to yield a pleasing picture. Using this knowledge, I can compose my photograph in a manner in which the light values will work, and I can salvage a shot; whereas, relying only on my camera's computer, I'd have had nothing.

This book is about these basics—those things that a photographer, especially a wildlife photographer using slide or transparency film, must know in order to consistently make outstanding images. Make no mistake, however; this second edition is not a beginner's book, no more than it is one designed or written solely for an advanced photographer. Instead, the purpose of this book is to provide, in a step-by-step manner, the material every wildlife photographer needs to know to make consistently great pictures.

As my little story about albatrosses and the wind illustrates, wildlife photography can be an exciting adventure, and a source of wonder and awe. It is becoming an increasingly popular hobby or part-time vocation, as more and more people take to the parks and wildlands

to pursue their own images. And, there-in lies a potential problem, and one that must be addressed.

As greater numbers of people take to the outdoors in pursuit of nature, inevitably there will be mounting pressure on natural areas and on the wildlife therein. There is the chance that some people, driven by competitive or commercial desires, will push a little too far, bending or breaking rules, or abandoning common sense as they try to make their photographs.

I urge you not to fall into this trap. Each year, park and refuge policies are evaluated and, sadly, usually tightened. Refuges once open from dawn-to-dusk are now restricted to businesslike hours, or are closed altogether on certain days. Parks, overcrowded by too many cars, have curtailed private vehicles completely. These types of policy changes certainly restrict access and limit opportunities, but this trend also places an increasing burden on all wildlife photographers, who must assume a mantle of responsibility and ethical behavior if they are to enjoy wild areas in the future.

In 1994, a group of concerned outdoor photographers got together and formed the North American Nature Photography Association. This group promotes and encourages ethical behavior, education, conservation, and similar issues that involve all wildlife and nature photographers. As our natural world shrinks ever-smaller, as increasing numbers of photographers strive to enjoy and document this natural world, and as public facilities, parks, and refuges grow more restrictive, an organization such as NANPA will play an important role in the future of this golden age of wildlife photography. I urge you to get involved.

There's really no question about it, making wildlife images is fun. It provides a wonderful opportunity for interacting with nature—to witness events and behaviors, and, perhaps, to get more in touch with a natural world from which we grow increasingly removed. As photographers, our very presence in the outdoors can be meaningful, showing that undeveloped land has value, that parks are utilized, and that wildlife refuges are treasured.

Photography gives us the chance to document all aspects of nature: both the beautiful and the ugly, that which makes us happy and that which saddens us. Our images can play a vital role in educating the public, in illustrating the hidden beauty of an area threatened with development, or in revealing the atrocities produced by a wanton disregard for how we treat our natural world.

Right: **SOUTH AFRICAN FUR SEAL**, Cape Cross, Namibia. 300mm F2.8 lens, 1/250 sec. at *f*/8, Fujichrome 100

At a large breeding colony on the southwest coast of Africa no fewer than six fur seals were collared by abandoned fishing nets, dooming the seals to a slow, painful death by strangulation or infection. Young seals are cute and animated, and at first, the colorful ring may look like a contrived anthropomorphic affectation. Perhaps knowing that baby seals will die from this pollution will focus attention on this issue.

Opposite: **LEOPARD,** Samburu Game Reserve, Kenya. 600mm F4 lens, 1/125 sec. at *f*/4, Fujichrome 100

At one time, coats made from spotted cats were a fashion rage. Today, as photography illuminates the beauty and hidden lives of these magnificent creatures, a threat from the fashion world is now a thing of the past.

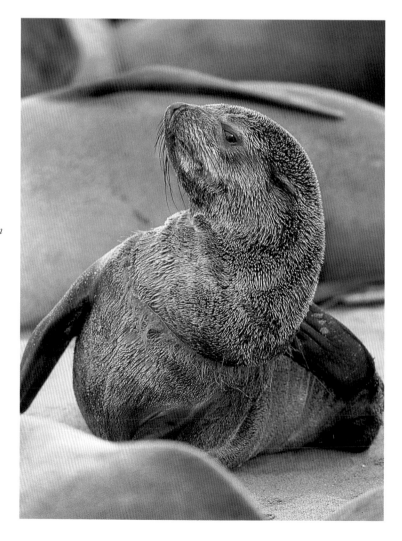

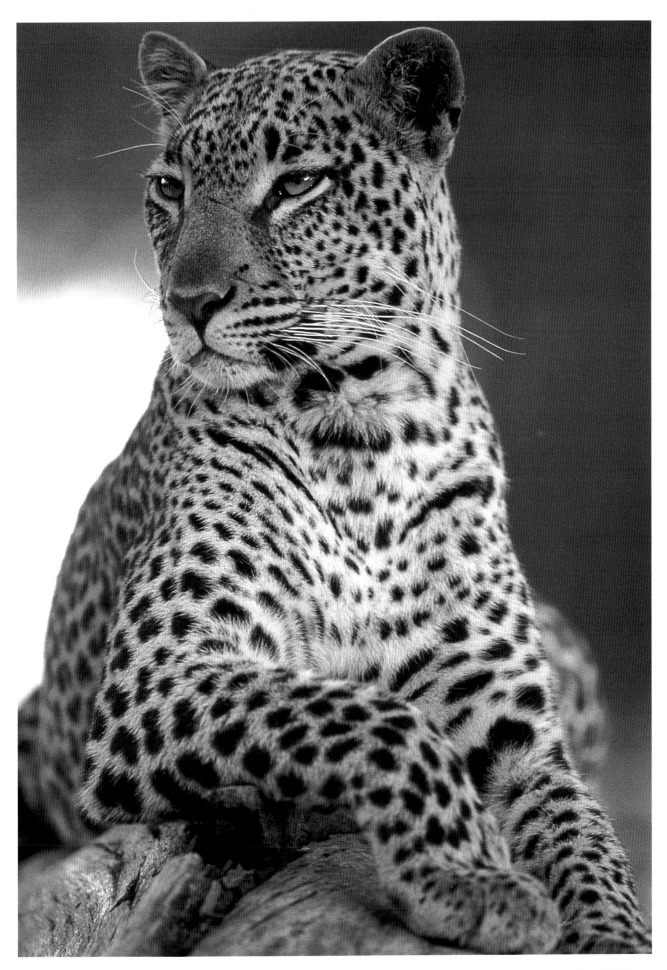

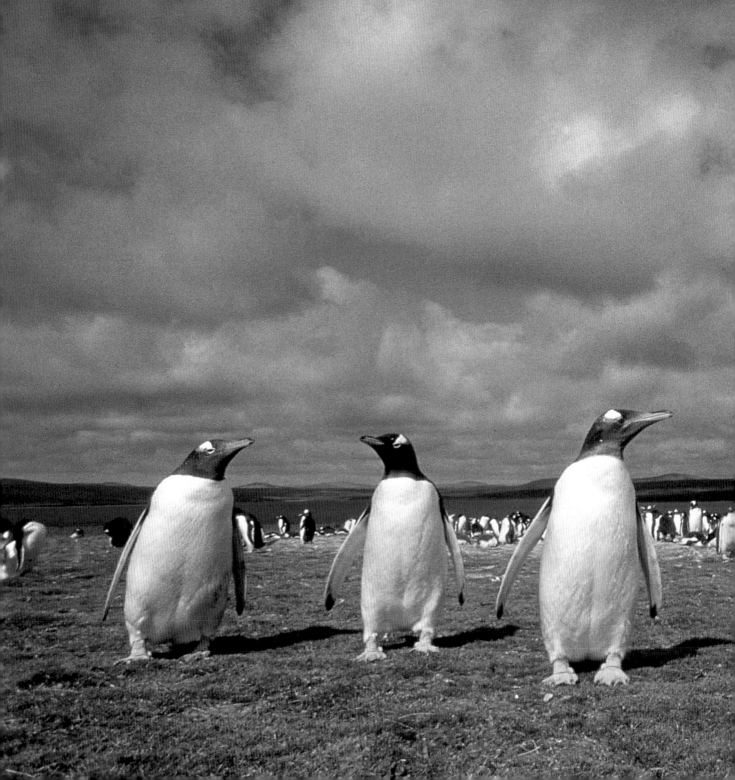

PART 1
THE BASICS

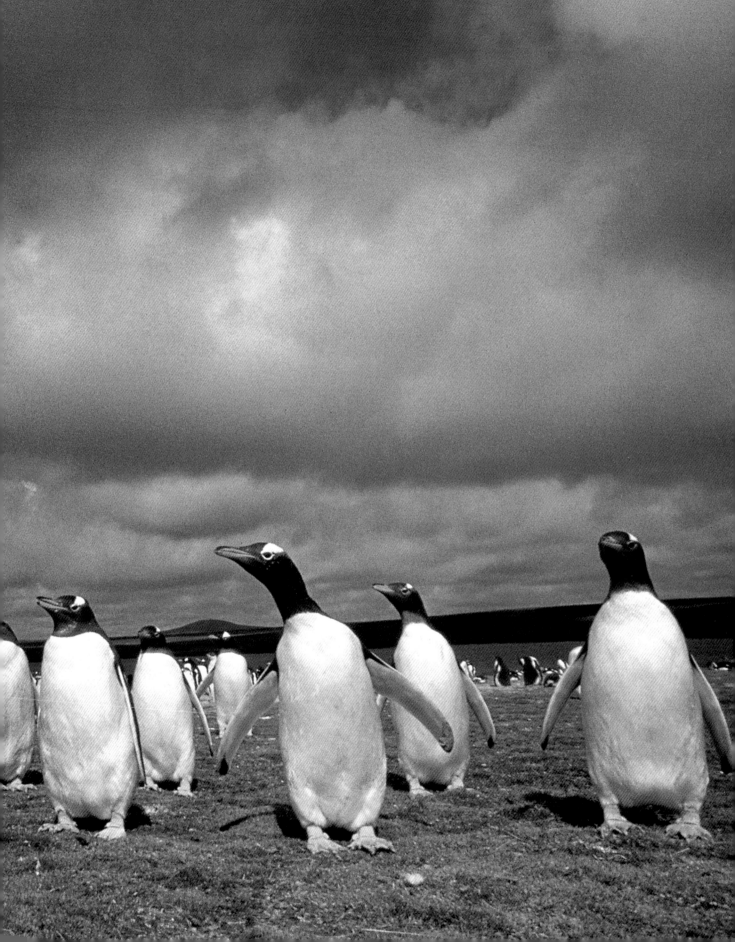

DISCOVERING SUBJECTS

It took nearly two hours, but by moving slowly and keeping low, our small group of six photographers was now within 30 feet of a flock of magnificent roseate spoonbills highlighted by the warm, late-afternoon light. At close to water level, the images we saw through our viewfinders were stunning.

Perhaps even more important than the images we made, our photography of the small flock of colorful spoonbills was benign. We had taken great care to move in slowly, painfully duck-walking forward, our rear ends occasionally dipping in the cool water as we advanced. By keeping low and moving slowly, we didn't present a

threat, and the birds tolerated our presence. The hour or so that we spent so close to one of North America's most beautiful wading birds was truly a milestone in our photography. When we finished, we were just as careful to move out in the same fashion so that the birds remained undisturbed, occupying the same stretch of shallow mudflats as they had when we arrived.

Large and colorful, roseate spoonbills are an obvious photographic subject. However, in most wildlife photography, obvious, cooperative subjects are the exception. Sometimes, try as you may to find one, there just doesn't seem to be a subject anywhere in sight. At

ROSEATE SPOONBILL, Myakka River, Florida. 600mm F4 lens, 1/500 sec. at ƒ/9, Fujichrome 100

By moving slowly and keeping a low profile, I was able to approach within 30 feet of a flock of roseate spoonbills resting and bathing in a quiet section of river.

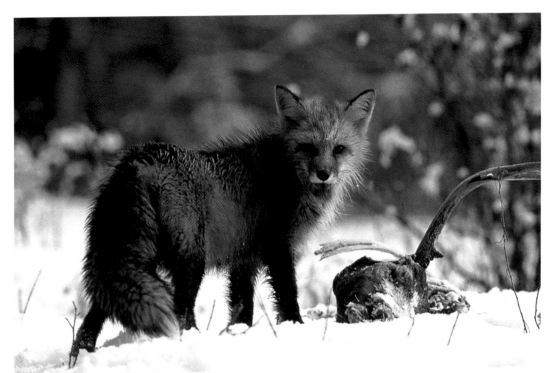

RED FOX (CAPTIVE), Wild Eyes, Montana. 500mm F4 lens, 1/500 sec. at ƒ/5.6, Fujichrome 100

Some fox "chow" was placed by the remains of an old deer, enabling me to create the impression of a fox scavenging a winter kill for food.

least, not while you're there. For example, at high noon a meadow may be nothing more than harsh shadows and blowing weeds, but at daybreak—when dew lies heavily upon still grasses and chilled insects—it can be a magical location. Indeed, there is often a magic to dawn, when mist, fog, and low light combine to create visual opportunities that no photographer could pass up. Every time of day offers something.

I've often found that by simply focusing my attention on a small area and seeking vignettes of the larger, more confusing, and less inspiring scene, I can make images where at first glance there seemed to be nothing. Not that this is easy. Sometimes *seeing* is work, requiring one to truly search out hidden subjects, textures, or patterns of light. Occasionally, I just sit for a few minutes to look at and contemplate the scene around me, and, in doing so, a photograph appears. That picture may not leap out at me, but may be as subtle as the interplay of a fern shadow upon a rock or the discovery of a hidden creature nearby.

It is usually not too difficult to find a wildlife or nature subject, but the true challenge lies in making a great photograph of what you find. Photographing animals without giving thought to anything but getting the picture is little more than taking snapshots. These have their place, but I think everyone hopes to make images that are beautiful or dramatic, as well. This requires effort. Some try to take shortcuts by simply relying on their gear. While the right equipment is necessary for specific tasks, having it doesn't guarantee that anyone can become a good photographer. There is more to photography than that.

I run an assignment during my photo workshops that I call "the chicken salad exercise," in which I take the workshop participants to an uninspiring location and ask them to make something exquisite—a chicken salad out of what appears to be nothing but chicken scratch. The object of the exercise is to fine-tune the eye to see hidden or unnoticed images, which the workshop participants then share and critique with one another.

The exercise can be humbling for the thin-skinned or for those who feel they must create a masterpiece in 20 very short minutes. Often, these are the people carrying the most gear, who at the end of the period are still wandering about, seeking images their minds will never recognize. In contrast, there is usually someone with a rickety tripod, carrying only two lenses, who is open both to improving and to seeing. Often, he or she is the one who sets up a truly outstanding image, for example, a pattern of shadows on a saw palmetto or a tree bark detail accented by a well-camouflaged, easily overlooked spider.

I'm not implying that good camera equipment isn't important—it is. And when used correctly it can improve your shooting dramatically. Instead, what I'm emphasizing is the importance of seeing—of previsualizing the image you wish to make and using your gear to do it. A contractor doesn't randomly cut wood, haphazardly nailing pieces together expecting to build a house. But, some photographers seem to do exactly that and are surprised when they look through their cameras and see what their lenses reveal. What they've framed may in fact be striking, but it is better to know what you're getting beforehand and not be surprised when you look through the viewfinder.

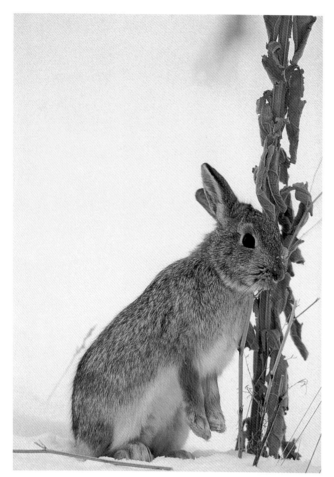

MOUNTAIN COTTONTAIL RABBIT, Yellowstone National Park, Wyoming. 500mm F4 lens, 1/125 sec. at ƒ/4, Kodachrome 200
While I was filming the geologic formations at Mammoth Hot Springs, a cottontail popped up from under the wooden boardwalk. Luckily, I had my 500mm lens in my backpack and was able to capture this image.

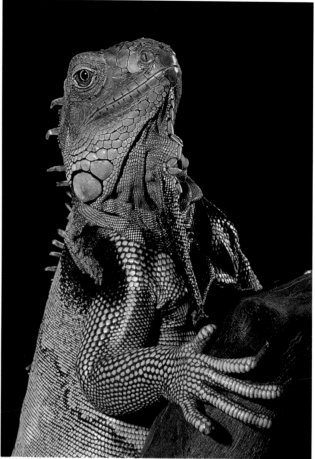

COMMON TREE IGUANA (CAPTIVE), McClure, Pennsylvania. 200mm F4 macro lens, 1/250 sec. at ƒ/16, manual flash, Fuji Velvia
A friend's pet iguana made a handy subject. Without worrying about the animal escaping or being stressed by my presence, I was free to practice a number of photographic techniques that I was later able to apply to my work in the field.

What is there for you to shoot? Plenty! Be it a drying mudflat or a grinning alligator, a roosting long-eared owl or glowing Indian paintbrush, the natural world offers a wealth of subjects for you to render beautifully and sensitively on film. If you take the time to look, you'll discover that it is worth the effort.

WHAT YOU NEED TO SUCCEED

Even when you're armed with a vision, wildlife and nature photography is still a challenging endeavor. Consistently successful wildlife photography requires understanding both your subject and your equipment, a priceless amount of patience and luck, and a generous amount of time. Which one of these things is the most important? I don't think any one can be placed above the others, for each contributes to a successful photographic image.

Knowing your subject will get you to the right place and enable you to predict an animal's behavior before it occurs. Being at the right place is important. For example, I could work for weeks in my home state of Pennsylvania and not produce a worthwhile image of a wary great

blue heron. In contrast, at Anhinga Trail in Everglades National Park, or at several other sites in Florida, I can easily photograph a great blue at any time of day in a variety of habitats. At some fishing piers, these tall birds even solicit handouts from the fishermen!

It is equally important to be at the right place at the right time. It does little good to wander the woods in June if the wood frogs you're seeking breed in vernal ponds in late March. In addition, reading about your subjects may not help; a field guide, for example, may list several months for wood frog breeding, and you might not know that these dates apply to the frog's entire range. Sometimes, to get the facts right requires further effort. Read, but also talk to people—especially to other photographers; watch educational television, and most important, go into the field and observe your subjects to acquire basic knowledge of them.

You must know your equipment well in order to succeed. Most people do not. I'm amazed at how often people don't know that their camera has a PC socket, or that they can flip to a vertical image via the tripod

collar on their telephoto lens, or that they can check their depth of field with a preview button. They use their gear improperly or grow frustrated with it because they don't know what the equipment can do. Here's a tip: Some of your most valuable photo resources are your equipment manuals; read them to learn all the capabilities and details of your gear.

If you're disappointed with your photographs, keep practicing. Gear can malfunction, and a poor image may not be your fault, but by experiencing a failure you may be tempted to stop using some gear or techniques rather than to seek out the reason for your disappointments. Like any other skill, photography and the use of complicated equipment requires time and practice.

Always continue to experiment and be innovative, even after you've technically mastered your gear. Photography magazines, books, and workshop leaders are continuously presenting new techniques or new ways of doing old things. Try to photograph subjects in more than just one way, especially if you find yourself repeatedly attempting risk-free compositions. If an opportunity arises and you have the time, bracket techniques, just as you might bracket exposures. Try new techniques, such as choosing a slow shutter speed to convey motion or using fill flash instead of a reflector. Try different lenses. For example,

when photographing an animal close by, use a wide-angle lens and include the landscape in your image rather than just making another frame-filling portrait. Experiment with different perspectives, as well, perhaps shooting from below your subject's level rather than at or above it.

Patience and persistence are vital ingredients for consistently successful wildlife photography. These qualities set great photographers apart from merely good ones. I have a classic example. Once, in a swamp in Florida, a group of photographers and I waited for a great blue heron to capture something it had struck at repeatedly. Time wore on until nearly three hours passed. Such comments as, "Watching grass grow is more exciting than this," from some of the group created an unrest that eventually lured all but three of us from the heron. Ten minutes after most of the group left, the heron slammed into the water, pulling up a greater siren, a huge aquatic salamander. It was *the* shot of the photo tour, missed by all but the three most patient photographers. The tenacity that keeps a good photographer behind the viewfinder when others quit is perhaps where "luck" is forged.

Obviously, patience is a trait all good wildlife photographers should strive to develop. Sometimes it is difficult to decide whether you're wasting your time when you're waiting for something to happen. I usually

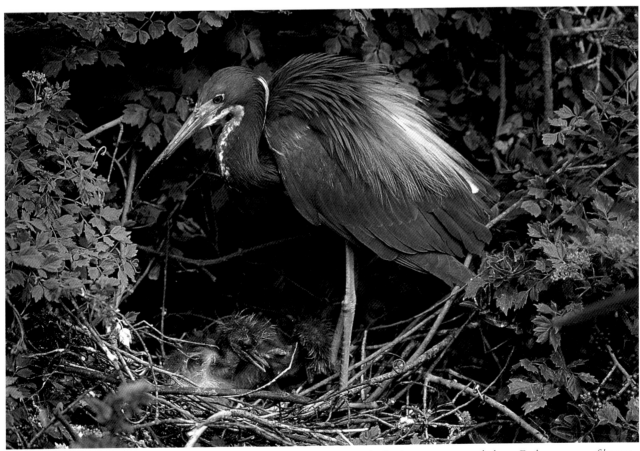

TRICOLORED HERON, St. Augustine Alligator Farm, Florida. 300mm F2.8 lens, 1/250 sec. at ƒ/5.6, Fujichrome 100

Great shooting opportunities can arise in the most unexpected places. Each year scores of herons and egrets nest within feet of the boardwalk crossing the alligator pond at this famous location.

recommend staying with the subject you have—the sure thing—because there's no guarantee that moving on will produce anything more interesting. This is especially true when an animal appears interested in something, whether it be a mate, a rival, or a meal.

Opportunity also plays a role in making great pictures. The more you are in the field, the more time you'll have to experiment, practice, and find more subjects. Filming backyard subjects, or those found close to home, gives you the chance to return as often as is necessary to capture exactly what you had envisioned. At the same time, you'll learn more about your subject and the area in which it lives.

Of course, better locales offer greater opportunities, and it is always worth the effort to seek out subject-rich habitats. This may not require very much work on your part, either. For example, in many state and national parks, the areas immediately surrounding the camping or parking areas are so trampled by the passing crowds that there is really very little to photograph. Fortunately, few people actually venture beyond their cars or campsites, and often just a few hundred yards away the photographic opportunities become far more diverse.

Edges are great places to check. That is, the border between a forest and meadow, or meadow and stream or pond—anywhere two different habitats intersect. Here the common residents of either habitat may overlap, resulting in far more subjects than one would find deeper in the woods or in the middle of a meadow. One of my favorite edges is the dozen yards of meadow grass that borders some of my neighboring ponds and lakes. At dawn, the tall grasses shelter dragonflies and orb web spiders, and sometimes, if I'm lucky, I'll discover the nymph of a dragonfly just beginning its metamorphosis to the adult stage. Frequently, I'm pleasantly surprised to find a well-camouflaged frog or toad lying quietly only a few feet from where I'm sitting.

Wildlife and nature photography is work. It takes effort to understand your equipment and an investment in time and money to find and get close to wild animals. It isn't always easy to be patient, accept a disappointment, and then tackle a difficult shoot after experiencing one failure. It also takes a real willingness to stay open to ideas, to recognize opportunities as they arise, and to push your creative potential to see images that aren't immediately apparent.

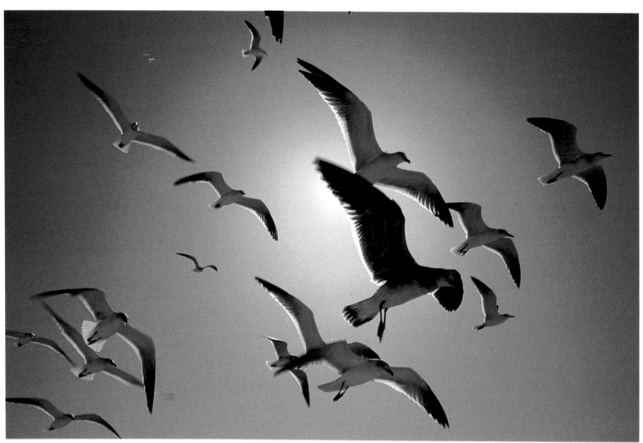

Above: **LAUGHING GULLS**, Sanibel Island, Florida. 35–70mm F2.8 zoom lens, 1/500 sec. at ƒ/8, Kodachrome 64

Several people were feeding the gulls along the beach, so I slid into the group with a wide-angle lens to capture the flock as it swirled overhead.

Opposite: **BULLFROG (CAPTIVE)**, McClure, Pennsylvania. 200mm F4 macro lens, 1/250 sec. at ƒ/16, manual flash, Fuji Velvia

What constitutes a captive? Several bullfrogs live in the ponds on our property, but for this shot, I captured one and placed it in a pool where I achieved the proper reflections. When finished, I released the frog in the exact spot from which I'd removed him only an hour before.

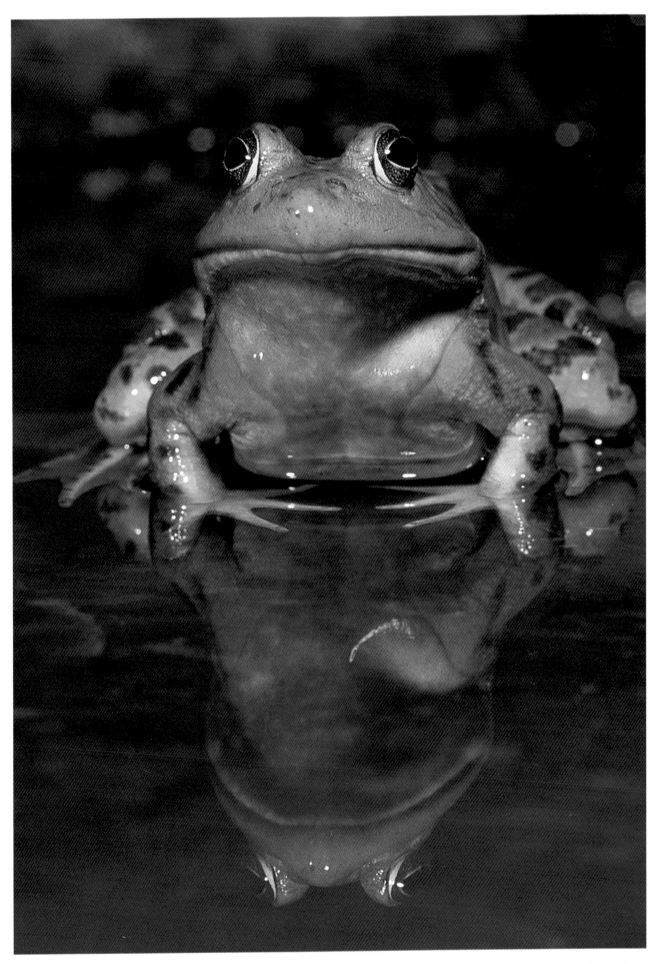

MASTERING EXPOSURE

Camera technology has come a long, long way, and modern exposure systems are light-years ahead of what they were just a decade ago. Still, they're not infallible, and at my photo workshops, I find the single most troubling technical aspect of my students' photography is determining the proper exposure. Today's sophisticated cameras offer one or more methods to produce correct exposures. Depending on camera type or model, such terms as *matrix, evaluative, spot,* and *center-weighted* describe various exposure systems. Most cameras offer one or more exposure modes, including *programmed, aperture priority, shutter priority,* and *manual.*

It is natural to assume that these modes or systems eliminate error and free you to concentrate on composition, but that isn't entirely true. No exposure mode or system can think, and none can determine the tonality of your subject all the time, whether your subject is white or black or middle-tone gray. The latest cameras—incorporating extremely sophisticated exposure programs and matrix or evaluative metering—come close, but even they can be tricked by unusual conditions. For other cameras, those not at the extremely high end of the price range, the problem of what's white, black, or middle tone becomes a very real issue.

There are a variety of ways to determine exposure, but all mechanical metering systems are designed to yield a pleasant, middle-tone value. That is an *18-percent reflectance,* or a middle gray between the extremes of tonality, bright white, and darkest black. You're probably familiar with a photographic *gray card,* which many photographers use to determine exposures. Gray cards work because they provide a ready exposure reference, although every color also has a middle-tone value that could be used to base an exposure.

Charles Campbell, author of *The Backpacker's Photography Handbook* (Amphoto, 1994), markets a packet of cards that provide an exposure reference for a variety of color tonalities. Called the Chroma-Zone System, the cards enable users to match a color card with the color tonality of their subjects and to bias the exposure a given

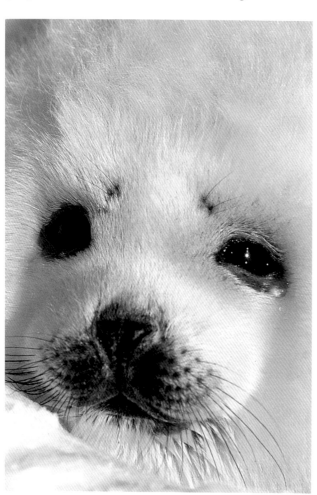

BABY HARP SEAL, Magdeline Islands, Quebec, Canada. 200mm F4 macro lens, 1/250 sec. at *f*/16, Fujichrome 100

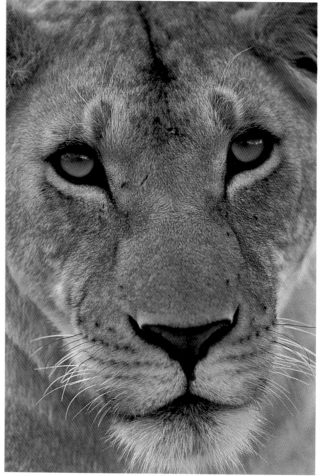

LIONESS, Masai Mara Game Reserve, Kenya. 600mm F4 lens, 1/250 sec. at *f*/5.6, Fujichrome 100

amount based upon the card's recommendation. The system provides an excellent review of tonality and a means to practice identifying middle tones.

Sometimes your subjects lie within a middle-tone range, and sometimes they don't. Consider three subjects: a white baby harp seal, a black-phase gray wolf, and a tan lioness. Most camera meters would expose all three animals as middle tones, resulting in improper exposures for the white seal and the black wolf. The seal, metered as middle tone, would be rendered gray or underexposed, while the black wolf, becoming a middle-tone gray, would be overexposed.

Sophisticated metering systems can adjust for varying tonalities if you override the standard exposure. To do so, you must be able to recognize what is and what isn't a middle-tone value.

DETERMINING A MIDDLE TONE
A photographic gray card is the perfect middle-tone value and can be used to base your exposures if the card and your subject are in the same light. This is critical, because a reflected-light reading taken off the card will be the basis for the exposure you choose for the subject. Gray-card readings won't be accurate if your card is in

the sun and your subject is in shade, because the card will reflect considerably more light than the shaded object. An underexposed subject would result.

Using a gray card isn't always convenient. Obviously, readings from a gray card are difficult to do if you're inside a blind, unless you've placed a card in the general area where you expect your subject to be. I'll frequently do just that if I'm filming at a bird's favorite songpost or at a den or burrow where I know my subject will appear. Readings are difficult, too, if you're trying to look through the viewfinder of a long lens and you're holding the card in front of the camera. You must also be careful not to shade the card with your lens or body, which might happen while you're looking through the viewfinder. If you do cast a shadow, the gray card will reflect less light than the subject, and a reading based on the card would result in an overexposure.

It often is more practical to substitute a middle-tone value that is in the same light as your subject. In fact, many wildlife subjects are middle tone. If your subject isn't middle tone, or if it is impossible to take a reading, use a substitute. Nature offers many, such as cattails in summer, a great blue heron, or a whitetailed deer. You could also try gray tree trunks, the northern blue sky, most grasses, or even your faded blue jeans.

Although these examples are satisfactory gray-card substitutes, I recommend that you develop your own sense of tonality so that you can recognize a broad range of middle tones by sight alone. I've found two easy ways to do so: Try metering something you consider middle tone, then compare that exposure with one you obtain by metering a gray card placed in the same light. Over time, you'll find it easy to pick out tonalities that are close to middle tone in value. You can also practice by comparing your camera readings of subjects with those obtained by an *incident-light meter.* Incident-light meters read the light that falls on their light-measuring face, usually an opaque white bulb. In addition, *reflected-light meters,* present in all single-lens-reflex (SLR) cameras, measure the light reflected from the subject. The two kinds of meters will give equivalent exposures. The incident-light meter reads 18 percent of the light that passes through the bulb, while the reflected-light meter reads 18 percent of light that reflects off an average or middle-tone subject. If the incident-light meter is in the same light as your middle-tone subject, the two readings should agree.

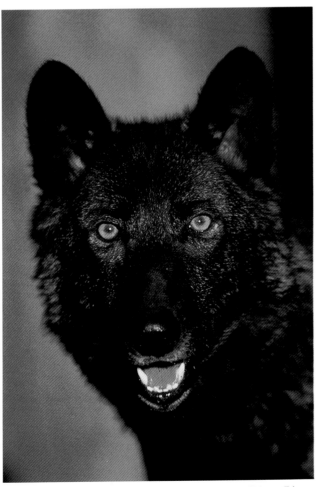

GRAY WOLF (BLACK PHASE), Wild Eyes, Montana. 500mm F4 lens, 1/250 sec. at f/5.6, Fujichrome 100

Most cameras would err in exposing the diverse tones of these three subjects all as middle-tone values. Some camera metering systems do a better job than others, but I'd suggest testing your system to see if you can trust your meter and, if you can't, to determine what degree of compensation might be required. All systems, using any exposure mode, should expose the lioness correctly.

However, metering off a gray card or middle-tone subject, or using the reading from an incident-light meter, won't guarantee a correct exposure if your exposure meter is improperly calibrated and inaccurately measures light. This problem can happen with the best of meters or cameras, even with brand-new models right off the shelf. This isn't evident with negative films, because errors in exposure can be corrected during printing. With slide film there is no chance for in-lab corrections, because the image obtained when the film is developed is the final result. You can't increase detail or decrease an exposure during a printing stage as you can with negative film. Slide film is also less forgiving in terms of exposure, and an exposure that is incorrect by more than a half stop is evident even to a novice. Overexposed images look thin or washed out, while underexposed images are often so dark that details in all but the brightest areas are lost. Although you might be responsible for this, it could be the fault of the meter.

If you compare four or five identical camera models or incident-light meters, you might find a difference of as much as two *f*-stops between meter readings. If this happens to you, don't panic—your meter isn't broken, and it won't have to be sent for repair. It just has to be recalibrated, which you can do. All you need is a middle-tone subject and a known quantity of light. If you're using an incident-light meter, the middle tone is the incident bulb. If you're using your camera's meter or a handheld spot meter, use a gray card. Finding a light source is easy—use the sun.

CALIBRATING YOUR EXPOSURE METER FOR "SUNNY *f*/16"

I've found that most fully electronic cameras—those introduced since 1990—are remarkably accurate in their metering. Unlike older models, which can be off and require calibration, contemporary, state-of-the-art cameras rarely need adjustment. Generally speaking, you can trust their meters, at least when it comes to reading middle tones. Calibrating a meter, therefore, isn't the critical issue it once was. However, it still is an issue for some, and it is nice to know that your meter is indeed correct. Here's how to find out.

To check the accuracy of any reflected-light meter, take a reading off a gray card around 10 A.M. with bright sunlight falling over your shoulder onto the card. Avoid doing the test in winter, when the sun can be so low in the sky that its brightness will be as much as one *f*-stop less than it is in summer. Likewise, make sure the sky is really a clear blue, as even a slight haze can mask some of the sun's brightness, resulting in an inaccurate calibration. With your aperture set to *f*/16, focus at infinity. This is necessary, because some lenses

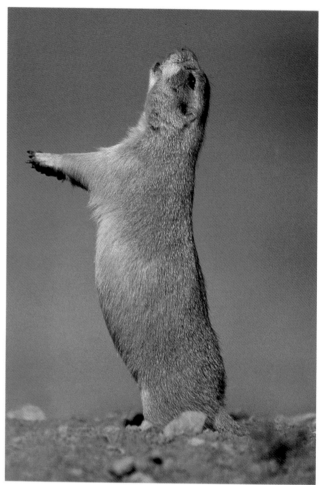

BLACKTAIL PRAIRIE DOG, Gray's Cliff, Montana. 600mm F4 lens, 1/500 sec. at *f*/8, Fujichrome 100
No metering is necessary for a middle-tone subject shot under sunny f/16 conditions. Of course, I used a faster shutter speed to stop action, using the "wildlife equivalent" for the usual rule.

increase in length as they near minimum focus, which decreases the light that passes through.

If you're using a zoom lens with a *floating aperture,* in which the *f*-stop and the amount of light that the lens transmits vary as the focal length is changed, set your zoom lens to its smallest focal length. Now you'll obtain the true light value for the lens. Floating-aperture zoom lenses, by the way, are identified by two *f*-numbers for their widest apertures. For example, Canon's 35–350mm zoom lens has a floating aperture identified by an *f*/3.5–*f*/5.6 mark on the lens. As you zoom from a wide-angle setting to a telephoto, the lens automatically adjusts for the reduced amount of light and displays the new aperture in the viewfinder. That's a common characteristic of many electronic cameras.

However, it isn't standard for all electronic cameras, or for those that incorporate mechanical and electronic features. For example, a 70–300mm *f*/4.5–5.6 zoom lens on a Nikon F4 will still read *f*/4.5 when the lens is zoomed out to 70mm, even though the aperture is

really at $f/5.6$ at that focal length. On an automatic exposure mode, the exposure will change automatically to adjust for this. On manual mode, the LED indicator will show a change in exposure—indicating that by zooming out you've underexposed by nearly a stop—but you'd still be required to change the shutter speed to compensate.

With the lens positioned at $f/16$ (remember, this may require zooming to the shortest focal length of your zoom, depending upon your system), set the shutter speed at the reciprocal of the ISO film you're using. For example, with ISO 100 film this is 1/125sec.—the nearest you can come to the true reciprocal of 1/100 in most cameras. At ISO 50, that would be 1/60 sec. At ISO 200, it would be 1/250 sec.

Of course, with electronic cameras that have shutter speeds in third-stop or half-stop increments, you could use 1/200 or 1/50 sec., as your film requires. Without these increments, you may be off by a third of a stop. If so, to fine-tune your calibration set the aperture mark between $f/11$ and $f/16$ if your shutter speed is greater than the film speed, or between $f/16$ and $f/22$ if the shutter speed is lower than the reciprocal of the film speed. Again, with electronic cameras, you could dial in the aperture in third-stop increments as well.

With everything set, a meter reading off the gray card should give a reading of $f/16$ at 1/ISO. This metering check is so accurate as a basis for an exposure that it is called the *sunny f/16* rule. (Remember, this check is valid only under the proper conditions; you must have bright sunlight falling over your shoulder onto your middle-tone subject.)

Unfortunately, you might find that your meter might not give you a sunny $f/16$ reading in bright, over-the-shoulder sunlight; this is more likely to occur with older, pre-1990 camera models. If this happens, it is easy to correct. For example, if you're using ISO 100 film, your meter should read 1/125 sec. at $f/16$, with the ISO dial set at 100. If instead it reads 1/60 sec., then your meter is off. To correctly calibrate your meter, simply adjust the ISO setting to the 200 mark; this will make your exposure meter twice as sensitive to light. Now you'll obtain the correct 1/125 sec. setting.

You can also calibrate your in-camera meter by using the exposure-compensation dial (if your camera has one). If your camera meter is reading too little light, set the compensation dial to the -1 position, which will add a stop of light to the exposure; now you'll obtain the desired 1/125 sec. shutter speed. Cameras differ, and some exposure-compensation dials are calibrated by +'s and -'s or by whole numbers and fractions, so be sure to check your camera's instruction manual for the method that applies.

Calibrating an incident-light meter is just as simple. Position the light-measuring bulb so that it points toward the sun. Remember, the bulb reads only 18 percent of the light that passes through it. If the meter needs correcting, you can do so either by adjusting the ISO as you would when fine-tuning your camera's meter or by adjusting a calibration dial if the meter has one.

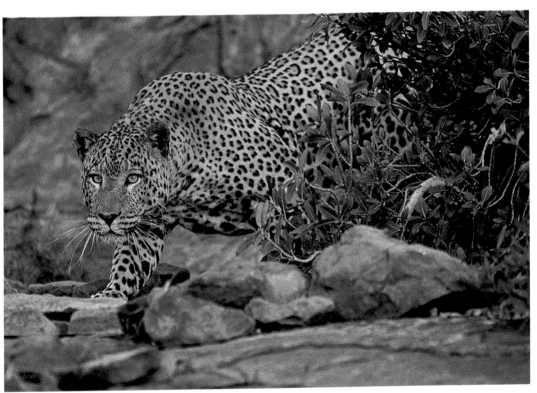

LEOPARD (CAPTIVE), Okinjima Africa Trust, Namibia. 300mm F2.8 lens, 1/125 sec. at $f/2.8$, Kodachrome 200

At the end of the day, light values change rapidly, especially when your subject is moving in and out of open clearings or thick brush. Since most of the subject matter here was a near middle tone in value, I trusted my Nikon's F5 color matrix metering to produce a correct exposure, which I think it did.

The sunny f/16 rule is also a great spot-check if you're using *DX-coded* film, in which the correct film speed is encoded onto the film cartridge in a bar code. The camera reads this bar code and automatically sets the proper film speed; however, a camera can misread a DX cartridge and set an inaccurate ISO. Always double-check the setting by hitting the ISO button. An inaccurate film speed becomes quickly apparent if your camera meter's exposures deviate from sunny f/16, or the equivalent exposures. If you've fine-tuned your camera's meter by changing the ISO setting, be careful when you change to a different film speed. Most contemporary cameras will maintain the ISO you've manually set and won't read the DX code unless you actually set the ISO mode to the DX setting. On more than one occasion, I've found myself shooting ISO 100 film when I've left my camera's film-speed setting at 40 after last shooting Fuji Velvia. Again, make sure you read your manual because some cameras automatically set themselves to the correct DX-coded ISO whenever you change films. As a matter of course, these days I invariably set my cameras on DX and leave them there.

Once you understand and accept the sunny f/16 rule, you can ignore your meter when filming middle-tone subjects in direct sunlight. I often do. Remember, you're not required to use f/16 and a shutter speed that is the reciprocal of your film speed (1/ISO). Your subject might require a faster shutter speed or greater depth of field. If it does, adjust accordingly.

There are limitations to the sunny f/16 rule. Within approximately two hours of sunrise or sunset, or during the winter months throughout much of the United States and Canada, this rule fails because the sun is low and the atmosphere masks some of its intensity. Thin, wispy cirrus clouds, faint fog, dust, or smoke may also lessen the sun's intensity and make a sunny f/16 exposure inaccurate. At high noon anytime near the equator or during summer in temperate zones, the sun is almost directly overhead and a sunny f/16 reading is possible only if you're looking directly down at your subject. If you're facing your subject at eye level, as you normally would, your subject will be top-lighted; you'll lose between 1/2 and 1 full f-stop. If you're using an incident-light meter, be sure to hold the face at your level—not flat and facing the sun—so that you will obtain an accurate exposure reading.

Some final points about calibrating your exposure meter should you need to: Once calibrated, you can trust your meter to yield accurate exposures on any middle-tone subject. Also, the degree of compensation required for one film speed applies to other film speeds, allowing you to expose those films accurately without doing another recalibration. Of course, changing the setting for the film's speed to achieve sunny f/16 doesn't

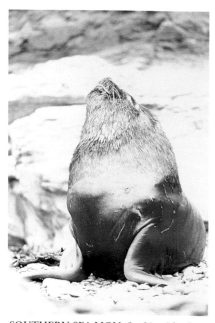

SOUTHERN SEA LION, Sea Lion Island, Falkland Islands. 300mm F2.8 lens with 1.4X teleconverter, 1/30 sec. at f/4, Fujichrome 100

I spot-metered the dark belly of this sea lion, knowing that by metering black I'd overexpose the image. While this may seem obvious, it points out the importance of aiming a spot meter at the correct area when using this metering method.

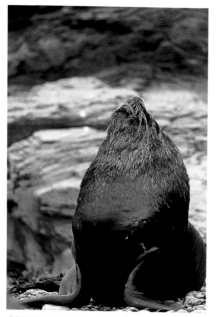

SOUTHERN SEA LION, Sea Lion Island, Falkland Islands. 300mm F2.8 lens with 1.4X teleconverter, 1/250 sec. at f/4, Fujichrome 100

I used the highly sophisticated metering system of the Nikon F5 on matrix mode, which reads the entire scene. The meter did a good job but, to my eye, still gave a little more emphasis to the dark seal while slightly overexposing the surrounding gray rocks.

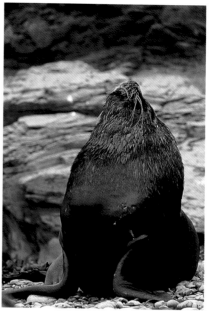

SOUTHERN SEA LION, Sea Lion Island, Falkland Islands. 300mm F2.8 lens with 1.4X teleconverter, 1/250 sec. at f/5.6, Fujichrome 100

I spot-metered the gray rocks, then overexposed off this middle tone setting by one stop. This lightened the rocks—but by a controllable amount—while also bringing some detail to the much darker seal.

THE VALUE OF "SUNNY *f*/16"

Modern camera meters are remarkably accurate. So, why bother with the sunny *f*/16 rule? Here are a couple of reasons why:

1. If you know your film speed, you'll always have a standard, baseline exposure with which to compare your camera's metering suggestions. If you get odd readings, you'll be alerted to double check. You might just be reading a super-bright area, such as a patch of sunlight reflecting off water, or a dark area behind your subject; or, your meter could be off.

2. A DX-coded roll of film could be misread by your camera if the bar code is scratched or marred. Or, the camera may not be set for DX, or you could be using a roll of film lacking the code. In any case, if you know the equivalent exposure for the film you're using, you'll be alert for unusual readings.

3. An unusual reading may simply remind you that you have an unwanted filter mounted on a lens. A polarizing filter, for example, can cost two stops of light. The sunny *f*/16 rule is a handy reminder that you're not getting the amount of light you are expecting.

4. An automatic-exposure mode will give the best exposure compromise it's programmed for doing. However, by obtaining readings in variance with "sunny *f*/16," you may be alerted that there's just too much contrast in a scene. Accordingly, you can recompose or reframe to eliminate the contrast.

COMPARING REFLECTED-LIGHT AND INCIDENT-LIGHT METERS

TONALITY	REFLECTED LIGHT	INCIDENT LIGHT
Middle	Should be accurate.	Should be accurate, but bulb must be in the same light as subject.
Whites	Two methods: 1. Meter white, then open up one *f*-stop. 2. Meter a middle tone, then close down one *f*-stop.	Close down one *f*-stop off suggested exposure.
Blacks	Meter a middle tone, then open up one *f*-stop. Don't meter black.	Open up one *f*-stop off suggested exposure.

affect the actual development of the film. Your film won't require special processing if, for example, you doubled the film speed in order to obtain sunny *f*/16, because you haven't really pushed the film. Finally, you won't have to continually calibrate your camera meter.

I suggest you do a sunny *f*/16 spot-check if you haven't used your camera for a few weeks, or on the first sunny *f*/16 day you have when you're on a lengthy vacation or safari. I often double-check my meter when I'm shooting middle-tone subjects in sunny *f*/16 light, which usually confirms the exposure I'm using. If it is off by only half an *f*-stop or so, I don't worry, because the subject's tonality may be that much different from a true middle tone. If it is off by one stop or more, I double-check the meter with a gray card. I mention this because I've seen photographers waste far too much time rechecking their meters, even when a great subject was only momentarily available.

Once you properly calibrate your exposure meter, you can trust it to correctly read middle-tone subjects in any type of light, not just the sunny *f*/16 conditions you use for calibrating. Just pick a middle-tone area that is in the same light as your subject and take a reading. If there is no middle-tone subject on which to base your exposure, take a reading from the palm of your hand and open up one stop. This works because your hand reflects about one stop more light than a gray card. Sometimes photographers are confused about whether you should open up or close down after metering your hand. If you think of your hand as opening up to expose the palm to the meter, you'll remember to open up for the exposure.

EXPOSURE COMPENSATION FOR SUBJECTS THAT AREN'T MIDDLE TONE

Some animals aren't middle tone, and exposures based on readings for middle tones won't be accurate. Bison, black bears, African buffaloes, and river otters are all darker than middle tone, and many birds, including swans, geese, terns, and egrets, are lighter than middle tone. A direct exposure reading off these subjects won't be accurate either. Exposures based on dark subjects overexpose, while those based on light subjects underexpose. If you

meter a middle-tone area instead, you'll still have exposure problems with dark and light subjects. Dark subjects will be underexposed and lose all detail, while white subjects will reflect more light and be overexposed. In either case, some *exposure compensation* is necessary. You can do this several ways.

When determining an exposure for a dark or black subject, meter a middle-tone area, such as grass or a gray card that is in the same light, and then open up one stop from that exposure. In effect, you're purposefully overexposing the middle tone by one *f*-stop, while adding light and some detail to the dark subject. If you're using an incident-light meter, hold the meter in the same light as your subject and open up one *f*-stop from that reading.

I use two different methods when metering white, depending on how large the white area is. If my subject is large enough to cover the metering area, I'll take a reading directly off the white, and then purposefully overexpose by 1 or 1 1/2 *f*-stops, depending on the lighting conditions. If the white subject is in the sun and appears bright white to me, I'll overexpose by 1 or by 1 1/2 *f*-stops. If it is in the shade, or if the light is overcast, white won't reflect as brightly and will need only a half-stop overexposure.

If I'm unable to take a meter reading off the white subject, I'll meter something middle tone that is in the same light, then close down, either a full stop for bright sunlight or a half-stop for shade or overcast skies. Remember, white reflects more light, so by closing down off the middle-tone reading, thereby underexposing the middle tone, the white subject will be less bright and will have more detail. When I take an incident-light reading, I close down because this meter only reads for middle tones. Again, the middle-tone areas will be underexposed as I compensate for white.

Of course, not all nature subjects fit into the neat categories of exactly middle tone, white, or black; some obviously fall halfway between. For these subjects, I suggest compensating by only one half-stop for subjects in sunlight and about one-third stop for those in shade or under overcast skies, opening up or closing down as the subject's tonality requires. With practice, you may be able to look at a subject and decide what, if anything, you'll use to base your exposure.

For example, imagine metering a bison as it grazes in a snowfield. Faced with a black subject on a white background, you might choose an area on the bison's hump on which to base your exposure. The hump is darker than a true middle tone but lighter than the rest of the animal, and could serve as a workable compromise between the contrasting tonalities.

SNOWY OWL (CAPTIVE), Raptor Project, British Columbia, Canada. 300mm F2.8 lens, 1/250 sec. at *f*/4, Fujichrome 100

There are several ways to determine an exposure for white subjects, and I use each depending on its ease and applicability for the situation at hand. Often, I'll meter the white directly, then overexpose that setting by 1 or 1 1/2 stops to "bring up" the white. Other times, I'll meter a middle-tone area, and underexpose off that setting by one stop. Sometimes, I simply follow the sunny f/22 rule.

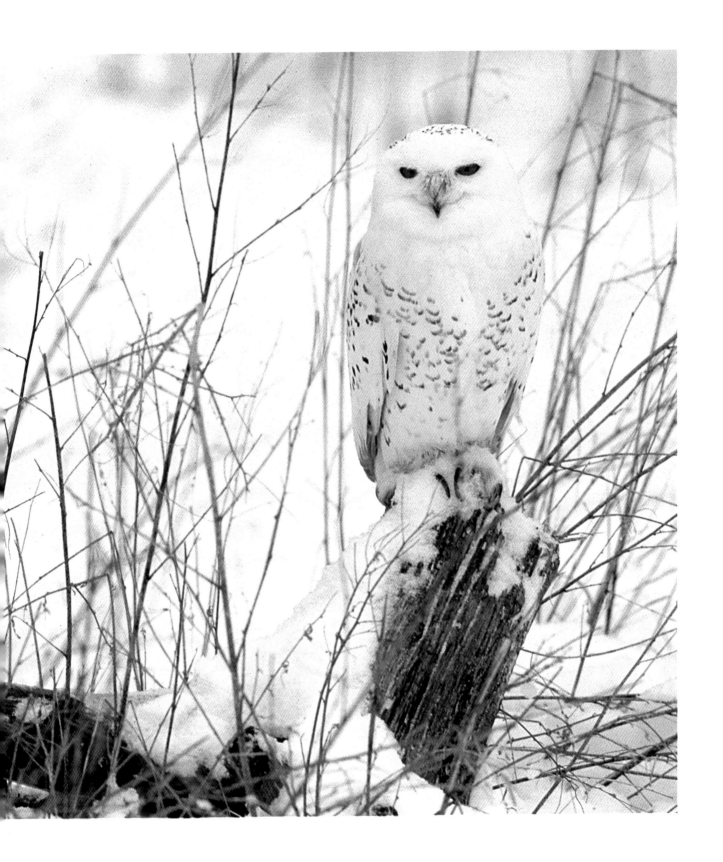

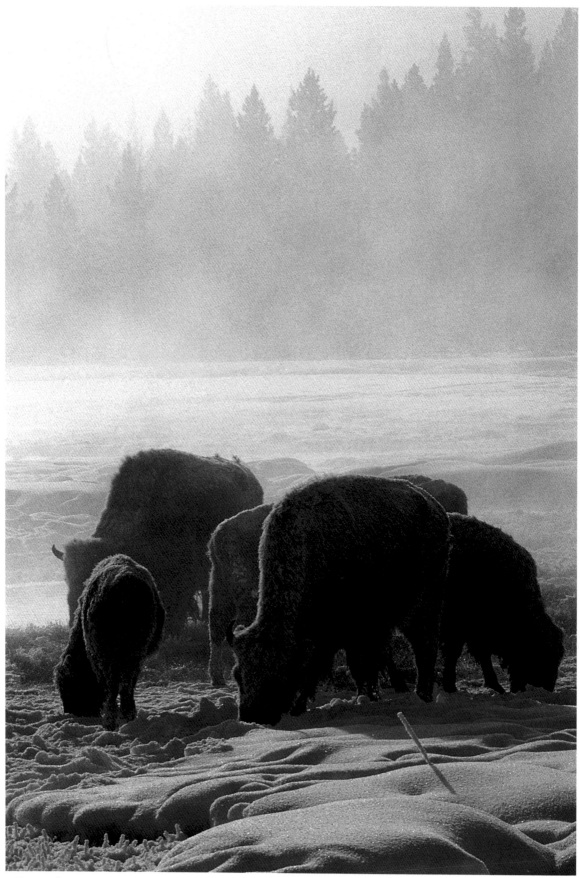

BISON, Yellowstone National Park, Wyoming. 80–200mm F2.8 zoom lens, 1/250 sec. at ƒ/5.6, Kodachrome 64

There is a range of potentially troublesome contrast in this scene. The fog and steam obscuring the distant trees are far brighter than the dark silhouettes of the bison. I metered the snow immediately above the backs of the bison and overexposed by 1 1/2 stops, pulling up the entire brightness in the scene.

Some cameras feature *evaluative metering* (also called *matrix metering*), which divides the entire picture area into sections that are read individually and given a specific amount of emphasis for the exposure. The latest advancements in this technique have convinced some photographers that their camera meters can handle virtually every exposure situation. The Nikon F5, for example, uses a matrix color meter with 1,001 sensing, yet there are conditions that can fool even this sophisticated a system. I wouldn't base all of my photography on my confidence in a computer. I'd suggest that you learn to recognize different tonalities by sight in order to base your meter readings. Work on developing this skill. Then, if you and your camera's programmed exposure agree, you won't be disappointed with your exposures.

EQUIVALENT EXPOSURES: RELATING APERTURE TO SHUTTER SPEED

One of the worst mistakes beginning photographers make after discovering sunny f/16 is exposing all their film at f/16 at 1/ISO. Upon doing this, they discover that their old exposures were better. Don't become a victim of this! The sunny f/16 rule is only a guide for making exposures of middle-tone subjects under the proper conditions. Shutter speeds faster than 1/ISO, or apertures wider than f/16, may be required. If you're using ISO 50 speed film, a shutter speed of 1/50 sec.

SUNNY *f*/16 EQUIVALENTS FOR POPULAR FILMS

Under "sunny 16" conditions, you can use any of the following aperture and shutter speed combinations with the following film speeds to achieve correct exposures for middle-tone subjects.

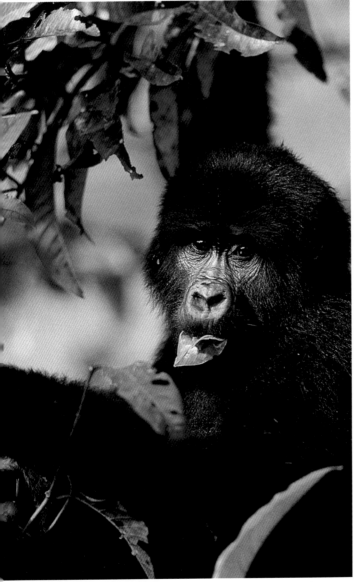

MOUNTAIN GORILLA, Bwindi Impenetrable Forest, Uganda. 300mm F2.8 lens, 1/250 sec. at *f*/4, Kodachrome 200

Filming mountain gorillas is often once-in-a-lifetime experience, and I didn't want to make any exposure mistakes. I metered the nearby leaves, which were in the same light as the gorilla, and overexposed that reading by one stop to bring detail into the dark gorilla.

APERTURE	FILM	SHUTTER SPEED
f/32	200	1/60 sec.
	100	1/30 sec.
	64	1/15 sec.
	50	1/15 sec.
f/22	200	1/125 sec.
	100	1/60 sec.
	64	1/30 sec.
	50	1/30 sec.
f/16	200	1/250 sec.
	100	1/125 sec.
	64	1/60 sec.
	50	1/60 sec.
f/11	200	1/500 sec.
	100	1/250 sec.
	64	1/125 sec.
	50	1/125 sec.
f/8	200	1/1000 sec.
	100	1/500 sec.
	64	1/250 sec.
	50	1/250 sec.
f/5.6	200	1/2000 sec.
	100	1/1000 sec.
	64	1/500 sec.
	50	1/500 sec.
f/4	200	1/4000 sec.
	100	1/2000 sec.
	64	1/1000 sec.
	50	1/1000 sec.

will be too slow to stop the motion of a bird crunching sunflower seeds at a backyard feeder. A shutter speed of 1/250 sec. or 1/500 sec. is required. Remember, however, that as you change the shutter speed, thereby reducing the length of time light reaches your film, you must compensate by allowing more light to pass through the lens during this shorter period of time. By opening up the lens two stops from *f*/16 to *f*/8 (for 1/250 sec.) or to *f*/5.6 (for 1/500 sec.), you'll have the same quantity of light reaching the film.

Each time you increase your shutter speed by one stop, you reduce the time that light has to reach your film by one half. This is often referred to as "a stop of light that is lost." To compensate, you must add a stop of light by increasing the aperture size, thereby opening up or making the aperture larger. An incorrect exposure will result if you changed only the shutter speed and not the aperture, or vice versa.

Photographers speak of fast and slow shutter speeds. Wildlife photography often requires speeds of 1/125 sec., 1/250 sec., or faster. You'll need at least 1/250 sec. to freeze the jaw motion of an elk chewing its cud, and at least 1/500 sec. to stop the motion of a great blue heron striking the water for prey. You can, of course, use slower speeds with animals if your subject is still or if you want a particular effect, such as intentional blurring where a sense of motion is implied.

The other part of the shutter speed/aperture relationship is just as critical. The *aperture,* designated by the *f*-number or *f*-stop, transmits a specific quantity of light. The larger the number, the smaller the aperture size. You might think a large number, such as *f*/22, represents a large aperture, but the opposite is true because *f*/22 is a very small aperture opening. The aperture settings are identified by how many apertures, or openings of a particular width, can fit between the lens' focal point and the camera's film plane. If you think of it in this way, it is easy to see that if 22 openings of one width (*f*/22) and 4 openings of another (*f*/4) both fit within this area, then the relative size of the opening for the *f*/22 aperture has to be smaller. Likewise, the actual size of the aperture differs, depending on the length of the lens in use. A very short 24mm wide-angle lens requires very tiny aperture openings to permit 22 apertures to fit within that space, while a long 500mm lens' *f*/22 aperture requires a much larger opening.

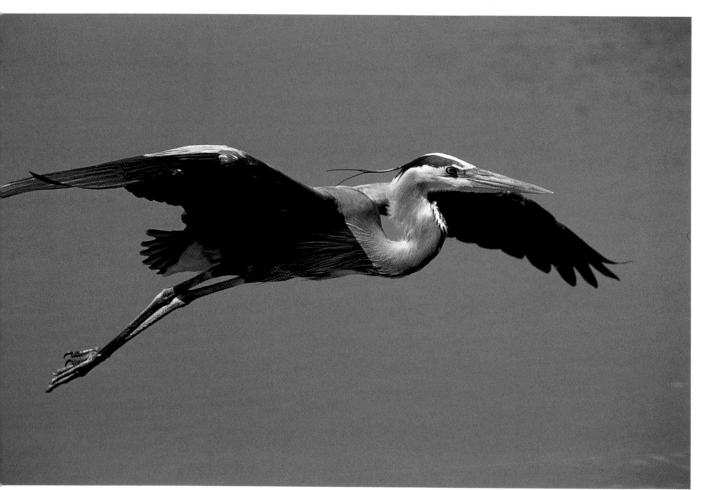

GREAT BLUE HERON, Venice, Florida. 300mm F2.8 lens with 1.4X teleconverter, 1/500 sec. at *f*/8, Fujichrome 100

I used the wildlife equivalent for the sunny f/16 rule to obtain the fast shutter speed necessary to stop this heron in flight.

Almost all lenses have aperture settings of *f*/4, *f*/5.6, *f*/8, *f*/11, and *f*/16. Some lenses have larger apertures, designated by smaller numbers such as *f*/1.4, *f*/2, and *f*/2.8, and many have the smaller apertures of *f*/22 and *f*/32. Increasing the numbers (from 2, 2.8, 4, 5.6, 8, 11, 16, 22, and 32) halves the amount of light passing through a lens each time, as the lens opening grows progressively smaller by 50 percent. When going from *f*/8 to *f*/11, you reduce the amount of light passing through the lens by exactly one stop.

Aperture size determines *depth of field,* the picture area from front to back that is in sharp focus. Large apertures (small *f*-numbers such as *f*/2.8 or *f*/4) yield little depth of field. Small apertures (*f*/16 or *f*/22) provide the greatest depth of field. At times, extensive depth of field is desirable, for example, when you are trying to photograph a group of animals together. Sometimes it isn't, because a shallow depth of field will isolate an animal from a busy or distracting background. As you change the aperture by one *f*-stop, the shutter speed must change by one also, to maintain the same exposure. Thinking in stops of light is convenient for adjusting both aperture and shutter speeds.

Always consider your subject's requirements or the composition when choosing an aperture or a shutter speed. Sometimes an image demands a particular shutter speed. Suppose you're photographing a ground squirrel barking an alarm in sunny *f*/16 light with ISO 100 film. You'll need a fast shutter speed to freeze the action. With ISO 100 film, the base exposure is 1/125 sec. at *f*/16. If you change to 1/1000 sec., which is a great speed for stopping action, light has the equivalent of three stops less time to reach the film. You have to open up the aperture three *f*-stops to compensate. Opening up from *f*/16 to *f*/11 (one stop), *f*/8 (two stops), to *f*/5.6 (three stops) results in the correct equivalent exposure. Cameras using a shutter-priority exposure system operate in this way automatically.

It is very important to remember which way a shutter-speed dial or aperture ring turns when working in stops of light on manual mode. In the previous example of the ground squirrel, had you used 1/500 sec. but turned the aperture ring the wrong way, you would have underexposed the image by four or five stops. In practice, this is easy to check by simply noting if an underexposure is indicated in the camera. If it is, you can recheck your settings.

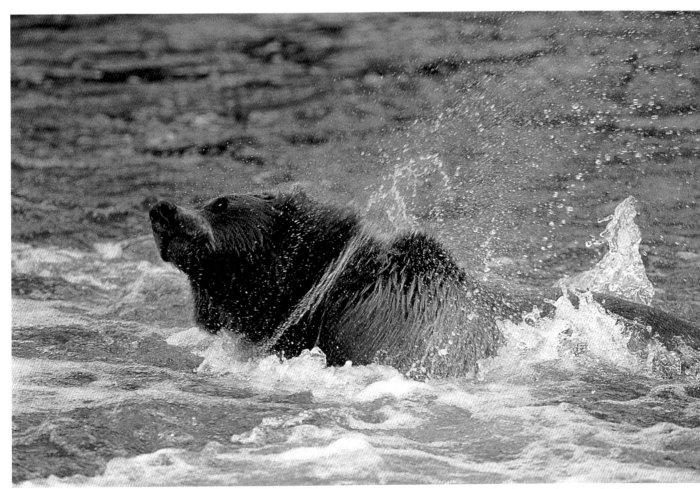

ALASKAN BROWN BEAR, Katmai National Monument, Alaska. 600mm F4 lens, 1/250 sec. at *f*/4, Kodachrome 200

It is important to choose a shutter speed capable of stopping the action. In the low light of this scene, I was limited by an aperture of f/4, and 1/250 sec. was the fastest I could manage. As you can see, it didn't completely freeze the bear's shake.

ESTIMATING EXPOSURES IN THE FIELD

In wildlife photography, seconds count, and often there isn't time to take a reading, count off *f*-stops, and adjust shutter speeds and apertures. Instead, under sunny *f*/16 conditions—bright skies with over-the-shoulder sunlight—your base exposure for a middle-tone subject, such as a gray card, should be 1/ISO at *f*/16 or an equivalent exposure. Memorize the "wildlife equivalent" for your ISO film, using 1/500 sec. as a standard shutter speed, and base your exposure on that (see the box below).

Because black subjects reflect less light, the correct exposure is made by reading a middle tone and opening up one stop. Under the same conditions as sunny *f*/16, that is, bright, over-the-shoulder sunlight falling on a dark-tone or black subject, use 1/ISO at *f*/11 or the wildlife equivalent as your base exposure. Call this the *sunny f/11 rule*. With ISO 100 under sunny *f*/16 conditions, 1/125 sec. at *f*/11 could be used. Memorize the wildlife equivalent of sunny *f*/11 as well. For ISO 100, it is 1/500 sec. at *f*/5.6 or 1/1000 sec. at *f*/4. You may need to know both, depending on the minimum apertures of your longer lenses.

WILDLIFE EQUIVALENTS OF SUNNY *f*/16, SUNNY *f*/11, AND SUNNY *f*/22

The recommended shutter speeds required for sunny *f*/16, *f*/11, and *f*/22 are frequently too slow for many wildlife subjects. Faster speeds than 1/60 sec. are necessary to stop an animal's motion, but sometimes there is little time available for you to adjust both shutter speed and aperture from a basic exposure setting. Instead, I recommend that you memorize the wildlife equivalents given below for "sunny *f*/16, *f*/11, and *f*/22" for the film speeds that you use. Just remember, you'll need the same brilliant sunshine when you use a wildlife equivalent as you would need when using the traditional sunny rules.

FILM SPEED	MIDDLE TONES	BLACKS	WHITES
Base Exposure	1/ISO *f*/16	1/ISO *f*/11	1/ISO *f*/22
25	1/250 *f*/5.6	1/250 *f*/4	1/500 *f*/5.6
50 or 64	1/500 *f*/5.6	1/250 *f*/5.6	1/500 *f*/8
100	1/500 *f*/8	1/500 *f*/5.6	1/500 *f*/11
200*	1/500 *f*/11	1/500 *f*/8	1/1000 *f*/11

* Although the wildlife equivalent is given, I suggest avoiding ISO 200 or faster films under sunny conditions because of the high contrast most of these films exhibit. Use a slower film speed instead.

White or very light subjects reflect more light, and just as you compensate by metering a middle tone and closing down, you can use the *sunny f/22* rule, 1/ISO at *f*/22. I photograph many white subjects, including egrets, snow geese, and swans, and the sunny *f*/22 wildlife equivalent is especially handy. For ISO 100, 1/125 sec. at *f*/22 is 1/500 sec. at *f*/8.

The wildlife equivalents suggested in the box probably differ dramatically from what your camera meter would recommend. For example, let's say you want to photograph a middle-tone duck in bright sunlight that is swimming in a still pond reflecting the black shadows of a forest or a cliff. A camera-meter reading based on the black water would overexpose the duck. Take a leap of faith by following a sunny rule. Disregarding your meter, you should say to yourself, "This is sunny *f*/16 light. I know what the exposure is. My camera meter is wrong!"

Consider only some compensation for middle-tone subjects smaller than 1/9 of your viewing area if the rest of the frame is not middle tone. Close down by one half-stop if the background is white. You have a choice with dark backgrounds: open up one half-stop if the background detail is important, or leave it as it is to create a more dramatic image. Do the same with small black or white subjects set against a middle-tone background. Open up for black and close down for white, but do so by only one-half a stop. In each case, you can be sure the estimated exposure will differ from the one your meter suggests.

You won't have the sun over your shoulder in every photographic opportunity, so the basic sunny rules won't always apply. As a rule, open up one stop off the appropriate sunny rule when filming a side-lit subject, adjusting for black or white accordingly. A side-lit white snowy egret, for example, may have a base exposure of 1/500 sec. at *f*/8 with ISO 100, instead of the *f*/11 you would use if it were front-lit. Back-lit subjects require more compensation. Open up two stops if you wish to preserve the effect of backlighting and have a slightly underexposed subject. Open up three stops if you want full detail in the shadowed areas.

Backlighting in early morning or late evening light can create magnificent *rim lighting* on mammals and birds, in which the outline of fur or feathers catches these rays of sunlight to create golden halos. Determining these exposures can be difficult because there might not be a middle tone and the sunny rules won't apply at this time of day. Depending on how low the sun is to the horizon, you'll lose between one and five stops. For example, on a clear day in flat country, you'll lose five *f*-stops off sunny *f*/16 in the last two or three minutes before the sun drops below the horizon. We don't normally think of a *sunny f/2.8 rule,* nor would it be practical to do so, but I guess we could. In high country, mountains may block the sun much earlier in the day and you may lose only three stops.

BLACK BEAR, Anan Creek, Alaska. 600mm F4 lens, 1/250 sec. at *f*/4, Kodachrome 200

Nothing is more difficult than determining the exposure for a black bear against black rocks in a dark canyon. I metered the gray rocks next to the bear and overexposed one stop to bring up some detail in the bear.

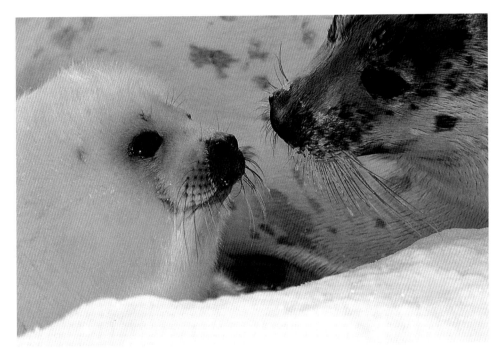

HARP SEAL AND PUP, Magdeline Islands, Quebec, Canada. 300mm F2.8 lens, 1/250 sec. at *f*/5.6, teleflash, Fujichrome 100

I metered the white seal pup and overexposed one stop, producing a natural tonality to the pup and its mother. The ice is virtually featureless, so your attention is drawn to the interaction between the two seals.

CHECKING ESTIMATED EXPOSURES AGAINST IN-CAMERA METER READINGS

Your camera meter's exposure and your estimated exposure will differ with all but middle-tone subjects. When estimating an exposure via a "sunny" rule, ignore the exposure determined by your camera.

TONALITY	ESTIMATED EXPOSURE	REFLECTED-LIGHT READING
Middle tones	Sunny 16 or equivalent	The meter should agree.
Whites	Sunny 22 or equivalent	The meter will indicate that the settings used will produce an overexposed image. Don't trust your meter.
Blacks	Sunny 11 or equivalent	Your meter will indicate that you're making an underexposure. Don't trust your meter.

In order to achieve a backlighting effect, I find it easiest to meter something I perceive as middle tone in that light. Then I either go with the reflected-light reading or close down one stop. If you don't do this, the middle-tone subject will be too bright and will appear unnatural. By closing down, this middle tone subject will be underexposed one stop, which reflects more accurately what our eyes see. However, if grass or other vegetation is in the picture, I do the opposite. Grass glows when back-lit, and after using it for my base reading, I'll open up one stop. This overexposes the grass, bringing back its brightness and translucence.

Most photographers agree that the light of dawn is exquisite and unique, frequently the best light of the day. You need practice to estimate exposures in the day's first half hour of light, but it is possible. As the sun rises, estimating exposures becomes easier, and within an hour after sunrise, the light is usually within a stop of sunny $f/16$. In the next hour, sunlight reaches its full intensity: This holds true regardless of where you are, provided the sky is clear. In much of the eastern United States, however, high humidity and industrial pollutants reduce sunny $f/16$ by at least a half stop.

With practice, it isn't too difficult to learn to read different types of light without a meter, at least when the sunny rules normally would apply. If you have an incident-light meter, it is easy to check yourself as you do. But there are times when obtaining a meter reading is impractical, too time-consuming, or simply impossible. Under ideal conditions, a meter reading isn't necessary and you can make some subjective judgments about the intensity of light.

When cloudy bright skies obscure the sun and eliminate shadows, open up one f-stop off any of the sunny rules. If you expose a black animal for 1/250 sec. at $f/5.6$ under sunny skies, use 1/125 sec. at $f/5.6$ for cloudy bright skies. Under overcast skies with thick cloud cover, open up 2 or 2 1/2 f-stops. Although shutter speeds or depth of field may suffer, this light eliminates contrasty shadows and is ideal for mammal portraits. Using ISO 64 film, a sunny $f/22$ egret would be exposed for 1/500 sec. at $f/8$ in sunlight, but in overcast light you should change to 1/500 sec. at $f/4$. In heavy overcast skies, when rain is likely, you'll lose at least three f-stops, and you'll need a faster film speed than you normally would use to capture fast-moving animals.

EXPOSING FOR SILHOUETTES

Silhouettes are possible when the area behind your subject, whether sky, sea, or landscape, receives more light than your subject. If there is more than a two-stop difference between the subject and the background, it is often prudent to expose for the background. This underexposes the subject and creates a silhouette.

Exposure determinations must be made in-camera, rather than by estimating, because the degree of brightness of the background can vary dramatically. This depends on the amount of moisture or dust in the air, the angle of the sun, and the background's basic tonality, which may range from bright and hazy to brilliant and crystal-clear. When making your reflected-light reading, exclude your subject and base your exposure solely on the background. If you don't, the dark subject will affect the exposure and overexpose the background.

FLORIDA SANDHILL CRANE, Myakka River, Florida. 300mm F2.8 lens, 1/500 sec. at $f/11$, Lumiere 100

Sunlight reflecting off water could trick a meter. You could meter the water in the upper right area of the frame, and then close down one stop to compensate for the bright expanse of water in the frame. Or, you could meter the bright water, and overexpose by two stops to bring up the brightness to a natural-looking level.

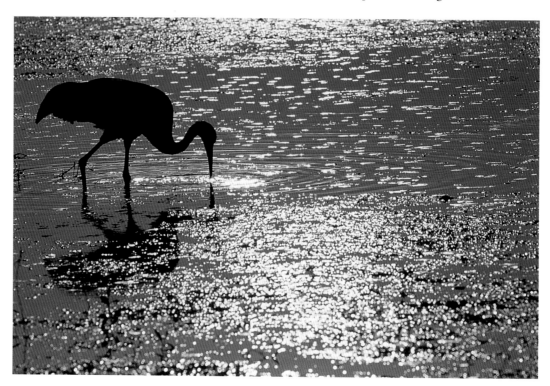

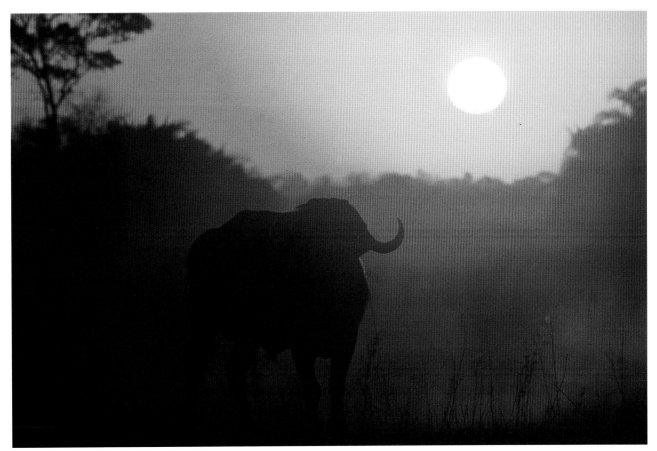

AFRICAN BUFFALO, Mombo Camp, Morami Game Reserve, Botswana. 300mm F2.8 lens, 1/250 sec. at *f*/4, Fujichrome 100

Three very different tonal values are evident in this shot. I chose the middle value—the red, dusty area to the right of the buffalo—as the basis for my exposure. After spot-metering that area, I overexposed one stop to pull up more detail in the back end of the buffalo.

Water backgrounds can be difficult if the water reflects the sun in multiple highlights. Decide if your image can be improved by minimizing these highlights. If it won't be, and if these highlights fill your viewing area, consider opening up two or three *f*-stops off your camera reading, in order to avoid underexposing. The in-camera meter will make these sparkles a middle-tone gray; you must bring back this brightness because the sun's highlights should be bright. Overexposing will do exactly that.

Bright skies are less of a problem. Meter the brightest area of sky that will appear in the final image, then deliberately overexpose by one *f*-stop. Because your meter reads this area as a middle tone, overexposing will bring back the brightness of the scene.

Even if you're including the sun in your photograph, exclude it from your field of view while you are taking the exposure reading. This will prevent severe underexposures; otherwise, the bright sun will bias your reflected-light reading. After taking a reading off the brightest area of the sky, recompose and place the sun back in your picture. Close down a stop if the sun is high and bright, but only close down a half-stop if the sun is low and orange-colored. (Be careful not to look directly at the sun, especially if you're using a telephoto lens, or you'll risk serious injury to your eyes.)

Also, don't align a silhouetted subject against another, unnoticed silhouette. That is easy to do if you're concentrating on the foreground and neglecting the background. You might not think the outline of something as unmistakable as an elephant, for example, could be lost but it can be. Two black images can easily merge as one to create a featureless, unattractive blob.

In reviewing this section on exposure, you may be confused because one method contradicts the procedures used in another method. Read more closely and you'll see that this is simply because of the tonality you metered. What you've based your initial exposure on will determine whether you'll then open up or close down. Remember, a meter can't "think," but if it did, it would think everything it reads should be a middle-tone gray. You know that not to be true, and you must adjust accordingly.

I don't like to recommend *bracketing,* the practice of firing multiple frames at different exposures to ensure one good exposure. Sometimes, however, there is little choice but to use this technique, especially when you don't have the foggiest idea of what to base a meter reading on. But don't rely on bracketing. You'll waste film, of course, but more important, you could miss the photograph of a lifetime when you bracket a shot simply because you haven't taken the time to master exposure.

CHOOSING YOUR FILM

Film choice is often a matter of personal taste. You may like a particular film's color, or grain, or "snap" (a subjective sense you have as to how a film's color pops out at the viewer). Not all films treat color the same way, and it may be useful for you to test several rolls of different brands to determine which ones you prefer. Hopefully, this book will help you in your decisions as I've identified what film I used for all of the images in this book.

You'll note that I use slide film. Most professional photographers do because their markets—the magazine, calendar, and book publishers—demand it. Slide film requires exact exposures because the film can't be corrected during a processing stage.

As you probably know, the ISO represents a film's sensitivity to light. Low ISO numbers refer to "slow" films that are less sensitive to light than are "fast" ISO films. Doubling or halving an ISO number doubles or halves the film's sensitivity to light. Thus, ISO 50 film is half as sensitive to light as ISO 100, but it is twice as sensitive as ISO 25. Faster films permit faster shutter speeds and smaller apertures than slow films used in the same light. All films register sharpness and color by their grain structure, and slow-speed films have the greatest sharpness. Fast films have more grain and show more contrast.

In nature and wildlife photography, ISO speeds of 50, 100, and 200 are the most frequently used. Most nature photographers use slow-speed films when they can, such as Velvia 50, Fujichrome Sensia II or Provia, or Ektachrome 200S Professional or Kodachrome 200. Some engagement calendars featuring birds, mammals, or landscapes list what types of films were used as part of the image captions, and these may be an excellent source for deciding what film will best fit your needs. All of the films cited have their merits, and most photographic magazines devote at least one article each year to film selection. Lately my film of choice has been Fujichrome's Sensia or Sensia II, which has fairly fine grain; good, accurate color rendition; and handles contrast fairly well.

SPOTTED HYENA, Masai Mara Game Reserve, Kenya. 600mm F4 lens, 1/250 sec. at ƒ/4, Ektachrome 200 pushed to ISO 400

Ektachrome 200 pushes to faster speeds extremely well. For this hyena, I doubled the ISO value and had the film processed for a one-stop push.

WOODCHUCK, McClure, Pennsylvania. 500mm F4 lens, 1/250 sec. at ƒ/6.3, Lumiere 100

Lumiere is a brown-biased film that produces wonderful earth tones. For subjects like this woodchuck and other brown animals, Lumiere would be a good film choice.

When a faster ISO is necessary, film can be *pushed,* or purposely set, to a higher speed. Velvia, Sensia, and Provia are typically pushed one stop, to ISO 100 for Velvia (or ISO 80 if you rate Velvia at ISO 40, as many do) and to ISO 200 for the other films. Ektachrome 200 can be pushed two stops easily, to ISO 400 or 800, although some photographers recommend setting the ISO at 320 and 640 instead while still having the film pushed a full one or two stops. When pushing film, shoot it just as you would any fast film. Pushed film requires special processing, which adds a few dollars to the normal developing costs.

Film can also be *pulled,* or developed as if the film was actually a slower ISO speed. Although film normally isn't pulled on purpose, this developing option is one way to salvage film that was accidentally exposed at an ISO less than its true value. Again, the extra effort involved in processing pulled film makes it a custom service that requires an additional developing charge.

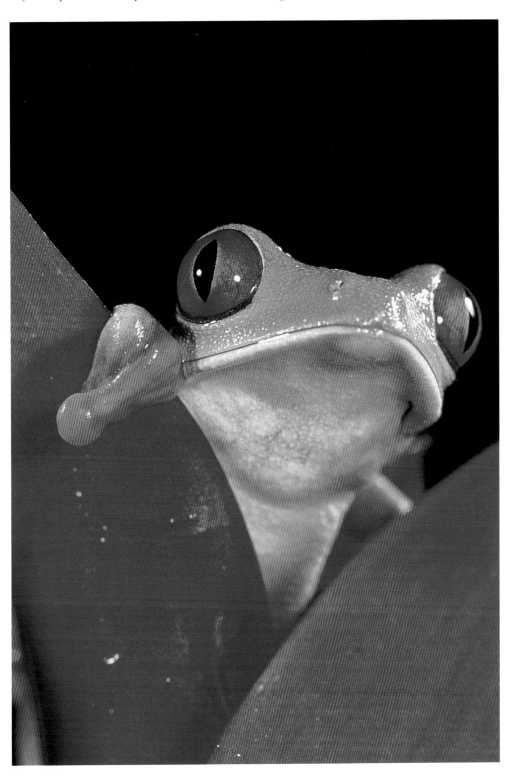

RED-EYED TREEFROG (CAPTIVE), McClure, Pennsylvania. 200mm F4 macro lens, 1/250 sec. at ƒ/16, Fuji Velvia

Fuji Velvia, with its bright, snappy colors, is perfect for reptiles and amphibians. It is a slow film, but that's not a problem when I use electronic flash and can determine the f-stop and, in studio at least, use any shutter speed I want.

EXPOSURE DILEMMAS

Sometimes photographers agonize over an exposure, or at least worry whether what they think is right actually is. The images here made me think twice.

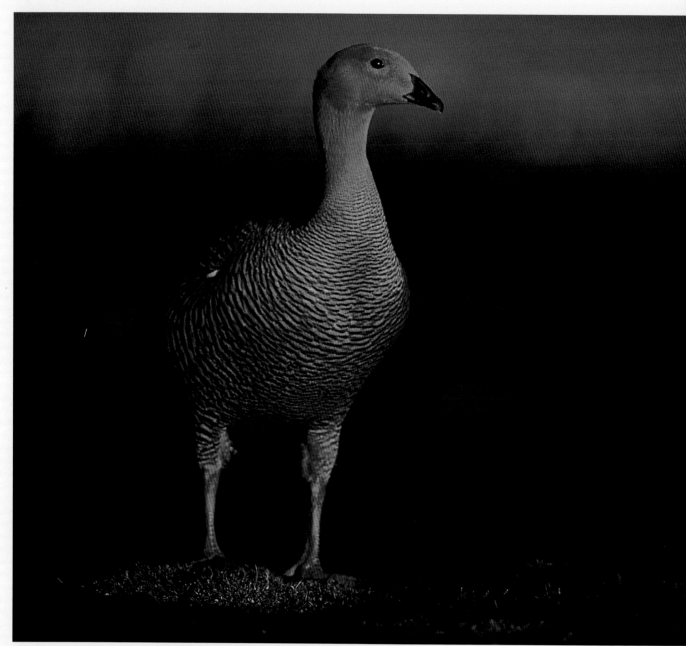

UPLAND GOOSE, Sea Lion Island, Falkland Islands. 300mm F2.8 lens, 1/125 sec. at *f*/2.8, Fujichrome 100

The sun was just a few degrees over the horizon on this cloudless evening. Though the goose was in full sunlight, a "sunny" rule could not be applied in this lighting situation. Instead, I metered the goose's head and neck and went with that setting.

DALL PORPOISE, Frederick Sound, Alaska. 35–70mm F2.8 zoom lens, 1/250 sec. at *f*/4, Fujichrome 100

Light values changed constantly as this porpoise weaved around the boat. I metered the dark water, underexposed it by 1 1/2 stops, and let that be my base exposure. Whenever the porpoise rose near the surface, I fired. However, whenever it broke the surface in a splash, the light values changed radically, and the porpoise was overexposed.

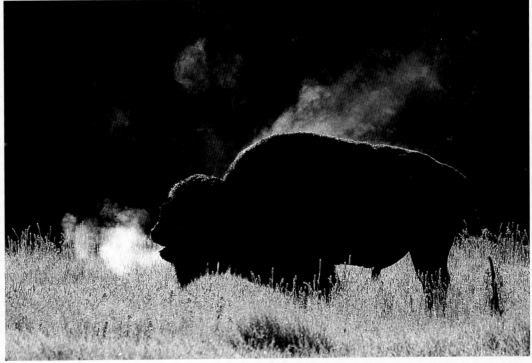

BISON, Yellowstone National Park, Wyoming. 500mm F4 lens, 1/250 sec. at *f*/5.6, Kodachrome 200

I overheard a workshop leader advise his participants to "just use matrix" to handle this scene. I didn't think that would work, afraid that the amount of blackness in the background and the dark bison would bias the reading to overexpose. Instead, I metered the backlit frosty grass and overexposed that area by one stop.

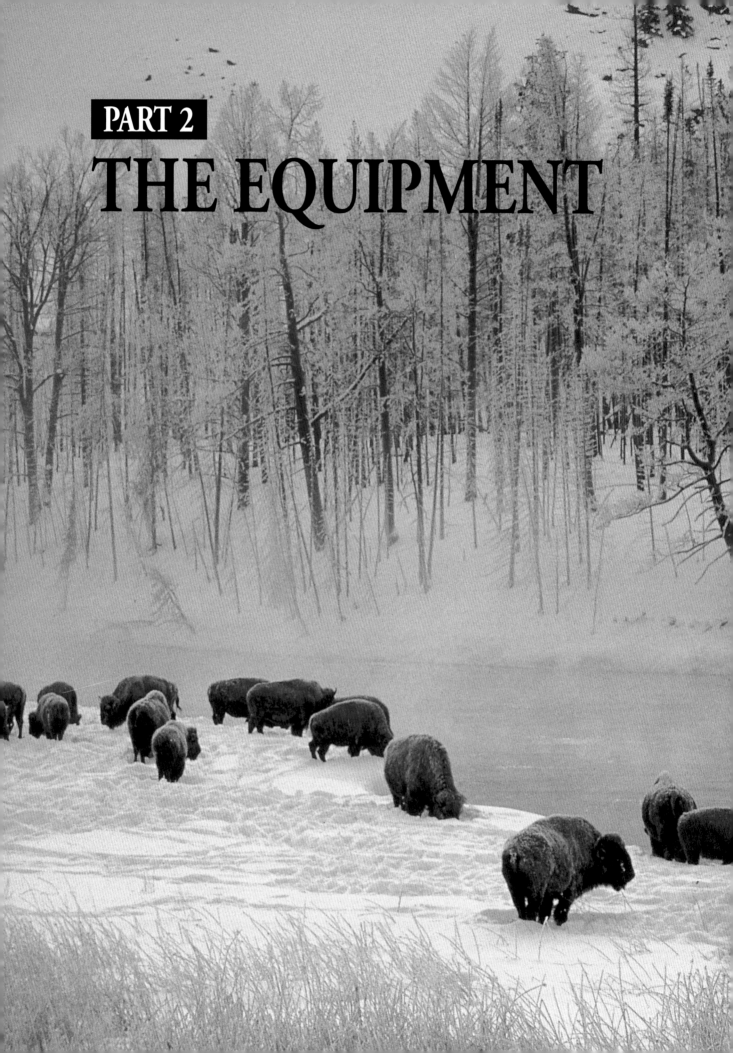

PART 2
THE EQUIPMENT

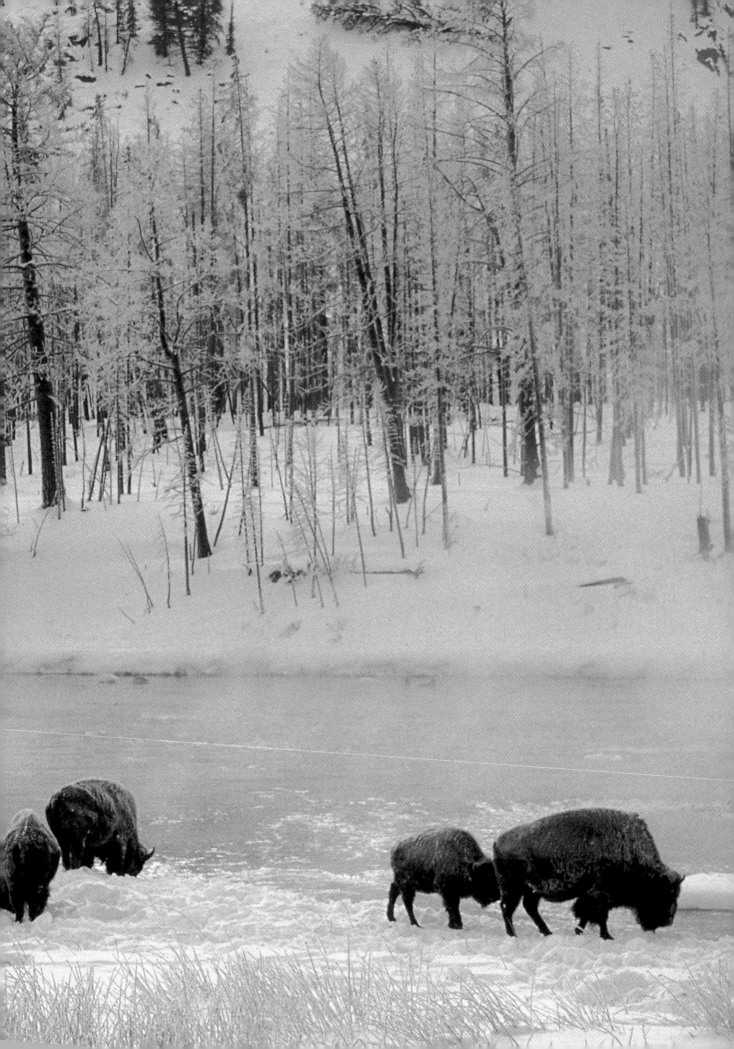

CAMERAS AND CAMERA HANDLING

The camera is the foundation of the photography system. Not too long ago, the camera was of far lesser importance than was the choice of lens, or even of tripod in some cases, but this is not so today. Therefore, choosing the right camera to meet your needs—and these most certainly can vary—is an important decision for today's photographer.

Most readers may already own a camera, and if you're happy with the camera you presently own, great. Truly, it is not the camera that makes a great image; it is the person behind the camera. Despite all the wonderful bells and whistles available on the latest, state-of-the-art machine, this reality has not changed from the first days of photography. The camera is only a tool.

This tool can be used properly or improperly, with either a great deal of dexterity or with an embarrassing amount of fumbling. It is truly not the type of camera you use that makes the difference in your photography—it is how you *use* that camera, how cognizant you are of proper technique, and how methodical you are when handling it. Developing good camera-handling skills will make a difference in the images you capture.

As a tool, some cameras are more efficient, durable, and useful than others. Unfortunately, many of today's cameras are so complex that all you need to do is depress the shutter button; focus and exposure are set automatically. The Ph.D.—"push here, dummy"—camera has come of age. Most nature and wildlife photographers use 35mm SLR cameras. There are many accessories available, with a host of manufacturers offering gear in almost every price range. The variety can be bewildering so you should carefully consider what you actually need.

CHOOSING YOUR SYSTEM

Most of today's 35mm SLR cameras offer autofocus capabilities; only a few do not. Both types are available in many models with one or more exposure systems. Although autofocus cameras represent the latest in camera technology and are the fastest sellers, not so very long ago all cameras focused manually. Working without autofocus can be difficult in certain situations in which focus might be missed either due to the subjects actions, a difficulty focusing in dim light, or the photographer's poor vision. Before the introduction of autofocus, photographers had managed to get by, at least most of the time.

The incredible advancements in autofocus capabilities have opened up a whole new world of photography. Action shots, once often the product of luck or the thin harvest of much wasted film, are now obtainable to anyone with the right gear. Standard portraits are no longer as interesting, especially when compared to images of animals running, or flying, or leaping.

Don't be depressed if you're still shooting a camera only offering manual focus. Great images are and will continue to be made with the older equipment. Just a few years ago my wife, Mary Ann, captured an image of two great egrets fighting in flight that became the BBC Wildlife Photographer of the Year winner in the Bird Behavior category; her lens—a manually focused 500mm!

However, if you're thinking of buying a new camera, or of changing systems, strongly consider choosing a camera that offers autofocus. Far more than the exposure modes a camera offers, the availability of autofocus can and will make a difference in your photography.

MULE DEER, Waterton-Glacier National Park, Canada. 500mm F4 lens, 1/250 sec. at *f*/4.5. Fujichrome 100

While it is not the camera alone that makes a great photograph, a good camera system can help you immensely in capturing majestic, satisfying images.

HUMPBACK WHALE, Frederick Sound, Alaska. 300mm F2.8 lens, 1/500 sec. at *f*/8, Kodachrome 200

Breaching whales don't allow you a lot of time in which to make a photograph; it is hard enough to catch the leaping whale in the viewfinder, let alone get it sharp. In such shooting conditions autofocus really shines. Once I had the whale in view, the camera locked on to it, and I fired away.

That said, I'm not advocating using autofocus for all your shooting needs. Not unless your vision is so poor that obtaining an accurate focus without autofocus is difficult or impossible. Even when using a manually focused lens, an autofocus camera will signal when your subject is properly focused (provided the subject is within the focusing brackets normally used to determine autofocus). With Nikon cameras, this allows you to use the older, manually focused lenses; with Canon EOS and Minolta, you're a bit more limited, since the lenses for these were made exclusively for the autofocus cameras.

Autofocus is fast. On stationary subjects, it locks into sharp focus faster than most photographers can focus manually. Although in some cases the focusing sensor requires your subject to be centered, this can be changed easily prior to taking the photograph by locking focus

and recomposing. Some models offer several focusing brackets to provide a little more freedom when composing an image. The Nikon F5 has five brackets, roughly arranged at the four compass points around a central bracket. Many Canon EOS cameras have five brackets that run horizontally across the screen. Almost all of these cameras allow you to lock onto a set focus and reframe, provided that you maintain a slight pressure on either the shutter button or a special focus-lock button.

I don't consider autofocus to be the panacea for all your focusing problems because it can create some new ones. Again, centering can be troublesome because most autofocusing brackets are located dead center in the viewfinder. Twigs, branches, blades of grass, and other obstructions between you and your subject can fool the autofocus sensor. As I write this, the Nikon F5

represents the latest advancement in autofocus technology, offering predictive focus that will maintain focus tracking even as a subject passes through or behind obstructions. I suspect Canon and Minolta will soon be offering cameras with similar capabilities. Still, running or flying animals can travel faster than the autofocus can function, even with cameras offering predictive capabilities. And, moving subjects must be followed within the focusing brackets to prevent the lens from *tracking* (when the lens focuses back and forth as it seeks the subject). While tracking, something as large as a frame-filling flying pelican can disappear within the view finder if the lens tracks in the wrong direction.

Fortunately, many autofocus lenses have focus limitations that can be set to restrict the amount of tracking. For example, on one of my 300mm lenses, there are three settings: full, offering the full range from infinity to 2.5 meters; close focus, from 2.5 meters to 7 meters; and distant, from 6 meters to infinity. Those lenses that don't have a focusing limitation, however, can be extremely frustrating to use.

Manufacturers recognize the limitations of autofocus and offer a manual-focus option for most lenses. Sometimes focusing manually is the only solution for photographing wildlife. I like to make the analogy that autofocus on a camera is like the fifth gear on a car; most of us drive down a highway in fifth gear, but not always. Use autofocus the same way, when it will work best for you.

Some autofocus cameras offer three features that are especially useful for photographing wildlife. One is *trap focus,* when the camera doesn't fire until something, hopefully your subject, passes at a preset focusing distance. This feature could be ideal for remote or unattended photography of nests, bird feeders, den holes, or game trails. Trap focus does, however, have some limitations. A fast-moving animal can pass through the focus point before the camera fires. Also, you have no control over composition; you might shoot a roll of film with the subject's head cut off. Although a few cameras offer trap focus as a standard feature, in most models it is available only as a costly accessory databack.

A second and extremely useful feature of autofocus is known as *predictive* or *track focusing,* depending on the camera manufacturer. With this system, the lens maintains focus even after the camera's reflex mirror flips up, when the image is momentarily lost from view. Because the camera's mini-computer is tracking the speed of the moving object, the camera is able to predict, in theory, where the subject will be. Some track- or predictive-focusing mechanisms work better than others, but most would be severely challenged by a pigeon-sized bird sweeping toward you at 40 miles per hour. That is, if you can even keep the bird within the focusing sensor!

Slower-moving and larger subjects are easier to track. Having the track-focus option may occasionally make the difference in successfully photographing animals or birds, especially those that are flying parallel to your film plane.

An autofocus camera's third, and also extremely useful, feature is *focus confirmation*. Most autofocus cameras have a liquid-crystal display (LCD) that shows an in-focus symbol when the area within the focusing brackets is sharp. This feature is useful for photographers who wear glasses and for photographing in dim light when sharpness is difficult to determine.

Before the choice of either auto- or manual focus was available, photographers only had to decide which type of exposure mode they needed. Most modern cameras offer various manual, automatic, and programmed modes. Using manual mode, you select the shutter speed and aperture combination that you need to properly expose the film. The manual exposure mode requires a fairly thorough understanding of exposure, but until recently, this knowledge was expected of any SLR camera user. Cameras with automatic modes include three basic types: completely automatic, shutter-priority, and aperture-priority modes. When set on automatic mode, the camera selects both aperture and shutter speed. You may not be happy with the camera's selection, because you may have needed a faster shutter speed or smaller aperture.

The other automatic modes address this. In shutter priority, you select the shutter speed, and then the camera sets the corresponding aperture that is required. Be sure to have enough light for the shutter speed that you've selected. If you don't, you can opt either to use a slower speed or to not waste a frame. In aperture priority,

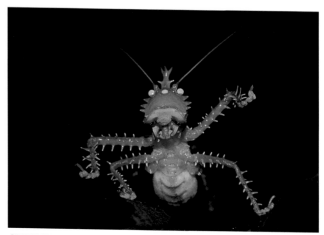

SPIKE-HEADED KATYDID, Amazon Basin, Ecuador. 200mm F4 macro lens, 1/250 sec. at *f*/16, TTL flash, Lumiere 100

The trap-focus mode on many cameras is useful for macro work. This mode allows you to move in slowly toward a subject with your focus, or magnification ratio, predetermined. With your finger depressing the shutter button, the camera will only fire when the subject comes into sharp focus. With TTL flash and a small aperture, a sharp image is almost guaranteed.

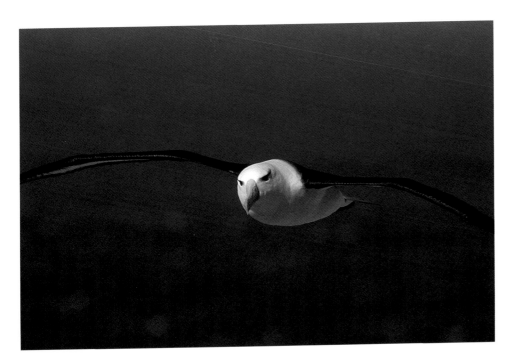

BLACK-BROWED ALBATROSS, Saunders Island, Falkland Islands. 300mm F2.8 lens, 1/500 sec. at f/8, Fujichrome 100

Predictive autofocus should maintain sharp focus once it locks onto a subject.

the camera sets the shutter speed after you've selected the aperture. This mode is useful in action photography with a fast lens set at the widest aperture because it ensures that you'll always be using the fastest possible shutter speed. It is probably the wisest choice for remote photography if the *ambient*, or available, light is continually changing.

Programmed modes work similarly to automatic modes, although you may have the option of choosing from a few set programs that offer a bias toward stopping action or providing maximum depth of field. This mode differs by camera manufacturer, requiring you to either set a mode selector switch on "P" (program mode), or set the shutter-speed dial and the aperture on "A" (automatic). The camera's exposure meter determines the correct shutter-speed and aperture combination based on a programmed set of conditions. To be honest, I've never shot any of my cameras on a program mode. I don't want to lose the creative control that manual, or even shutter- or aperture-priority modes allow, and I doubt that I would be satisfied with the camera's selection of settings. Program mode may be fine for home use, parties, snapshots, and the like, but in my opinion, a program mode is not a serious option for nature or wildlife photographers.

The following scenario illustrates your shooting options with the various exposure modes available. Let's say you're photographing a white-tailed deer as it slowly walks through an open forest in the late afternoon. The deer is middle tone in value, and metering the deer, you obtain an exposure reading of 1/60 sec. at f/4 for ISO 100 film. You're using a 300mm f/2.8 lens mounted on a tripod. What are your options? Will 1/60 sec. freeze the action as the deer walks? What exposure mode would produce the best result?

Although it would be pushing the limits, a shutter speed of 125 sec. might stop the deer's movement, but it's likely that a speed of 1/60 sec. will not. In the manual mode, you have to set the aperture at f/2.8 and the speed at 1/125 sec. If you're excited, you could forget to do either or both. In shutter priority, if you have the camera preset at 1/125 sec., the aperture will adjust automatically to the required f/2.8. In this mode, a mistake is less likely to occur. For example, if you have the shutter speed set at 1/500 sec., the camera will signal an underexposure.

In aperture priority, you can preset the aperture to f/2.8 to ensure having the fastest possible shutter speed. However, if you err and have the aperture set at f/5.6, you'll shoot at 1/30 sec. Depending on the camera system, your camera might alert you to a low light situation or the need for flash, if this occurs. Either way, 1/30 sec. would probably be far too slow to yield a satisfactory image of a walking deer.

In a programmed mode, the camera will select an option you may or may not like. Although it is a personal choice, I'd suggest using manual or shutter priority. You'll have to determine the shutter speed, but you'll be more likely to stop the deer's movement than if you trust an aperture-priority mode to set a shutter speed that may be too slow for your needs. With either shutter-priority or manual mode, you can decide on the speed that's required, then balance that decision with the aperture required in order to obtain the correct exposure. If the speed is too fast and there's not enough light, you'll know you needn't waste the frame.

Remember, no exposure system offers a selection where the camera meter thinks for you and automatically selects the correct tonality on which to base your exposure.

WHY AREN'T YOUR IMAGES SHARP?

A transparency's sharpness can be determined by studying a slide with an 8X optical lupe or with a reversed 50mm lens. Check for sharpness by examining the edges of your subject, especially around the eyes or the faces of animals. If your images aren't sharp, consider the shutter speed used, the tripod, the lens length, and any physical factors. If your subject was still and you were rock-steady, then camera shake may be at fault. To eliminate camera shake, brace your camera and avoid specific slow shutter speeds, or only use a camera with mirror lockup when using a slow shutter speed or a super telephoto lens.

You must do this. Because I learned my craft when there was only one exposure mode available, I'm comfortable using my camera on manual. But that is a personal choice, and I've encountered very competent photographers who use one or more of the other systems.

All of the above exposure modes can be used in various metering modes in which you select how much picture area is considered for the exposure. In an *averaging* mode, the entire picture area is read, although an emphasis is placed on the central section. *Center-weighted* systems work similarly. *Evaluative,* or *matrix,* metering is even more sophisticated; in these modes, the entire viewing area is divided into blocks that are given a predetermined influence on the exposure. This provides a reasonable chance of obtaining correct exposures, even when you can't determine a subject's tonality. However, the metering system can be fooled, as when, for example, you're filming a white subject on snow or a dark subject against a dark background.

In *spot metering* only a small central area ranging from 3 to 12 percent is read. Wildlife photographers often deal with small subjects, and many find the spot meter ideal. When a telephoto lens is used, a spot meter makes very precise exposure determinations possible. For example, a 500mm lens offers about a 5-degree angle of view, compared to the 46 degrees a 50mm lens offers. If your spot meter reads only 3 percent of this 5-degree angle of view, you'll be reading an extremely limited area. Spot metering on manual mode is the method I use to determine ambient exposures in-camera 90 percent of the time.

ACCESSORY FEATURES FOR SLR CAMERAS

If your SLR camera is less than 15 years old, it probably doesn't have a mirror-lockup lever, a power-cord (PC) socket, or a mechanical-release socket. It may also lack a depth-of-field preview button, something I consider essential for any serious wildlife or nature work. Today, only "professional" cameras incorporate all of these features. If your camera lacks one or more of these accessories, *don't* despair; depending on how you work, you might not need them. In choosing an SLR camera, decide which features are important for you to have. Here's a quick rundown of what's available.

Interchangeable focusing screens. Many cameras offer optional screens to replace the one standard for your camera. Many wildlife and nature photographers prefer to use either an all-matte screen or a matte screen with lines inscribed that is generally used for architectural photography. An all-matte screen is ideal for most work, since portions of the screen won't darken or block up when long, or slow, lenses are used. Architectural grid screens are perfect for keeping horizon lines sharp, trees growing straight, and the like, by aligning them with the inscribed grids.

Depth-of-field preview. You focus and compose with the lens at its widest aperture opening. At the moment you fire, the aperture closes down to the predetermined *f*-stop. Most cameras have a button or lever that manually closes down the lens aperture. This enables you to see the depth of field and the degree of sharpness present in the out-of-focus areas before you actually take the picture.

Although many lenses have depth-of-field scales inscribed on the barrels, it is impossible to visualize the effect a particular amount of depth has on your composition. Incredibly, some inexpensive electronic SLR cameras lack a depth-of-field preview button. This button is essential for critical macro and landscape photography. Also, it is useful for photographing birds or mammals with a telephoto lens.

Mirror lockup. Most SLR cameras have a hinged mirror that flips up the instant before the shutter opens. At fast shutter speeds, this happens so quickly that you might not notice the momentary viewfinder blackout. This mirror movement slightly shakes the camera, although at fast shutter speeds this tremor won't affect image sharpness. At slow speeds, this shake can significantly reduce image quality, especially if you're using macro or telephoto lenses.

The vibration caused by the mirror lasts about 1/15 sec., and exposures made at 1/15 sec., 1/8 sec., and 1/4 sec. record it. Shutter speeds faster than 1/15 sec. or slower than 1/4 sec. progressively reduce the effect of the tremor on your image. There is no mirror shake if the mirror is manually locked up before exposure, but only a very few professional cameras permit this.

Mirror shake is eliminated in Canon's EOS 1N RS by the use of a stationary pellicle mirror that simultaneously transmits light to the film and to the viewfinder. This two-way mirror will cost you 2/3 stop of light, effectively making an ISO 100 film ISO 64, but it's worth it. Since the mirror is stationary, the EOS RS has the shortest electronic lag time—about 1/180 sec.—which makes it the perfect camera for use with Shutterbeams or other triggering devices. On a few cameras, activating the self-timer also locks up the mirror.

You can also reduce camera shake by placing some additional weight on the camera. This will absorb some of the vibration created by the flipping mirror. Place a small sandbag onto the camera's *pentaprism* (the block-like top of the camera where the viewfinder is located) to cancel out these mirror-induced vibrations. A half-pound cloth bag of birdseed works fine for this. Additionally, you can reduce camera shake by supporting both the camera and the lens on separate tripods, but this is cumbersome to do.

Self-timer. This feature lets you include yourself in your photograph, which can add scale or a center of interest to

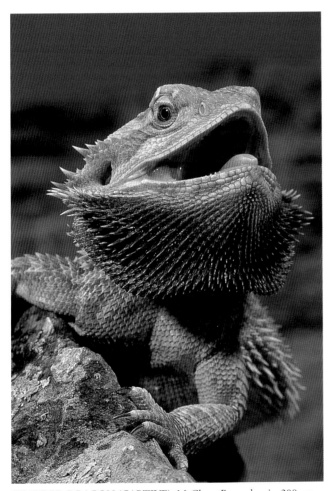

BEARDED DRAGON (CAPTIVE), McClure, Pennsylvania. 200mm F4 macro lens, 1/250 sec. at ƒ/16, manual flash, Fuji Velvia
In this shot, a depth-of-field preview button was handy, allowing me to determine just the right depth for an effective composition.

a scene. As mentioned, the self-timer can increase image sharpness if the mirror automatically locks up when the timer is used. Regardless, using a self-timer provides time for vibrations (induced by hand-tripping the shutter) to dissipate, and image sharpness will improve.

Some cameras offer variable time delays from 2 to 30 seconds, which can be handy if you need only a short delay or a very long one. Don't, however, make the mistake of using a self-timer to dissipate motion when you're filming an animal that may move. Chances are, just as the camera completes its countdown, the critter will step out of focus!

Cable and electronic releases. Some people abruptly depress the shutter button; others are so excited by what they're shooting or so out of breath after reaching their subject that they're shaking as they depress the shutter. In any case, image sharpness suffers.

Releases separate you and your shaky fingers from the shutter button. There are two types of releases. Inexpensive cable releases screw into the shutter button or into a special receptacle on the camera body. They are available in a variety of lengths, although I find the shortest ones the most convenient to use and the cheapest to replace. Electronic releases plug into a special socket in the camera body. These releases are considerably more expensive and are usually longer than is necessary to simply trip a shutter. Unless they're shortened somehow, they're likely to snag on something and break.

Either type of release works, but don't assume you're always required to use one. Sometimes they're not necessary, especially if you're properly braced and your body weight adds to the total mass of the camera and lens. This is especially true when you're photographing in windy areas or when you're using a *motordrive,* where the continuous slapping of the mirror can create a vibration.

Use a release when you're using shutter speeds less than 1/30 sec. with any lens, and under 1/60 sec. when using macro or telephoto lenses. Consider using a release and a self-timer together if you're trying to position mirrors, reflectors, or flashes on a macro subject and you need an extra "hand." The remote release frees you from the viewfinder and lets you get closer to your subject, while the self-timer gives you the time to align everything before the camera fires.

Releases are easily lost if they fall out of their sockets. You'll locate a dropped one more easily in the field if you tie strips of fluorescent surveyor tape to each one.

Motordrives and motorwinders. Both power motorwinders and motordrives advance film and cock shutters automatically. Power winders advance film between one and three frames per second (fps), while the heavier, bulkier motor drive does so at up to seven, eight, or

even nine fps, depending on the camera and the power source used. Both types allow you to keep firing without moving your eye from the viewfinder or your finger from the shutter release, and both provide the potential to overshoot. You can fire 36 frames in less than 4 seconds with a motordrive. Amateurs or those on budgets probably don't need multiples of nearly identical frames.

Motorwinders and motordrives can be useful in macro photography, where exact alignment or a critical composition is required, because advancing the film by hand could move or misalign the camera. They're also necessary for remote photography, as they permit continuous shooting until a roll of film is exposed. They're especially useful in bird and mammal photography, where peak action or interesting poses can occur repeatedly. However, neither guarantees that you'll capture peak action; for that you need timing, anticipation, and luck.

For example, let's say an African chameleon is about to snatch a grasshopper from a branch with its long, sticky tongue. The chameleon takes only fractions of a second to part its jaws, then blast out and retract its body-length tongue with the captured insect attached. You hope to record the strike—that instant when the tongue is stretched farthest in capturing its prey; there's sunny f/16 light, and you're shooting at 1/1000 sec. at f/4 with a motordrive firing six fps. Can you capture this action?

If you fire the instant the lizard's jaws begin to part, at six fps you'll record only 6/1000 of a second's time. The other 994 parts of the second elapse as the film advances five times. A lot can take place during that time, including the strike you hope to capture.

It is difficult to capture such a fast-moving event without an electronic assist like the Shutterbeam described on page 100. But you'll have a better chance

CHEETAH, Samburu Game Reserve, Kenya. 600mm F4 lens, 1/250 sec. at f/8, Fujichrome 100

This—my only chance at a close-up of a drinking cheetah—lasted less than half a minute, but with a powerful motordrive zipping film through my camera, I shot two rolls of film during that time. Motordrives are invaluable in circumstances like this.

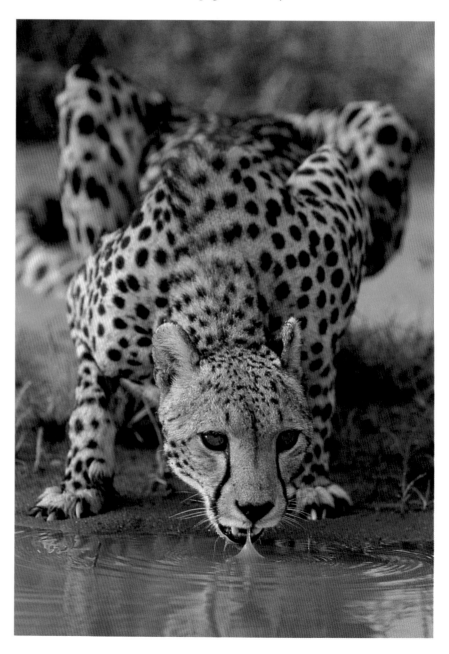

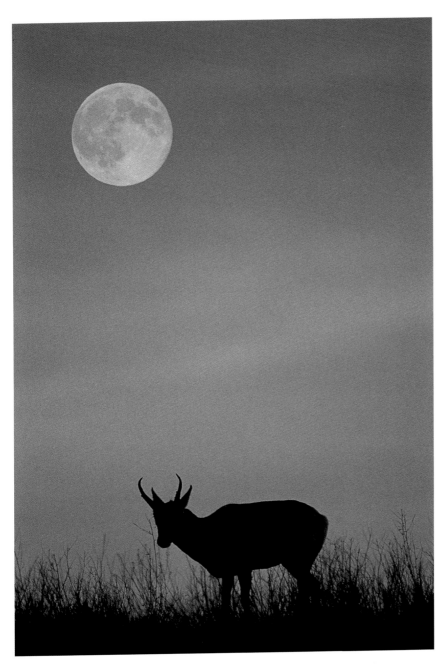

PRONGHORN ANTELOPE, Yellowstone National Park, Wyoming. 500mm F4 lens, double exposure: antelope at 1/125 sec. at *f*/4 and moon at 1/250 sec. at *f*/8, Fujichrome 100

This is the only double-exposure image in this book. After exposing for, and shooting, the pronghorn, I went to dinner. Afterward, under a clear night sky, I shot a second exposure of the moon. It is handy to have a camera that facilitates making double exposures just for those rare times you'd like to make one.

of capturing the action if you anticipate and fire just as the tongue shoots forward. It is frustrating work, but it can be done. Your chances are significantly greater if you try to anticipate the peak action.

Many electronic cameras have built-in power motorwinders, although some cameras will also accept a motordrive as an accessory. Built-in motorwinders or motordrives are not only convenient but also quieter than accessory units attached to the camera. A quiet film advance is less likely to frighten a skittish animal, such as a coyote you've lured close by means of a game call.

Double-exposure capability. Most cameras offer some method for making double exposures, but electronic cameras make this simple. You'll rarely use this feature for wildlife or nature work unless a special effect is required.

Power sources and batteries. Although there's no standard power source, the 1.5 volt AA battery is used in many cameras and is available nearly worldwide. I'd suggest you use a camera that can be powered by AA batteries at least as a backup if other energy sources, such as rechargeable nicad batteries, aren't available. Carry spare batteries with you. Some batteries, including the increasingly popular lithium batteries, are expensive and not easily found in remote corners of the United States or elsewhere.

It is always wise to conserve battery power. Autofocus eats up batteries, especially if you use a focus-confirmation beeper. Sometimes it is just as efficient to focus manually. For example, a smooth-skinned frog, shot up close with a macro lens, may not offer the area of contrast an autofocus sensor needs to lock on. The result is wasted time and wasted batteries as the lens tracks back and forth.

Automatic film rewind also uses considerable energy. If you have the option, rewind by hand, especially if you're running low on batteries in an area where finding replacements may be difficult. (Another good reason to rewind film manually is that automatic film rewind can generate static-electricity marks on film in extremely cold, dry weather. A slow rewind, done by hand, is less likely to do this. However, if your camera lacks a manual rewind and you're photographing in extremely cold, dry weather, consider warming up the camera by placing it inside your jacket for a short time before you rewind the film.)

DX film coding. Most electronic cameras use DX-coded film, whereby the film speed and the number of frames are set automatically. DX-coded film is useful if you shoot many different speed films and might otherwise forget to set the ISO for each new film. Also, be sure you don't scratch or cover up a DX code by accident. Some cameras, like the Nikon F4, will not operate if the DX-code area is covered, unless the ISO is manually set. Additionally, a camera can misread a DX code. It is always wise to check that your camera is reading the correct code by depressing the ISO set button immediately after you load a new roll.

Cameras accepting DX-coded film frequently have tiny film windows in the back of the camera to provide a visual check of the loaded film. This feature may prevent shooting with an unloaded camera. Even without a film window, you can check for loaded film if your camera has a rewind knob. Turn the rewind knob until you feel tension, then watch to make sure the knob rotates when you trip the shutter and advance to the next frame. If the rewind knob doesn't rotate, either the camera is empty or the film leader is off the sprocket.

Electronic flash. Modern electronic cameras offer through-the-lens (TTL) flash control, a real advantage over other flash systems. Flash units synchronize with shutter speeds at a specific limit, 1/60 sec. or 1/90 sec. in many mechanical cameras and up to 1/250 sec. with most electronic cameras. The electronic camera's faster *sync speed* has some definite advantages over the mechanical camera's slow speed. The faster sync speed allows you to use your flash in bright sunlight when the ambient light is brighter than the flash's light. With ISO 100 film, the base exposure for sunny *f*/16 light is 1/125 sec., or if the subject was white, 1/250 sec. A flash-sync speed of 1/60 sec. would require an aperture of *f*/22 for middle tone, and *f*/32 for white, in order to be correctly exposed for the ambient light. Unfortunately, many wide-angle lenses and some 50mm lenses stop down only to *f*/16, and an overexposure would result if the camera were set at the slow sync speed of 1/60 sec. However, by using a faster shutter speed and basing your exposure on the natural light, you can simply use your flash's light to fill in the shadows created by bright, ambient light. This technique, known as *fill flash,* is very useful in reducing the typical contrasty images encountered at high noon when the top of your subject is sunlit and the lower half is in deep shade. The shadows are "filled in," hence the term fill flash.

WHITE-LINED SPHINX MOTH, Madera Canyon, Arizona. 200mm F4 D macro lens, 1/250 sec. at *f*/22, TTL flash, Fuji Velvia

An erratically moving moth challenges both focus and exposure. While I usually find autofocus useless in these conditions, TTL flash does work to produce the right exposure. In this case, the middle-tone flower and the moth occupy a large enough area of the frame that the distant background did not trick the flash meter into overexposing the image.

Many cameras fire a flash off a *hotshoe*, a little bracket usually mounted on top of the camera's pentaprism and designed to accept the grooved foot of a small flash unit. These flash units have special connector pins that match the contact points on the camera hotshoe. This eliminates the need for a special power cord (PC) to connect the camera and flash. Additionally, some cameras also offer a PC socket to allow flash units made by a variety of manufacturers to be used. Cameras without PC sockets can be used with flash units that require a PC socket. All that is required is a universal adapter mounted onto the camera hotshoe.

Technology changes so rapidly that today's strongest recommendation may be obsolete within a year. Thoroughly evaluate what you need for your type of work, then decide on a specific camera and the various accessories.

WHAT FEATURES DO YOU NEED IN A CAMERA SYSTEM?

ESSENTIAL FEATURES	COMMENTS
Depth-of-field preview	I wouldn't purchase a camera without this feature.
Electronic release	For remote photography.
Manual exposure	For serious nature and wildlife photography when exposure control is needed.
Manual focus	Standard in almost all camera systems.
Mirror lockup	For serious macro, landscape, and super telephoto work.
Predictive focus	I don't think autofocus is especially useful without this feature.
TTL flash	I wouldn't buy a new camera without this feature. Useful for teleflash photography of wildlife, aquarium and zoo photography, macro photography, and candid portraiture.

USEFUL FEATURES	COMMENTS
AA battery power	These batteries are available virtually everywhere.
Aperture priority	For landscapes, plants, macro. A benefit when using an unmanned camera in remote work. Useful for action sequences when fast shutter speeds are needed.
Autofocus	For wildlife (moving at moderate speeds) that eludes success with manual focus.
Automatic rewind	For wildlife photography; facilitates fast reloads.
Averaging mode	For general scenics.
Cable-release socket	Mechanical releases are inexpensive to replace.
DX film coding	Handy for the forgetful or hurried.
Film window	Same as above; will prevent shooting 50 exposure rolls.
1/250 flash sync	For outdoor, fill-flash, and teleflash work.
Hotshoe flash mount	For fill-flash and some macro work.
Manual film rewind	Very handy in cold weather.
Matrix/Evaluative	For all shooting, as a backup for spot metering, and for fill-flash techniques.
Motordrive	Extremely useful in serious wildlife and bird work.
Nicad batteries	For wildlife and scenics in cold weather; nicads last longer than AA batteries.
PC socket	For inexpensive compatibility with many flash systems, off-camera flash, studio setups.
Power winder	Convenient, especially with wildlife.
Self-timer	A substitute for a cable release at slow speeds, and for self-portraits.
Shutter priority	For wildlife when the light is fairly constant.
Spot-metering mode	For wildlife, macro, and landscapes, to isolate and read middle tones.
Trap focus	For remote photography of wildlife at nests or dens.

THE PERFECT CAMERA SYSTEM

There probably isn't one perfect camera system, but as the following examples illustrate, there are features that play an extremely useful role when you're photographing a variety of wildlife subjects.

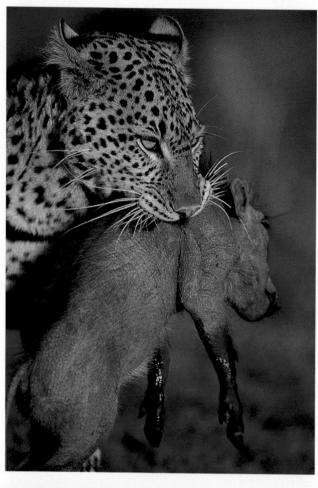

LEOPARD, Masai Mara Game Reserve, Kenya. 600mm F4 lens, 1/500 sec. at *f*/5.6, Fujichrome 100

When a leopard walks toward you carrying prey, it is hard to even think straight! Continuous, predictive autofocus maintained image sharpness as the cat walked to and then beyond my position. Without autofocus, my keeper rate would have been a tenth of what it was.

PLUMED BASILISK LIZARD (CAPTIVE), McClure, Pennsylvania. 70–200mm F2.8 zoom lens, 1/250 sec. at *f*/19, flash and Shutterbeam, Fujichrome 100

An infrared Shutterbeam tripper fired my Canon EOS 1N RS about 1/180 sec. after the lizard crossed the triggering beam. The RS has a pellicle mirror permitting these short response times. With other cameras, a lag time of 1/10 sec. to 1/30 sec. is typical and far too slow to consistently obtain sharp images of fast-moving animals passing through a beam.

WESTERN SCREECH OWL (CAPTIVE), Project Raptor, British Columbia, Canada. 300mm F2.8 lens, 1/250 sec. at ƒ/5.6, Kodachrome 64

I needed a certain amount of depth-of-field to maintain sharpness in the owl's head, but with too much, the trees in the background would have taken on shape and proved distracting. By using my depth-of-field preview button, I could determine what aperture yielded the right amount of sharpness without introducing distractions.

SUPPORTING YOUR EQUIPMENT

Although some may argue this, there are three characteristics that are usually present in all good wildlife photographs: an accurate exposure; a pleasing composition; and a sharp, well-focused image. Sharpness is obtained through a combination of factors; high-resolution lenses, slow-speed films, and steadiness all contribute. One photographer may use great lenses and slow speed films, yet have images that are not sharp. While another photographer might shoot with an average lens and fast, grainy film, but obtain sharp images. Why? The difference might be attributable to who uses a tripod—the most neglected but essential piece of photo gear—and who doesn't.

Without a doubt, one of the most important accessories you'll ever own is a good tripod. Almost all serious nature photographers use one, and usually, it's a good one. Beginners, on the other hand, often don't use a tripod, and if they do, they often use one that's inadequate for their equipment. Don't buy a tripod that's too light, too short, or too limited in its controls for convenient use. An adequate tripod is as essential as any camera or lens. Buy a good one, and use it.

Using a tripod isn't always easy. Tripods can be cumbersome and awkward to set up. They can be a bother to carry or to pack for a trip, and they seem to grow heavier after a long day in the field. Despite these disadvantages, a tripod is worth the effort. A sturdy tripod yields razor-sharp images with even the heaviest lenses. It gives you the opportunity and the time to scan the edges of your view finder when you are fine-tuning a composition. When you photograph wildlife, a tripod will keep you poised and ready to shoot.

CHOOSING A TRIPOD

Selecting a tripod is a bit less confusing than deciding on a camera system because there are fewer features to consider. The correct choice makes using one a pleasant experience or, at the very least, a habit you can develop.

BOTTLENOSE DOLPHIN, Sea of Cortez, Baja California, Mexico. 70–200mm F2.8 zoom lens, 1/500 sec. at *f*/8, Fujichrome 100

It is difficult to use any type of camera support on a running boat; engine vibrations will run right up the legs of a tripod or a monopod. It is often easier, and more practical, to either handhold the camera or use a shoulder support. Of course, the real problem is capturing an image; by the time you see a dolphin leaping, the animal is usually back beneath the waves.

Sturdiness. A basic rule about tripods is: The heavier the tripod, the sturdier it usually is. To determine how sturdy a tripod you'll require, think about the equipment you own now as well as the heavy or long lens you might be adding in the future. If you anticipate owning a big, heavy lens in the future, buy a heavier tripod that will enable you to support it. When you shop for a tripod, bring along your heaviest lens or borrow one at the store. You can determine the tripod's sturdiness by mounting the equipment and working the controls. Raise the legs to their full height, then lightly tap the front of your lens. If the lens wobbles, try a heavier tripod or tripod head. Sturdy tripods aren't tiny or lightweight; my tripods are about an inch in diameter at their smallest, but they're capable of holding my big lenses.

You might consider one of the models that most serious amateurs and professionals use, such as the Gitzo 320 or 340, or for large lenses (like a 600mm, for example) the Gitzo 500 or 505. Since I travel a lot, I use one of the new carbon-fiber tripods that weigh about a third of the aluminum tripods; it is the Gitzo 1349, and although it is probably pushing the limits of stability, I shoot 500mm and 600mm lenses off it when I'm in foreign locales.

Don't buy a sturdy *monopod,* a one-legged support, in an attempt to save weight. There are too many advantages to using a tripod that aren't available with a monopod, including being able to simply set it up and leave it. Some photographers use monopods when following moving subjects over long distances because they can set up the lightweight supports quickly. I don't recommend this. Although a three-legged tripod is heavier than a monopod, you can use your tripod like a monopod and enjoy the same amount of mobility and speed. Just extend one or more of the legs to a comfortable length while keeping the other legs folded in. Should the subject you're following suddenly stop, you'll be able to unfold the tripod legs and enjoy the increased stability. A monopod can't do that!

I have used one monopod that I liked: the Stabilizer Quick Shot. It is effective because it incorporates a metal shoulder stock, in addition to a monopod, that can be extended to the ground or mounted into a special belt pouch for more mobility. Even with a Quick Shot, however, you'll have your sharpest images with zoom lenses such as an 80–200mm F2.8.

Don't spend all your money on cameras and lenses, then skimp when buying your tripod. On a Galapagos Islands trip, a person tried supporting an expensive 300mm F2.8 lens and motordriven camera on a tabletop tripod. After catching his gear three times when one of the pencil-thin tripod legs collapsed, he admitted his foolishness in attempting to save money on this essential piece of gear. Unfortunately, he was stuck with an inadequate tripod for the remainder of the trip.

LESSER EARLESS LIZARD, Madera Canyon, Arizona. 200mm F4 D macro lens, 1/250 sec. at *f*/11, TTL flash at -1.7, Fujichrome 100

Besides being a rock-steady camera support, a tripod provides a stable platform for fine-tuning a composition. You can make minute adjustments that wouldn't be possible with a hand-held camera.

A good tripod will provide a great deal of shooting flexibility. Here, I'm sitting behind the breast of a dam with all three tripod legs in a flat, horizontal position, enabling me to shoot just a few inches above water level.

Maximum working height. Right or wrong, most people use a tripod from a standing position. Consequently, if the tripod doesn't extend as tall as the user stands, the user is forced to stoop over every time he or she looks through the viewfinder. This gets tiresome, fast.

Most tripods aren't tall enough to allow you to look through the viewfinder unless the tripod's center column is elevated. When you elevate the center column, you are, in effect, mounting your camera on a monopod that is supported by a tripod. This introduces instability. Avoid raising the center column and you'll maintain a rigid, sturdy camera support.

Buy a tripod that enables you to stand upright and see through the camera's viewfinder without having to extend the center column. Such tripods are more expensive and heavier than those that have center columns providing the required height. However, it is worth both the price and the extra weight for the stability you'll enjoy.

Minimum working height. Many wildlife subjects are found at or near ground level, and your most effective compositions may be at your subjects' level. Unfortunately, many tripods don't drop low enough to allow this. Buy one that does. Tripods that can be used at ground level usually have legs that extend independently to a near-horizontal position.

Many Gitzo tripods offer a flat accessory plate that mounts directly onto the tripod and replaces the center column, allowing you to shoot virtually at ground level. Unfortunately, most tripods capable of reaching ground level have a long center column, which gets in the way unless it is removed or replaced. Some of these, like the Bogen 3021 tripod, have a two-sectioned center column, which can be lowered when the lower half of the center post is removed with an *alum wrench.* Fortunately, one is supplied with the tripod, but even with the lower post removed, there's still a short column, and true ground-level shooting is not possible.

Some tripods, such as the Gitzo 320, require you to purchase an accessory short post to reach ground level, unless you cut off the unnecessary length of the standard center column with a hacksaw. I wouldn't do that because you may need the additional height of the longer center column at some time. In the field, I sometimes use my center column for scenics when I'm shooting from on top of the hood of my car. In the studio, I frequently use the center column to save floor space that would be otherwise occupied by extending the tripod legs to a greater height. (I don't have to worry about camera instability when I'm using electronic flash because the flash's illumination produces the necessary sharpness.)

Other Gitzo models offer an accessory circular camera platform that enables a tripod to lay as flat to the ground as the spread legs permit. With some models, the tripod is supplied with a center column and this flat plate.

If your tripod doesn't reach ground level when its legs are extended, there are other, less satisfactory ways to reach ground level. Reversing the center column is the least advantageous because the camera will become unstable, as it would with a raised center column. Additionally, you might not fit between the legs of the tripod to use your viewfinder if you're large or if you're wearing heavy winter clothes. Finally, if you're using a wide-angle lens, the angle of view could include a tripod leg.

Tripod head. You can usually purchase better-quality tripods without an attached head; however, the tripod head is permanently attached to inexpensive tripods. Nevertheless, all tripod heads should allow movement in several directions. *Pans* (left-to-right movements) and *tilts* (vertical movements) should be accomplished easily with whichever head you use.

My favorite head is a ball head, in which a single knob controls all movements. If you use long or heavy lenses, as I do, try the Arca Swiss B-1 or the larger B-1G ball head. Similar heads are offered by Foba, Studio Ball, Kirk, and Kaiser. I've had my best luck with the Arca Swiss.

Other head styles have separate handles or levers for each movement. Some, like the Bogen 3047, can provide very precise control in scenic or macro photography, but I find these awkward to use when I'm photographing wildlife. Often, a number of movements occur simultaneously as I'm moving the camera from left to right and from a lower to a higher position. I've found this action difficult to perform with a three-levered tripod head. It is less of a problem when using three hands, but I have only two. Finally, I wouldn't recommend purchasing different heads for specific functions. Invariably, you'll find yourself with the wrong head at the wrong time.

There may be one exception to this, however, and that's if you regularly use long lenses for action photography. Several manufacturers offer *action heads* that work on a gimbal principle where the lens swings and rotates quite smoothly. Because of their design, however, most don't lend themselves to all-around use; but they work fine for the purposes for which they were designed. Wimberly, Nature's Reflections, and Poleschook's Nature Photography all offer models. Wimberly, in fact, has recently introduced an adapter that allows its gimbal system to interface with a normal, quick-release ball head for lenses of 300mm or smaller.

Mounting mechanism. Cameras (and lenses equipped with tripod mounts) are either mounted directly onto tripod heads or onto special plates or plugs that fit into quick-release mechanisms fitted for tripod heads. I prefer

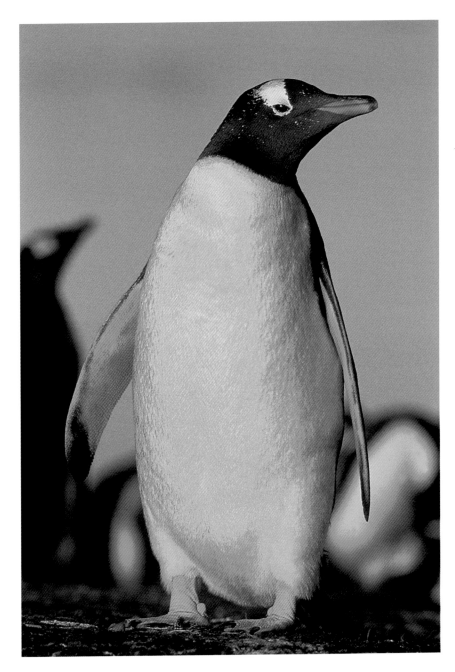

GENTOO PENGUIN, Sea Lion Island, Falkland Islands. 300mm F2.8 lens, 1/250 sec. at f/4.5, Fujichrome 100

For this low angle, I unscrewed my Arca Swiss ball head from the tripod and placed the head directly on the ground. By flipping to a vertical format within the ball head's grooved slot, I dropped another few inches for this low-angle portrait.

quick-release, or dove-tailed, mechanisms; they enable you to quickly change bodies or lenses if each piece of equipment has its own plate. This is especially useful if you're rushed. Otherwise, when you hurry to change your gear, you can strip the mounting threads or attach the camera improperly. In fact, all of my cameras and lenses have their own plates. Manufactured by Really Right Stuff, the plates designed for long lenses and for macro lenses can be mated with special flash arms that allow a flash to be mounted above the lens, regardless of the vertical or horizontal position of the camera. This provides a more natural-appearing light than if the flash were mounted onto the camera's flash hotshoe.

Most photographers, myself included, carry their tripod and gear slung over their shoulders. But there is always the chance that the gear will unscrew and fall off the tripod head. Check the tightness of your mounts periodically. Make it a habit to have either the camera or the lens strap wrapped around a locking knob on the tripod head or clamped inside the tripod legs. Each year, a workshop participant who observes this rule saves his or her big lens or camera when it unexpectedly falls off the tripod head.

Leg locks. Tripod legs lock via the tightening of either a threaded collar or a locking lever. Screw collars are more secure but are slower and more likely to get stuck with sand, salt, or mud. Levers are faster and less likely to jam, but they may lose locking tension over time and they're more easily snapped or broken off.

USING YOUR TRIPOD EFFECTIVELY

Tripods are to use and to move. Don't anchor yourself to the spot where you first place your tripod. Often the best perspective is just inches away from where you're positioned; sometimes it is dozens of feet away. First scout your "shoot" without your tripod just by hand-holding the camera and looking through the lens. After determining the best spot, get your tripod, mount the camera, and shoot. But, don't lock yourself into just one spot simply because you have your tripod in place.

After you've made some exposures, move around and find something new. Or, if your subject moves, pick up your tripod and follow it! For example, along the narrow canal lining Anhinga Trail in Everglades National Park, snakelike anhingas regularly hunt for fish. Invariably, it seems that just before catching a sunfish, the bird swims down the canal and out of the view of the many waiting photographers. Instead of following along to capture the peak action, the photographers all too frequently complain about their

PIED-BILLED GREBE, Ding Darling National Wildlife Refuge, Florida. 600mm F4 lens, 1/500 sec. at ƒ/8, Fujichrome 100

Water-level shots of waterfowl, usually made from float blinds, are extremely effective. I was on shore here, but had two of my tripod legs extended into the water, with the third leg lying flat against the sand.

ROYAL TERN, Captiva Island, Florida. 600mm F4 lens, 1/500 sec. at ƒ/5.6, Fujichrome 100

My 600mm lens requires a tripod support, so I extended my Gitzo 505 tripod legs to their most flat-out position for a low-angle view. In sand, it is important that you extend the lower legs a few inches so that, as the legs sink, the leg-locking collars are above the sand. It is wise, too, to unscrew and clean tripod legs after use in sand.

bad luck. Remember, tripods have legs and so do you. When animals move, follow them with your gear.

You should use your tripod at varying heights, depending on the demands of your subject and the composition. Examine a scene from every angle and perspective for the ideal location before you set up, rather than after you've positioned the tripod and are behind your viewfinder. Also, be sure to check all of the locking mechanisms before stepping away from your gear. I'm sure I'm not alone in occasionally forgetting to do this, having a tripod leg slip, and crashing an expensive camera to the ground.

When working with a shy or elusive animal, anticipate the working height you'll need before approaching your subject. If you're photographing shorebirds, collapse the tripod's legs to their minimum height before you begin to work close up. However, if you're working in sand or mud where the legs will sink in a few inches, extend the lowest sections of the legs out far enough to keep the screw collar or locking levers clear of this surface. Additionally, if you immerse your gear in salt or muddy water, rinse the legs off with fresh water as soon as possible to keep them from gumming up.

Often, in national parks such as Yellowstone, you first spot game from the road. An animal may remain in an opportune spot for only a few moments, and time is precious. You'll have a better chance of getting to your subject quickly if you don't collapse the legs between stops but keep them at the length you normally use for shooting. If that isn't possible, set the legs to the required height before you reach your subject, instead of waiting until you're ready to shoot.

Don't use your tripod as a brace or crutch when rising from a sitting or a kneeling position. Even a sturdy tripod will bend and the locking levers will snap if enough weight is placed on them. For the same reason, be careful not to lean on a tripod when in deep snow. Keep in mind that in time, any tripod's leg-locking mechanism may weaken or slip. Although professional repair may be necessary, you can temporarily secure a loose leg by wrapping gaffer's or utility tape below the joint to prevent the leg from sliding up. The tape can be stripped off and reapplied a few times before it loses its adhesive strength, but I wouldn't suggest leaving your gear unattended, just in case.

PROBLEM SOLVING FOR STEADINESS

Although a tripod is invaluable for razor-sharp images, adverse terrain, wind, bizarre angles, or very mobile subjects can make using one difficult or impossible.

Wind. A steady or gusting wind can shake the sturdiest camera or tripod, making sharp images soft or fuzzy. You can add weight to the bottom of the tripod to increase

MAKING A BEANBAG SUPPORT

Although many beanbag supports are commercially available, it is easy to sew your own. I suggest that you make a bag about the size of a large brick (about 2 × 4 × 12 inches). Use a zipper closure—not Velcro—so that the bag is spill-proof. Fill the beanbag with birdseed, and you'll have a handy source of natural bait should you need it. If you make several bags, fill each one with different amounts seed so that they can be easily stacked or wedged together if you need to raise or brace a long lens.

the unit's total mass, but this does little to stop your camera and lens from shaking. To minimize shake, add weight to the top of your gear over its center of gravity. In other words, place the additional weight over the part that is attached to the tripod. Don't put weight on a lens if the camera is mounted to the tripod. This will damage the lens mount.

If you're using a long lens with a removable or telescoping lens hood, you may be able to reduce the wind's vibration. For example, the hood of my 500mm lens extends about six inches past the front element and acts like a sail, shaking my lens violently when I'm working in a strong wind. By removing the lightweight hood, I'm able to significantly reduce the surface area exposed. I suggest removing the hood only if there isn't a danger of lens flare or of windblown particles of sand or grit scratching the front element of the lens. Either is unlikely to occur if the sun and the wind are to your back.

Vibrations. Besides locking up the camera mirror, there are other ways in which you can dampen vibrations caused by mirror slap, the action of the mirror flipping up during exposure. Some photographers use two tripods with 600mm or longer lenses, placing one tripod beneath the lens and the other beneath the camera. This method works, but it is very cumbersome; it is most useful with stationary subjects.

You can also support the back of the camera with a brace that mounts to one of the tripod legs. While there are several special accessories that permit this, I think the best one is also the most versatile. A Bogen Magic Arm with Super Clamp—an adjustable, fully articulating "arm"—works great, with one end screwing into the camera baseplate and the other end clamping onto a tripod leg. The Magic Arm can also be used as a camera support when you're using a small lens, or to hold a flash. With long lenses, however, it is especially effective if there's a beanbag or sandbag resting on the camera's viewfinder to also dampen vibrations.

Low Angles. For a dramatic or an intimate perspective, I often try to film at my subject's level. This is sometimes difficult to do, especially with small, ground-hugging subjects. To obtain a low perspective, you can remove the tripod head and place it flat on the ground. This will shave off two to four inches in height. If you're using a longer lens with a tripod collar, you can get even lower by using the grooved slot on the ball head normally used for vertical compositions. Then, if you need a horizontal composition, just rotate the lens and camera inside the lens collar.

If you must be even lower, rest the camera directly on the ground. This works best with horizontal compositions because the camera baseplate provides additional support. You may need to elevate the front of your lens with a twig or stone to clear the foreground. Anything can work as a solid camera or lens support. On more than one occasion I've used one of my shoes as a low-level support for my 200mm macro lens. Hand-holding your camera at ground level works if your hands can rest on the ground and support the gear. Use smaller lenses and faster shutter speeds for your sharpest images with this technique.

If you need to be midway between ground level and your tripod's minimum height, brace the tripod and camera on a rock, log, or your gadget bag. Make sure you weigh down the end of the tripod to prevent it from tipping forward. After you've decided on your composition, lock the head and use a cable release to ensure that your gear neither slips nor moves.

Other Supports. At times, using a tripod is impractical or impossible. At many National Wildlife Refuges, shooting is most easily done from a car, and it is mandatory on an African safari. Although you can use a tripod inside a car, it is easier simply to use the vehicle as your camera support. Turn the engine off and put your lens on a jacket or beanbag draped over the window. I frequently carry one or two brick-sized beanbags in my car, on which I rest my lens. Several outfits sell beanbags expressly made for photography, including Kinesis, Vested Interest, and Ben-V Beanbags.

When photographing from a vehicle, I use a special window bracket, called the Groofwin, as my support. Marketed by L. L. Rue, the Groofwin is a flat, sturdy, adjustable brace that accepts a tripod head. I prefer to use only beanbags as camera and lens rests for the Groofwin because this minimizes the metal-to-metal contacts and potential vibrations that adding a tripod head produces. It is a sturdy system. Using this method, I've shot razor-sharp images using shutter speeds of 1/125 sec. with a 500mm lens—with three other photographers in a safari van.

You can use a tripod on a boat, provided the engine is off. If not, you must hand-hold the camera or use a shoulderstock. Stocks provide an extra measure of stability beyond hand-holding, because you use your shoulder as well as both your hands for bracing. Whether you're hand-holding or using a stock, think about limiting yourself to shutter speeds no less than the reciprocal of the focal length of the lens you're using. With a 300mm lens, use either 1/350 sec. if your camera has half-speeds, or use 1/500 sec. When hand-holding a camera, support the lens in one hand and the camera in the other. Brace your elbows against your waist and breathe shallowly as you focus and fire. If you're swaying, try to fire at the peak of your upswing when the camera is momentarily stationary.

Shoulderstocks provide an added measure of stability. A good one enables you to hold the stock to your shoulder and trip the shutter with one hand while using the other hand to focus. If you set your camera on autofocus mode, use your free hand to hold the stock for additional support. A stock made of wood or metal is less likely to break under stress than one made of plastic.

Some stocks come with a camera strap that wraps around your shoulders or waist for additional support. Don't encumber yourself in this way in a boat if there is any danger that the boat will capsize. Camera equipment sinks, and you will, too, if you're attached to it.

Above: Here I'm resting two beanbags on top of a Groofwin Pod to support a 500mm lens. This is my standard setup for filming from a vehicle.

Opposite: **BAT-EARED FOX**, Masai Mara Game Reserve, Kenya. 600mm F4 lens, 1/250 sec. at *f*/5.6, Fujichrome 100
Using a Groofwin Pod and several beanbags, I supported my lens from the window of a Land Rover. Naturally, the vehicle was turned off and the other photographers in it were still.

USING LENSES EFFECTIVELY

In the previous section, I stressed the importance of the camera as the foundation for your photography system. Nowhere is this more evident than when you consider lenses. An SLR's ability to accept a variety of different lenses gives the wildlife photographer a chance to document or interpret the world as he or she chooses, and a good camera system provides a lot of options for doing exactly that.

The lens options are staggering. You're probably familiar with terms like standard, telephoto, super telephoto, wide-angle, zoom, macro, and mirror that describe particular lenses or the effect they create. If, like me, you're interested in a wide variety of subjects, you're likely to need a wide assortment of lenses. No one lens can do it all. If, on the other hand, you're a specialist, perhaps only interested in birds or bugs, just one or two lenses may do. A bird photographer would look for lenses of high magnification and speed, while the bug or macro photographer would seek some magnification and close-focusing capabilities.

The standard, "normal," SLR-camera lens is 50mm in length and produces an image similar to what you see with your unaided eye. This lens is the standard to which all other lenses are compared. *Wide-angle* lenses are smaller than 50mm in length and provide a greater angle of view and less magnification. *Telephoto* lenses are longer than 50mm and offer a more restricted angle of view along with greater magnification. You can determine the power of magnification of a lens by dividing 50 into the focal length of any lens. A 500mm telephoto provides 10X magnification (500mm/50mm = 10X), making objects appear closer than they really are. Conversely, a 24mm wide-angle lens yields half the magnification; objects viewed through a wide-angle lens appear smaller or farther away. Zoom lenses incorporate a variety of focal lengths in just one lens, saving photographers money, space, and weight, as one lens replaces several. Photographs made with a high-quality zoom lens are excellent and rival those taken with an equivalent-length fixed lens.

Although lens choice is personal, wildlife photographers might think about following "the doubling rule" when purchasing new lenses, by adding lenses that either halve or double the focal length of your present lenses. You can cover everything from scenics to elusive wildlife with a set of five lenses—24mm, 50mm, 100mm, 200mm, and 400mm in focal length—without duplicating an effect or a magnification. However, you could reduce the weight and trouble of carrying these five lenses by using zoom lenses instead. A 35–70mm or 28–80mm

zoom lens, an 80–200mm zoom lens, and a 400mm telephoto lens provide even broader coverage with less gear. In the Canon EOS system, as few as two lenses might suffice, the 17–35mm zoom and the 35–350mm zoom. Regardless, these two, three, or five lenses make a great "starting set." If you add either a macro lens or an extension tube, a teleconverter, and perhaps a smaller wide-angle lens, you'll be able to cover almost everything nature has to offer. Of course, you might not need all of these lenses, or you might need even more. Exactly which ones you'll need depends on what you plan to photograph and how much you're willing to spend.

Since we normally use Nikon equipment in the field, my wife and I have adapted the doubling rule in our selection of telephoto lenses. Instead of using a single telephoto lens for wildlife, we use a 300mm F2.8 lens for those situations where image size isn't as critical as

CHEETAH, Masai Mara Game Reserve, Kenya. 600mm F4 lens, 1/250 sec. at *f*/5.6, TTL teleflash at -1.3, Fujichrome 100

This shot is a traditional portrait, in which my long lens simplified the image. I used a TTL teleflash to illuminate the shadows caused by the cheetah's hooded eyes.

CHEETAH, Masai Mara Game Reserve, Kenya. 20–35mm F2.8 zoom lens, 1/125 sec. at ƒ/9, Tiffen warming polarizing filter, Fujichrome 100

It is always tempting to shoot close-ups. However, you should also be aware of the landscape around you. Here, the skies were beautiful, and a wide-angle view captured the grandeur and beauty of the cheetah's grassland habitat.

obtaining sufficient light. At 6X, the 300mm still affords an adequate image size. When light isn't an issue, Mary often carries the lighter 300mm F4 lens instead, especially when we're traveling overseas where weight and packing space is limited. We always carry a matched 1.4X teleconverter to use in situations when we need greater magnification. This "costs" one stop, turning my 300mm F2.8 into a 420mm F4, and Mary's F4 into a F5.6 lens.

When we need more magnification, Mary uses a manual focus 500mm F4, and I switch to a 600mm F4 autofocus. If we need even more magnification—and this is rare—our 1.4X teleconverters will change Mary's 500 into a 700mm F5.6, and my heavy monster into an 840mm F5.6 lens. With these lenses and our 80–200mm zooms, we can cover most wildlife subjects.

CHOOSING THE RIGHT LENS

Selecting a lens involves considering focal length, lens speed, minimum focus, weight, and ultimately price, as the latter generally reflects these other considerations. You'll save money using zoom lenses. Although a "good" zoom is expensive, it is still cheaper than buying two or more lenses of equivalent quality that lie within the range of the zoom lens. An 80–200mm zoom lens, for example, incorporates three "standard" lenses—the 80 or 90mm lens often used for human portraiture, the 100 or 135mm medium telephoto lens, and the 200mm telephoto lens—as well as every focal length in between. However, don't expect that just one or two "super-zoom" lenses will satisfy all your needs, especially in terms of optical quality and lens speed. For example, Canon's 35–350mm lens is a relatively slow F5.6 at its maximum focal length. If sharpness and lens resolution are important to you, you may want to use modest zoom ranges, such as 20–35mm, 35–70mm, and 80–200mm. Telephoto-zoom lenses cover the focal lengths between 100mm and 500 or 600mm, but most of these are heavier, slower, and not as sharp as are fixed-length telephoto lenses.

Both zoom lenses and fixed-length lenses are available over a very broad price range. You can expect to pay anywhere from less than $1 per millimeter to over $10 per millimeter of lens. For example, the price of a 400mm telephoto lens ranges from under $300 dollars to well over $7,000. This significant price discrepancy in lenses of the same length reflects major differences in lens quality, brand name, and speed.

Invariably, brand-name lenses offered by the major camera manufacturers cost more than generic lenses produced by independent lens makers. Although you may be paying something for the brand name, the lenses offered by camera manufacturers are usually better built and are less likely to need repair if subjected to minor abuse. Field photographers should take this into account

BIGHORN SHEEP LAMB, Yellowstone National Park, Wyoming. 500mm F4 lens, 1/250 sec. at *f/4*, Kodachrome 64

The 10X magnification of my 500mm lens enabled me to create a frame-filling portrait without crowding my subject. Longer lenses lessen the chance of stressing wildlife and also narrow the angle of view, thereby simplifying your compositions.

because working outdoors can be very hard on equipment. Recently, when I turned some gear in for repair, the clerk actually said, "Man, you're hard on equipment!" But that's why I pay top dollar, and over time, I save money on repairs by using my camera manufacturer's lenses.

Often, there are also price differences within one manufacturer's line, depending on the optical quality of the lens. The distortion created as light passes through glass is corrected in the best lenses. These lenses are often referred to as *apochromatic* (APO) and concentrate the various wavelengths of visible light at the same focal point. Lens and camera manufacturers may identify these color-corrected, more expensive lenses by the letters APO, LD

(low dispersion), L (luxury), ED (extra-low dispersion), or AT (advanced technology). (These descriptive terms are not industry standards; they simply identify "good" glass.) Optically, many generic lenses and manufacturer's lenses are similar; you can be safe buying the generic lens if you treat your equipment with care.

The *speed* of a lens, or its maximum aperture, also affects the cost. Faster lenses have wider maximum apertures and are more expensive than slow lenses with smaller maximum apertures. Speed is relative to lens length; while an $f/2.8$ maximum aperture on a 50mm lens is very slow, it is very fast for a 300mm or larger lens. Most manufacturers offer several different lens speeds for a particular focal length. Speeds of $f/2.8$, $f/4$, $f/4.5$, and $f/5.6$ are common maximum apertures on 300mm telephoto lenses. A color-corrected fast lens is often four to six times more expensive than a slow, uncorrected lens.

In wildlife photography, a fast lens offers many advantages. Because a camera focuses with the lens wide open—that is, at its maximum aperture—a fast lens is brighter and easier to focus. Since depth of field is shallowest at the maximum aperture, images "pop" into focus. Additionally, you can use faster shutter speeds in any given light, which is critical in obtaining sharp images. Unfortunately, fast telephoto lenses are heavy. The average 300mm F2.8 lens is almost three times the weight of a standard 300mm F5.6. A slower, lighter lens may be better for a backpacking photographer or someone lacking the strength needed to carry a heavy lens.

SHUTTER SPEED, APERTURE, AND LENS CHOICE

On page 49 I discussed some shooting options with various modes, using the example of a deer walking through a forest. The ambient exposure was 1/60 sec. at $f/4$ with ISO 100 film. Now I want to talk about this lighting situation in terms of available shutter speeds with different speed lenses.

With a 300mm F2.8 lens, a shutter speed of 1/125 sec. may "stop" the deer's motion, but not if the deer were walking rapidly, especially if the image size is large and fills the frame. A 300mm F4 lens requires a 1/60 sec. exposure. A moving deer would be blurred, but you could obtain a clear image if the deer pauses.

A 300mm F5.6 lens needs an even slower shutter speed of 1/30 sec. Although it would be difficult to capture a walking deer at this speed, 1/30 sec. could yield a very effective pan if the deer were running. Likewise, the same shutter speed could be effective if the deer were motionless, provided you used good camera-handling techniques.

Besides speed, other factors can influence cost. At one time, autofocus lenses were less expensive than manual-focus lenses, but the reverse is probably true now. Another way to save money is to purchase a floating-aperture zoom lens instead of a zoom lens with a fixed maximum aperture. These lenses are identified by the two stops listed for their widest aperture. In a floating-aperture zoom lens, the aperture varies with the focal length in use. For example, on a 35–70mm F3.5–4.5 zoom lens, $f/11$ at the 35mm setting becomes $f/16$ at the 70mm setting. This aperture change occurs automatically with electronic camera models, like the Nikon N90, F5, and Canon EOS series, that read the true f-stop; and, it isn't a problem when any camera is set on an automatic-exposure mode, since the camera adjusts accordingly.

It can, however, be a problem for mechanical cameras set on manual mode as either you must know at what point you've lost some light, or you must continually check your exposure by metering through the lens. This will be inconvenient for photographers who use incident-light meters, estimate their exposures off the sunny rules, or use manual electronic flash and set the aperture accordingly.

Some lenses offer *internal focus* (IF), which means all focusing movements occur within a fixed-length lens. Lenses without internal focus often increase in length as they focus closer. This increase can affect exposure because some of the light that passes through the lens is lost.

An IF lens can be useful when you're photographing from a blind; shy subjects are less likely to be frightened by a stationary lens projecting through a porthole than they might be by a non-IF lens that increases or decreases in length as the lens collar is rotated. There is also an advantage when using *polarizing filters.* These filters polarize light and are very useful when shooting scenics. Polarizing filters "pop out" clouds as they darken blue skies; they eliminate reflections off glass and water, and help saturate color as well. The amount of polarization you achieve depends on the rotation of the filter, and since the front of many IF lenses are stationary even as you focus, you won't have to adjust a polarizing filter after focusing.

The minimum focusing distance of a lens may be important to you. An IF lens usually focuses closer than a non-IF lens, so a larger image size is possible. However, this shouldn't be a decisive factor in lens selection because minimum focus can be extended by adding an inexpensive extension tube to most lenses.

Due to their weight, telephoto and zoom lenses of 200mm and longer frequently have a *tripod collar* at their centers of gravity. This collar provides more stability to the system and causes less stress on a lens mount than is possible if the camera is mounted to a tripod. An additional advantage is that your perspective remains

the same when flipping from horizontal to vertical, since the camera position remains stationary as the lens rotates within the collar. This is extremely convenient when photographing active wildlife.

True *macro* lenses focus closely enough to offer at least 1:2, or one-half life-size, magnification. Some macro lenses focus to 1:1, or life-size. The numbers representing magnification can be confusing; think of these as fractions. The ratio 1:2 could be written as 1/2, or half life-size. It is easy to see why 1:2 and 2:1 are not interchangeable and represent different ratios. The ratio 2:1, or 2/1, represents an image twice life-size.

Fixed macro lenses are available in 50mm, 90mm, 100mm, 180mm, and 200mm focal lengths. Sigma also makes close-focusing 300mm and 400mm telephotos that offer 1:3 reproduction ratios, which is enough for a frame-filling butterfly or greenfrog at a comfortable working distance. Although I own a 50mm macro lens, I rarely use it for macro photography, although it does see use as a scenic lens. I use the 100mm macro lens for insects when I'm using a Saunders macro-flash bracket. The working distance of a 100mm macro lens is useful for studio setups of reptiles and small mammals when space is limited. A 200mm macro lens is ideal for wildflowers, reptiles, and amphibians in the field, and for some studio work. Most 200mm macro lenses have tripod collars, which makes changing from horizontal to vertical easy.

Although some zoom lenses offer a macro mode, many of these focus only to a 1:4 magnification and are really only close-focusing zoom lenses. A few will focus into a true macro range of 1:2 or more. Don't necessarily buy a zoom lens that offers a macro mode at its smallest focal length because of this feature. The working distances within the 24mm, 35mm, and 50mm range are often too short for practical use. On the other hand, a wide-angle look, incorporating a broad field of view, can be a refreshing difference in macro images—but not without some difficulty. Working very, very close, as you must with short focal length lenses, is bothersome.

APPLYING CRITICAL DATA ON LOCATION

Too many photographers take into account only the size and magnification of their lens when composing images. Lens length also determines the working distance, the angle of view, the amount of compression, and the depth of field. Understanding these factors and their interrelationships is critical to producing good compositions. One of the most important factors is magnification. As you double the lens length, magnification also doubles, enabling you to have the same image size from twice the distance. Increasing a lens by any given factor increases its magnification by the same amount.

Although images get larger as you increase the magnification, the *coverage area,* or *angle of view,* becomes smaller. A 50mm lens has a 48-degree angle of view. At 2X magnification, a 100mm lens has a 24-degree angle of view, a 200mm lens has a 12-degree angle of view, a 400mm lens has a 6-degree angle of view, and at 16X magnification, an 800mm lens has an angle of view of approximately 3 degrees. Reducing the angle of view by using a longer lens can simplify or clean up a messy composition, as this will reduce the amount of area present in the background.

Many photographers don't think about lens length when photographing approachable macro subjects, that is, those requiring magnification that approaches life-size on film. Let's use, as an example, a portrait of a dew-covered dragonfly at dawn, made with a tripod-mounted camera positioned about 30 inches above the ground. At dawn, it is easy to approach dragonflies, and working distance isn't a problem. A dragonfly can be

WESTERN DIAMONDBACK RATTLESNAKE (CAPTIVE), McClure, Pennsylvania. 200mm F4 macro lens, 1/250 sec. at *f*/13, manual flash, Fuji Velvia

Working distance is very important, especially when dealing with dangerous subjects. Although I used a 200mm lens, a close-focusing telephoto would have provided the necessary magnification and given me a bit more working space and safety.

MACRO LENSES AND WORKING DISTANCE

What length macro lens do you need? I rarely use my 50mm macro lens because the short working distances it requires are very inconvenient. I use this lens when I want to include some background habitat, and when I couple it with an extension tube for greater than 1:1 magnification.

Likewise, I use my 35–70mm macro zoom very infrequently, and then only as a means to include habitat in a close-up image. At the 35mm setting, where the 1:3 macro mode applies, my working distance is only 4 1/2 inches.

I use the longer macro lenses far more frequently. Along with the greater magnification, I find the increased working distance has many benefits. For example, I'm less likely to disturb a subject or the vegetation surrounding it with my tripod legs or flash cords, and I can keep a safe distance from potentially dangerous subjects. It is a lot more comfortable using a 200mm, 300mm, or 400mm for a frame-filling head shot of a rattlesnake than it would be with a 50mm or 60mm macro at 8 inches!

photographed with either a 50mm macro lens or a longer 100mm or 200mm macro lens. Each of these macro lenses is capable of producing an image that is one-half life-size, and depending on the manufacturer, they can also reach a life-size reproduction ratio.

A photograph of the dragonfly made with the 50mm lens may include a distant horizon line and bright sky, as well as any vegetation visible within the 48-degree angle of view. However, if you switch to a 200mm lens, you can still maintain the same image size you had with the 50mm lens simply by increasing the working distance between the lens and subject. Or, you can magnify the dragonfly four times if you maintain the same working distance for both lenses. Either way, with the 200mm lens, you'll have less background clutter.

Remember, doubling the magnification also doubles the distance required to produce images of identical size. You create the same image size of the dragonfly by using a 50mm lens at 10 inches, a 100mm lens at 20 inches, or a 200mm lens at 40 inches. However, the amount of background included is progressively reduced, and the composition will be simpler with the longer lenses because of their smaller angles of view. You may not think a greater working distance is important when you're photographing easily approached, sleepy, chilled dragonflies, but it is when you photograph a dragonfly at high noon when they are active and far more elusive.

DETERMINING DEPTH OF FIELD

Beginners often falsely assume that they can obtain greater depth of field by using a shorter lens, but this is not entirely true. Depth of field is dependent on two factors: aperture size and image size. Depth of field increases as aperture size decreases, that is, as the f-numbers grow larger. Conversely, if you're using the same f-stop, depth of field decreases as image size increases, whether you accomplish this by using a longer lens or by shortening the working distance. The same depth of field is obtained with lenses of different focal lengths when the image size and the aperture of the lenses are identical. This is advantageous in macro work, when it may be helpful to use the working distance of a longer lens.

Let's go back to the example of the dew-covered dragonfly. A portrait shot at a working distance of 40 inches with a 200mm lens at $f/11$ has the same depth of field as one taken with a 50mm lens at $f/11$ when you're 10 inches from the subject. The depth of field, less than one-half inch, is quite shallow with either lens. The depth of field changes if the focal length changes, but only if the working distance remains the same. For example, if you switch from a 200mm lens to a 50mm lens without repositioning your tripod, you'll have greater depth of field, but your image size will be only one-fourth the original size. If you move closer with your 50mm lens to obtain the image size that you obtained with the 200mm lens, the depth of field with the 50mm lens will equal that of the 200mm lens.

I often incorporate these ideas of working distance, depth of field, and angle of view when I photograph wildlife in crowded parks, or when background clutter detracts from my subject. For example, although I'm able to obtain an adequate image size of a ground squirrel on a campground with a 100mm lens, I often back off and use a 300mm lens instead. The longer lens eliminates the background clutter of tents, picnic tables, and people.

Lens choice can also exaggerate or compress the distance between objects within your frame. The standard 50mm lens records distance relationships much as the human eye perceives them. Lenses smaller than 50mm exaggerate distances, while telephoto lenses compress or shorten distances. This is why photographers use short telephoto lenses for human portraiture. Because these lenses compress subjects, facial features are flattened, rather than pronounced. Portraits made with wide-angle lenses distort and produce huge noses on pinheads. Most people find this unappealing.

In nature photography, using a longer lens can "stack up" an animal against a distant geologic feature because the lens shortens the apparent distance between the background and the subject. You can also use this compression to shorten the distance between scattered animals, thereby creating a tight flock or herd, or you

can use it to simply frame a subject against a simpler or more pleasing background.

For example, let's say you're photographing Dall sheep 100 feet away as they graze on a steep slope in Denali National Park in Alaska. Directly behind the sheep, but 20 miles away, the 20,320-foot-high Denali (Mount McKinley) juts skyward. With a 100mm lens, both the Dall sheep and the huge mountain towering over the Dall sheep are magnified 2X. You can exaggerate their relative size by increasing the working distance to the sheep. By backing off to 400 feet, you can obtain the same image size of the sheep with your 400mm lens that you had with a 100mm lens at 100 feet. However, that additional 300 feet from Denali is insignificant when compared to the 20 miles separating you from the mountain. Denali at 8X will tower over the Dall sheep. Also, at 400 feet, a 400mm lens is close to infinity focus. Both the sheep and the mountain will be detailed, especially if the lens is stopped down to $f/8$ or smaller. Although depth of field might not seem especially significant in this example, at the close distances typical of most wildlife photography, depth of field is important.

Depending on your camera model, you can determine depth of field in as many as three ways: by depressing the depth-of-field button on your camera or lens, by reading the depth scale inscribed on some lenses, or by consulting a depth-of-field comparison chart available in books and lens manuals. The first method works best because you can see what is in focus and what is not.

KING CORMORANT, Sea Lion Island, Falkland Islands. 300mm F2.8 lens, 1/500 sec. at $f/8$, Fujichrome 100

Up close, depth of field is very narrow, and as image size increases, depth of field decreases. When the cormorant's beak is facing me (above), it is soft; the depth, even at $f/8$, did not reach from the eyes to the tip of the beak. However, when the bird turned its head, I maximized my usable depth of field (left); since the beak and the eyes were essentially the same distance from the camera, both are sharply in focus.

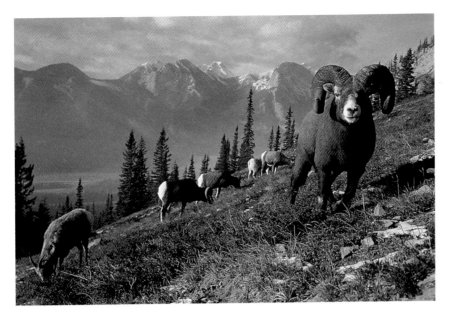

BIGHORN SHEEP, Jasper National Park, Canada. 35–70mm F2.8 zoom lens, 1/125 sec. at *f*/11, Fujichrome 100

Wide-angle lenses distort distances. With my zoom set to approximately 35mm, the bighorn—here, only a few feet away—looms large, while the mountains are small (left). Such images give a sense of location but may distort the actual scale between the sheep and mountain.

Using a telephoto (below left), I emphasized the scale and grandeur of the mountains by magnifying both sheep and background by 6X. Of course, the sheep were much farther away than they were for the wide-angle image—a necessary condition for conveying this type of scale.

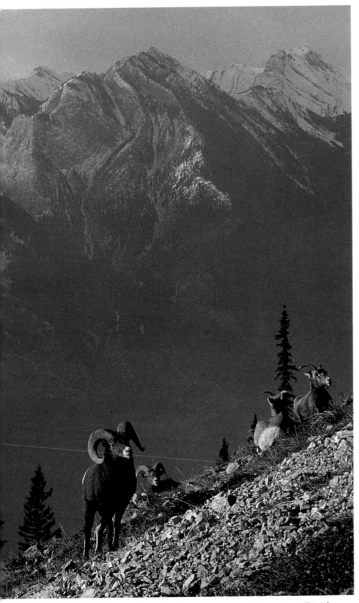

BIGHORN SHEEP, Jasper National Park, Canada. 300mm F2.8 lens, 1/250 sec. at *f*/4.5, Kodachrome 64

Because the viewfinder darkens when the lens is closed down, it is sometimes difficult to determine true sharpness, especially in dim light. Objects or features that may look sharp to your eyes through the darkened viewfinder are not, when louped on the editing table.

Closing down the aperture with a preview button has another advantage, though. By doing this, you can see the degree of sharpness present in the areas that are "technically" outside the true depth of field. Depth-of-field scales, whether they're inscribed on the lens or listed in books, only define the distance that is truly sharp. They provide no information on the degree of sharpness or fuzziness, which I call the *zone of apparent sharpness,* which is present both in front of and behind that area. In fact, the depth scales on lenses longer than 100mm are so small they're almost useless, but closing down and making a visual inspection to determine the zones of apparent sharpness is quite worthwhile.

Surrounding areas can be very important to your composition. Imagine a portrait of one flower among many in a field. Without a visual check, it is impossible to determine what amount of sharpness you need in the other flowers that frame your subject. Should they be fuzzy blurs of color or sharp enough to be nearly in focus? Which effect best complements your subject? You won't know unless you can check by using a depth-of-field preview button.

Depth scales are useful in accurately determining a lens' *hyperfocal distance.* This is the point of focus where everything from half that distance to infinity is sharp and within the depth of field. The hyperfocal distance approaches infinity as the aperture widens or as the lens focal length increases, because in both cases, the depth of field decreases. Hyperfocal distances can be invaluable when you want to maximize depth of field. To find your lens' hyperfocal distance, set the infinity mark on the

HYPERFOCAL DISTANCES AND LENSES

Understanding the relationship between aperture and lens length is more than an exercise in photo trivia. The knowledge can be very useful when you're photographing scenics or wildlife in landscapes when maximum depth of field is required. A 24mm lens at f/16, focused at the hyperfocal distance of four feet, will have a depth of field extending from two feet to infinity. At f/8, the depth of field narrows, extending from four feet to infinity, with the hyperfocal distance at eight feet.

When you use longer lenses, the hyperfocal distance is farther from the camera and closer to infinity. A 50mm lens at f/22 is sharp from 6 feet to infinity with the hyperfocal distance at 12 feet. Nothing closer than six feet will be sharply in focus, but those areas outside the true depth of field may appear sharp by being within the zone of apparent sharpness.

Unfortunately, many wide-angle lenses no longer display a depth-of-field scale like this on the lens barrel, but they should. With my aperture at f/16, my depth of field extends from 2 feet to infinity. Note that the lens is focused just passed 3.5 feet, or approximately four feet—the hyperfocal distance for a 24mm at f/16.

AFRICAN ELEPHANT,
Samburu Game Reserve, Kenya. 20–35mm F2.8 zoom lens, 1/250 sec. at f/9, Fujichrome 100

I used a wide-angle zoom to include the attractive sky and landscape when the elephants walked close by. Because of their size, the animals were still far enough away for me to avoid the distortion common in close-up images made with wide-angle lenses.

lens focusing collar over the f-stop on the depth scale, assuming your lens has a depth scale (many new lenses do not) for the aperture you're using. You'll find the minimum point of sharpness will be directly above the f-stop mark at the other end of the depth scale. As you do this, you'll find that the lens' true focusing mark is somewhere between these two distances. That distance represents the hyperfocal distance.

I think some of the confusion in hyperfocal distance lies in people's belief that the "distance" refers to a range. It does not—the hyperfocal distance refers to the point of focus. After that point is determined, the range of depth, from half the hyperfocal distance to infinity, is determined. If you understand this, you'll understand why the focusing mark on the lens will be at twice the distance of the minimum focus marked by the depth scale.

For example, suppose that the depth of field ranges from two feet to infinity. The focusing mark will be at four feet. If you wish to have a foreground object as close to you as possible and still be in sharp focus, position it at two feet. Here, that object may look soft and out of focus when the lens is wide open. Beginners see this, panic, and reposition themselves so that the object is back at four feet, or they refocus so that it now appears sharp at the two-foot distance. They forget that the depth of field will extend to the two-foot mark, which they would see if they used a depth-of-field preview button.

SPECIAL LENSES AND ACCESSORIES FOR CLOSE-UP WORK

Too frequently, animals are either shy or are small and require special macro or telephoto lenses to make an

SPECTACLED CAIMEN (CAPTIVE), McClure, Pennsylvania. 300mm F2.8 lens with 1.4X teleconverter, 1/250 sec. at *f*/5.6, Fuji Velvia

Sometimes working distance isn't a problem, but perspective or distractions are. With a shorter lens, the background clutter would have been included in the frame, but by backing up and narrowing my angle of view, the 420mm perspective made a clean shot, framing the caimen in a pool of green reflections.

interesting photograph. Although both macro and telephoto lenses provide large images, macros do this by focusing closer, while telephotos do this by magnifying or decreasing the angle of view. There are other ways to reach macro, or near-macro, capability without using a macro lens. Special lenses and accessories for shooting wildlife close-ups include mirror lenses, teleconverters, telescope converters, close-up diopters, extension tubes, and bellows.

Mirror lenses are squat, barrel-like telephoto lenses that rely on a *catadioptric,* or *reflex,* mirror to achieve their focal length within a very short length. A series of mirrors within the catadioptric lens bounces the light back and forth to produce the same degree of magnification found in a traditionally shaped lens, but at a cost. Mirror lenses are slow, with a fixed aperture that is usually one or two *f*-stops slower than a normal telephoto lens. Because a mirror is located in the center of the front element, an optical aberration occurs: Out-of-focus highlights appear as doughnuts, instead of blurry dots as produced by straight lenses. These doughnuts can severely detract from an image. However, some mirror lenses are very sharp. Most are far less expensive, and significantly lighter and easier to carry, than traditional telephoto lenses. I've seen excellent work done with mirror lenses, although the slow speed of the lens and the doughnut highlights deter me from using them regularly. If price and weight factors are more important to you than speed and natural highlights, by all means, purchase a mirror lens.

Many telephoto lenses and some zoom lenses couple with special *teleconverters* to increase a focal length by a factor of 1.4X, 1.6X, or 2X. There is little loss of image

quality if the teleconverter is optically matched to your telephoto lens. However, you lose light by the same factor as you gain magnification. A 300mm F2.8 lens becomes a 420mm F4 lens with a 1.4X teleconverter, or a 600mm F5.6 when a 2X teleconverter is added. Most photographers agree that a high-quality 1.4X teleconverter produces sharp images, but that most 2X teleconverters do not. I recommend having a 1.4X teleconverter. If you must have a 2X teleconverter, I suggest that you carefully test one to determine if its degree of sharpness is sufficient to meet your requirements.

Determining exposures with a teleconverter is simple. Remember, the converter reduces the light that reaches your film by the same factor as it magnifies. With a 1.4X teleconverter, the reduction is one *f*-stop, and with a 2X teleconverter, it is two *f*-stops. Your in-camera meter, or your camera's TTL flash-metering system, will automatically compensate for the loss of light. You really don't have to worry that your 300mm F2.8 lens is now a 420mm F4 lens.

Some confusion can result if your camera electronically reads the aperture. If you were shooting the lens wide open, for example at *f*/2.8 with a 300mm lens, your electronic camera would display the new aperture of *f*/4, because that's the new, wide-open aperture for the "converted" lens. However, if your lens is set at *f*/8, your camera may read *f*/8 or *f*/11, depending on the camera model. If it reads *f*/8, it doesn't mean that your camera is broken, just that the adjustments are done automatically.

This can be really confusing if you're accustomed to manually opening up the aperture when you've used

a teleconverter, or if you use both older mechanical cameras and modern electronic models. Learn to trust the electronic display, and if you're still doubtful, experiment by taking meter readings off a standard, such as a gray card, so that you can see how the readings change or don't change depending on the type of camera you're using.

If you estimate exposures using one of the sunny rules, or if you use an incident light meter, the same procedure applies. With electronic cameras, the aperture display reads the true aperture, and takes into account that a teleconverter is added. With a manual camera, you'll have to remember to open up one stop. For example, if the incident meter reads 1/125th sec. at $f/8$, your actual settings would be 1/125th sec. at $f/5.6$, since the teleconverter costs one stop of light.

Again, if you use your in-camera meter, don't worry about the effect the teleconverter will have. Your camera will adjust automatically. If you don't use that meter, remember to increase your exposure by one stop of light, just as you'd have to do if a cloud suddenly obscured the light in your scene. You'd open up then, either by changing the aperture or the shutter speed, and you need to do the same when you add a teleconverter.

Some telescopes and spotting scopes offer camera adapters for wildlife photography. Although the optical quality of a few of these is excellent, most *telescope converters* lack optics comparable to the least expensive, smaller telephoto lenses. All telescopes are incredibly slow, with maximum apertures of $f/11$ or smaller that require fast, grainy films.

Almost any lens will focus beyond its minimum focus if auxiliary close-up diopters, extension tubes, or bellows are added. In each case, infinity focus is lost as the lens' focusing range shortens. Of the three, the simplest to use are the *close-up diopters* (also called close-up lenses) that screw onto the front of your lens like a filter. There is no reduction in light, and the optical quality of those incorporating two lens elements is quite high. These close-up diopters are especially convenient when you're traveling, if space is limited, or when a macro lens may not be necessary. Buy one large enough to fit the largest lenses it can be used with. For example, Nikon's 5T and 6T dual-element filters have 62mm filter threads. But with step-up filter rings, they can be used on lenses with filter threads of 58mm or 55mm lenses as well. Canon makes two element diopters with filter threads of 77mm, which work perfectly with their 70–200mm F2.8 lens or with a Nikon 80–200mm F2.8.

Extension tubes, as the name implies, are hollow cylinders that you mount between the lens and the camera to shorten the focusing distance of the original lens. Tubes are available in various lengths, depending on the manufacturer. For example, Nikon's extension tubes include lengths of 8mm, 27.5mm, and 52.5mm;

Canon's are 12mm and 25mm, and Kenko's, a generic brand made for several types of systems and compatible with autofocus, offer tubes of 12mm, 20mm, and 36mm. They can be used alone or in combination, depending on the amount of magnification you require. This procedure is objectionable to some photographers because you must modify the combination of extension tubes as you move closer or farther away from your subject. I don't mind the inconvenience because tubes have advantages: They're easy to pack on trips, as a set of tubes is no longer than a 100mm lens, and perhaps most importantly, they're less likely to be damaged than a bellows.

For some of my set-up work, either in the studio or when filming flying birds with a Shutterbeam, I use a Canon E0S 1N RS and a 70–200mm F2.8 lens. By combining either the 12mm or 25mm extension tube, the 500D two-element close-up lens, and a 1.4X or 2X teleconverter, I have a wide variety of options. Using the 500D, a 25mm extension tube, and the 2X teleconverter, I have almost a 1:1 ratio.

The larger, bulkier *bellows* offer a continuous range of extension throughout their length. Bellows resemble an accordion bellows, with pleated folds that expand and contract as the bellow unit is focused or as a degree of magnification is determined. Because the bellows are soft and pliable, a focusing rail is required to support the lens and camera. This rail adds to their weight and bulk, which you don't need when you're in the field, and you'll find that the leather or plastic bellows material can rip on thorns or sharp branches if you're not careful.

Both tubes and bellows merely conduct light; they don't have lenses. The prime lens, the lens that is attached to your camera body, is the lens that determines the image quality. The tubes or bellows, which are placed between the prime lens and the camera, enable you to focus more closely with that lens and, thus, increase magnification. You can determine the amount of magnification by using the formula:

$$\text{Magnification} = \frac{\text{length of extension}}{\text{length of prime lens}}$$

For example, a 25mm tube added to a 50mm prime lens yields 1:2 magnification. This is frequently called the *reproduction ratio*. Most macro lenses have some extension built in. Most 50mm macro lenses have 25mm of built-in extension, most 100mm lenses have 50mm, and some 200mm lenses have 100mm of built-in extension, providing 1:2 magnification in each case. This built-in extension must be considered when determining magnification. Adding a 25mm tube to the 25mm of built-in extension for a 50mm macro lens at minimum focus provides 50mm of total extension. Thus, 50/50 = 1:1, or life-size.

Reproduction ratios are inscribed on the lens barrel of macro lenses and some other lenses. Most begin at 1:10, or one-tenth life-size, and continue down to 1:4, 1:2, or 1:1, and you can assume that the required amount of extension is built in. If a 100mm macro lens focuses down to 1:2, assume it has 50mm of built-in extension. Adding an extra 50mm of tube will yield 1:1.

Adding extension reduces the amount of light reaching your film. The greater the amount of extension, the more light is lost. If you're using your camera's meter, no exposure compensation is required when taking a reading because the meter adjusts for the reduced light. However, if you're estimating your exposure or using an incident meter, you'll have to take the light reduction into account. A 50mm tube requires an increase in exposure of about one f-stop as the light reaching the lens is reduced. You must take this into account when you're estimating exposures or when you're using an incident-light meter or manual flash. With in-camera metering or TTL flash, this is done automatically.

It is wise to add only the minimum amount of extension necessary to obtain your required image size. Don't use a 50mm tube on a 100mm lens if you only need to extend the minimum focus by a very small amount. Adding too much extension can bring you closer than you need to be, and it will always cost more light.

Adding extension tubes to an 80–200mm zoom lens is an inexpensive and practical way to achieve macro capabilities at a broad range of working distances. By adding a 50mm tube, you'll have 1:2 magnification when the lens is set on 100mm at infinity focus, and nearly 1:1.5 at 80mm. However, with the lens set on 200mm, you'll have either 1:1.5 when the lens is

EXTENDING A TELEPHOTO LENS' FOCUSING RANGE

I regularly use a 300mm lens for small bird and reptile photography. By adding 25mm of extension, I change the focusing range of my lens from its original 9.5 feet–infinity to only 6.33–13.5 feet, which overlaps slightly with the lens' original minimum focusing range. Adding a 50mm tube limits the focusing range still further, from 5–8 feet, but with an exposure loss of almost two f-stops of light. However, at this final minimum focus, an object only 3.5 inches wide fills the frame.

focused at its minimum distance setting or approximately 1:4 magnification when the lens is set at infinity. With a 1:1.5 reproduction ratio, my 200mm lens has a working distance to the subject of approximately 17 inches. At 1:4, that distance increases to 34 inches.

Close-up diopters can be used in conjunction with extension tubes for even greater magnification. I find the 80–200mm zoom particularly convenient for this. With my 80–200mm zoom, a Canon 500D two-element close-up lens, and a 50mm extension tube, I obtain just slightly less than 1:1 when the lens is zoomed to 80mm, and about 1:1 at 200mm when the lens is focused at infinity. If I focus down to the minimum focusing distance, the reproduction ratio changes significantly. At this closer distance, the magnification is about 1.4:1, or greater than life-size, when the lens is zoomed to the 200mm setting. Thus, with this combination, by zooming from 80 to 200mm while maintaining the same distance setting on the focusing barrel (let's use 10 feet as an example), the image size increases, while the angle of view and the working distance decreases.

This zoom/tube/close-up-lens setup provides a great deal of flexibility when composing without having to move the tripod's legs. If I need less magnification, I can either remove the close-up lens for a modest reduction or turn the focusing barrel toward the infinity mark. If I need a significant decrease in magnification, I'll remove the extension tube from the zoom. Try this for yourself. Get a ruler, a zoom, and the various close-up accessories you normally use. I think you'll agree that the setup provides a great deal of compositional freedom and flexibility.

In fact, using close-up diopters and extension tubes is so convenient, you might question whether a macro lens is necessary. Perhaps not, if you rarely pursue macro subjects. But if you need the added sharpness and the convenience of continuous focus from infinity to close-up, using true macro lenses is a good idea. They're certainly required for my work.

ACRAEA MOTH, McClure, Pennsylvania. 100mm F2.8 macro lens, 1/250 sec. at f/16, TTL flash, Fujichrome 100
The macro image documents a moth extending its glands to emit pheromones to attract a mate.

LENSES ON LOCATION

Although I don't always succeed, I try to use every lens I carry whenever I'm on a trip. It forces me to look at my subjects from different viewpoints and perspectives. It's too easy to get lulled into using one favorite lens and to do all your shooting with it. By forcing myself to use all of my lenses, I obtain a variety of different looks. And, by doing so, it makes carrying the darn things worthwhile!

On a recent trip to the Falkland Islands I did exactly that, but it took a special effort as most of the birds were so tame and approachable that a long lens wasn't necessary. In two weeks I only used my heavy 600mm lens on three different days.

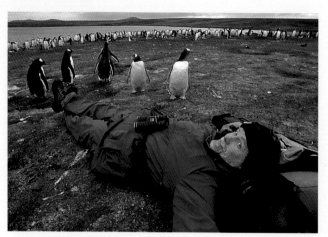

ME WITH GENTOO PENGUINS. 20–35mm F2.8 zoom lens, extension cable

With a short remote release, I recorded my friends and I visiting.

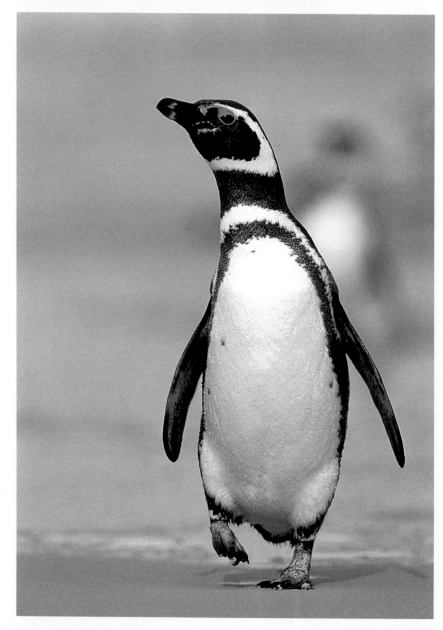

MAGELLENIC PENGUIN, Cow's Beach, Falkland Islands. 600mm F4 lens, 1/500 sec. at *f*/4.5, Fujichrome 100

My first location offered rather skittish penguins, and getting close was difficult. With a 12X 600mm, however, I obtained a pleasing image size at a comfortable working distance. Using autofocus, I captured a series of shots as this penguin trotted through the surf toward me.

GENTOO PENGUIN, Sea Lion Island, Falkland Islands. 20–35mm F2.8 zoom lens, 1/125 sec. at f/8, Fujichrome 100

Penguins are often incredibly curious and will approach anyone sitting or lying down near the nesting colony.

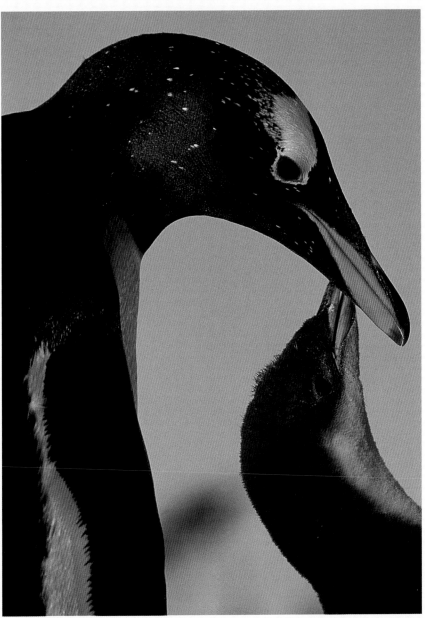

GENTOO PENGUIN AND CHICK, Sea Lion Island, Falkland Islands. 300mm F2.8 lens, 1/250 sec. at f/4.5, Fujichrome 100

Although this image looks to be pretty straightforward, it was actually difficult to make; the two heads moved everywhere, and getting both in focus was a real challenge. With these types of images, it is critical to get both subjects in sharp focus; if one isn't, the image usually fails.

ELECTRONIC FLASH

One of the most valuable, and barely used, accessories available to the wildlife photographer is the electronic flash. Many photographers are afraid of flash, and although they might own flash equipment, they rarely use it. Many are disappointed with their flash images and, consequently, avoid using flash. Fortunately, this doesn't have to be the case. When compared to the flash units of old, a modern electronic flash is very simple to use. In fact, most camera systems incorporate dedicated flashes in which the exposure is determined in-camera and *through-the-lens* (TTL), just as ambient-light readings are. Choosing a flash is as important as any decision you'll make when selecting gear.

CHOOSING A FLASH SYSTEM

Electronic-flash units can be divided into four types, based on how the exposure is determined. Two of these, *automatic* and *dedicated automatic,* are of little use to wildlife and nature photographers. Exposures made with either one can be inaccurate. The exposure sensors are located on the flash or in a special off-flash unit and might not correctly read the same quantity of light that actually reaches the film. In contrast, a flash unit incorporating TTL-flash metering has a sensor located within the camera body. This sensor reads the light that reaches the film. Depending on the camera make or model, these flash-exposure systems are referred to as either TTL or *off-the-film* (OTF). For the purpose of this text, they're sufficiently similar that both can be referred to as TTL. This metering system is extremely convenient, especially when you use telephoto or macro equipment. It does, however, have some limitations (see page 88).

There is also *manual* flash, where charts, dials, exposure formulas, or special flash meters enable you to determine the exposure. Despite the advantages of using TTL, you still have to use manual flash in certain situations where TTL flash can't be used. For example, if your subject is small, not centered, and against a non-middle-tone background, an incorrect exposure can result with TTL flash. Also, if there is a large reflective area, such as wet skin, water, or glass, the TTL sensor may prematurely shut off the flash.

I've already recommended that any new camera you consider buying should incorporate a TTL flash system. Fortunately, most TTL flashes can be used in a manual mode, too, so you really have the option to use either one as the conditions require.

In the field, I find a TTL flash very convenient to use. I can either mount the flash directly onto a hotshoe or use off-camera TTL flash cables to place the flash wherever I wish. Since the flashes have a manual mode, I also have that option when necessary. In the studio, or when multiple flash setups are required for a broader light coverage, I'll use the manual mode of my TTL flash units or my manual Sunpak units. All of these units have variable power ratios, enabling me to use very short flash durations when required.

MEASURING FLASH POWER IN TERMS OF GUIDE NUMBERS

Flash units vary in the intensity of their light output, which determines the aperture that can be used at a given distance. The intensity, or power, of a flash is indicated by a *guide number* (GN). The larger the GN, the more powerful the flash and, usually, the more heavy and bulky the flash unit.

AFRICAN BROWN TREEFROGS, Lake Nakuru, Kenya. 200mm F4 macro lens, 1/250 sec. at *f*/16, TTL flash, Kodachrome 64

In the field, TTL flash is usually the easiest option. A single flash mounted several inches above my 200mm lens kept the shadows below the upper treefrog and not directly behind it, as a hotshoe mounted flash may have.

**GABOON VIPER
(CAPTIVE)**, McClure,
Pennsylvania. 200mm
F4 macro lens, 1/250 sec.
at *f*/16, manual flash,
Fuji Velvia

*For this image, I used
a three-flash-head
studio system to create
the lighting effect I
desired. In a situation
like this, it is important
that not all the flashes
be mounted high, so
shadows aren't cast
beneath the snake's head
and jaws. I avoided
this by having one of
the three flashes close
to camera level.*

FILM SPEED IN RELATION TO GUIDE NUMBERS

Doubling an ISO doesn't double the GN, but it does double the power of the flash unit, and a smaller aperture can be used. If your flash is rated at GN 80 for ISO 100, the GN for other film speeds will be:

ISO	GN	f-STOP AT 5 FEET	f-STOP AT 10 FEET
400	160	32	16
200	110	22	11
100	80	16	8
50	56	11	5.6
25	40	8	4

When comparing flashes, keep in mind that guide numbers based on ISO 100 film are given. Although the GN changes as the ISO rating changes, it doesn't change by the same factor. Doubling the film speed doesn't double the GN, although it does increase it. A flash with a GN of 110 for ISO 100 has a GN of 160 at ISO 200, and a GN of 80 at ISO 50. Although this may seem confusing, there is an explanation. The guide number is based on a simple equation:

$$GN = f\text{-stop} \times \text{flash-to-subject distance}$$

In flash-exposure tests, film is exposed at a fixed distance—usually 10 feet—at various apertures. Multiplying the aperture chosen for the best exposure by the flash-to-subject distance gives the GN. Thus, if the ideal exposure is $f/11$ and the flash-to-subject distance is 10 feet, then the guide number is 110. Now, recall that you gain one stop of light when the ISO doubles. If you have $f/11$ at ISO 100, you'll need $f/16$ for ISO 200, because the aperture closes one f-stop with a film that is twice as sensitive to light. This aperture, $f/16$, multiplied by the flash-to-subject distance, 10 feet, yields the new guide number, 160. Following this reasoning, for ISO 50, the GN is 80 because $f/8$ is one stop less than the $f/11$ of ISO 100.

The GN changes if you use zoom flash heads. These special flash heads contain built-in Fresnel lenses that change the angle of light coverage emitted by the flash. Most zoom flash heads have an illumination range between 24mm and 85mm, and many adjust automatically to provide the proper coverage for the lens in use. Guide numbers are smaller at wide-angle settings because the light disperses to cover a larger area. With Nikon's SB26 flash unit, for example, the GN

ranges from 98 at the 24mm angle of coverage to 165 at 85mm. Similarly, the guide numbers for a Canon 430EZ range from 83 at 24mm to 145 at 85mm. Don't worry if you're using a lens longer than 85mm, because the longer lens' angle of view will fall within the coverage area produced by the 85mm zoom setting on your flash. If, however, you're using a lens smaller than the minimum zoom setting—for example a 20mm wide-angle lens—some vignetting or underexposure will appear around the edges because the light dispersed by the flash can't cover this larger angle of view.

The factory-set GN is determined in a controlled, indoor setting where a room's walls confine, and thus intensify, the flash's illumination. If a flash were to be tested for the GN outdoors, where you'll probably be using it, that number would be lower, often by a full f-stop. Additionally, the listed GN usually refers to the full-power setting. For flashes on manual mode, the GN changes as the power ratio is dialed down to a

The top picture shows the back of a flash unit on TTL mode. With ISO 100 and the flash head zoomed to its maximum 85mm setting, at f/22, TTL should work from less than 2 feet to around 8 feet. Of course, at 8 feet the flash will be emitting its maximum power, and a subject could be underexposed at its maximum range. The bottom picture shows the back of a flash unit on manual mode. At a full power setting of 1/1, a manual flash will only supply the correct exposure for an f/22 aperture (with the flash head zoomed to 24mm) when the flash-to-subject distance is approximately 4 feet. If the flash is zoomed to 85mm, that distance will change to approximately 7 feet. At an f/2.8 setting at 85mm, this distance would extend to approximately 60 feet, and at 24mm to 30 feet.

SPIDER WEB AND DEW,
McClure, Pennsylvania. 200mm
F4 macro lens, 1/60 sec. at *f*/5.6,
Fujichrome 100

SPIDER WEB AND DEW,
McClure, Pennsylvania. 200mm
F4 macro lens, 1/60 sec. at *f*/5.6,
manual flash, Fujichrome 100

Without flash (top), the tiny trapped mayfly is somewhat soft, but the colors and details of the meadow are visible within the dew drops. With flash (bottom), the background color disappears and the droplets take on an entirely different appearance. The mayfly is sharper, too. Both images are interesting.

lower power. With a Nikon SB26 flash unit having a GN of 164 at full power for ISO 100, the GN drops to only 21 when the flash is dialed down to its minimum 1/64 power setting. This is the factory rated GN. Outdoors, in actual use, the GN is often much lower! This very low GN requires the extremely short flash-to-subject distance of around 18 inches for use with an aperture of *f*/22. However, as you'll see in the next chapter, that distance can be increased by using an accessory teleflash or Fresnel lens. The benefit of these low power settings is in the flash duration. At full power, the flash duration on an SB26 flash is approximately 1/1000 sec., but at 1/64 power, it is 1/23000 sec. The latter is fast enough to stop the motion of almost any living thing.

If you're using TTL, it doesn't really matter whether or not you know the GN because exposures are automatically determined in-camera. But if you use your flash on manual mode and your GN seems inaccurate (as often happens outdoors), knowing how to determine the correct GN is critical. Here's how to find it: Do an exposure test outdoors using a middle-tone subject that is 10 feet from your flash. Bracket exposures both above and below the suggested aperture and record the frame number for each exposure. Use slide film, because a poorly exposed negative can still yield a reasonable print, depending on the developing. After processing the slide film, pick the best exposure and multiply the *f*-stop used for that slide by 10. If *f*/5.6 happens to be the best exposure, your new GN is 56 (*f*/5.6 × 10 feet).

How powerful a flash do you require? You'll need a flash with a high GN if you plan to use your flash outdoors for bird or mammal photography. Most high GN flashes mount off-camera on a special bracket. These powerful flashes are usually bigger and heavier than hotshoe flashes; this may be a consideration when traveling or hiking. Low GN flashes usually mount via a camera hotshoe. These units are smaller, more convenient to use, and easier to pack. A low GN unit is all you'll need for macro flash techniques.

If you're planning to do high-speed flash work, don't assume that all low GN flash units have a very short flash duration. They might not. If you need an extremely fast flash, use a unit that has a power-ratio setting on its manual mode. These flash units have large capacitors and flash tubes. They also have low guide numbers due to the short flash durations, not because of small flash tubes that are incapable of producing large quantities of light.

APERTURES AND FLASH

The flash unit's GN and the flash-to-subject distance determine exposure. With TTL, you must be within a specific working distance for the aperture in use, for although the exposure is determined automatically, it is based on the same principle. The closer you are to a subject, the smaller the aperture you can use. Determine exposure by the following formula:

f-stop = GN/flash-to-subject distance

You can change the apertures by varying the flash-to-subject distance. If the flash is too far away, the required aperture may be larger than your lens' maximum stop. If the flash is too close, the required f-stop may be smaller than the minimum aperture. As I just mentioned, your TTL flash must be within a specific distance range for the TTL metering system to emit the proper amount of light. If the flash is too far away for the aperture in use, the TTL flash may signal that the distance is too far or that the flash had dumped all of its energy in attempting to light the scene. Depending on the system, this may involve the flash ready light blinking, or a lightning signal blinking inside the camera's viewfinder, or, if you're using off-camera cables with some cameras, no warning at all.

For example, let's look at Nikon's SB26 flash unit set for an 85mm coverage. With TTL, the usable working distances change as the aperture changes, shortening as the f-stop becomes smaller. At ISO 100 and $f/2.8$, TTL works within a range of 6 to 60 feet at the 85mm flash setting, and at $f/16$, TTL works only between 2 feet and approximately 12 feet. At the maximum range for each aperture setting—60 feet at $f/2.8$ and 12 feet at $f/16$—TTL fires at full power. At these distances, the

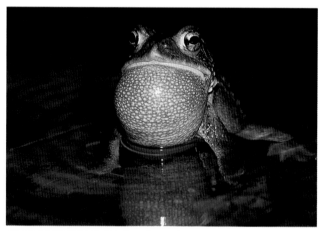

AMERICAN TOAD, McClure, Pennsylvania. 100mm F2.8 macro lens, 1/125 sec. at $f/16$, TTL flash, Kodachrome 64

At close working distances, TTL flash recycles quickly. These two images were made within seconds of each other. With TTL, I am free to concentrate on focusing and composition, and provided I am within the working distance of the aperture in use, I can photograph without worry.

flash uses most of the energy that is available, and a few seconds must elapse while the flash *recharges,* or *recycles.* When a flash fires, it discharges, to some degree, the energy stored in its capacitors. The flash then requires time to recycle before it can fire again. With TTL flashes, larger apertures or shorter flash-to-subject distances lessen the recycling time.

At the minimum working distances presented in our example of 6 feet for $f/2.8$ and 2 feet (it's actually less) for $f/16$, very little energy is consumed. The flash recycles quickly, perhaps even fast enough to be used with a motordrive. With a manual flash, the recycling time is based on the power setting. Some flashes offer a high and low setting; others dial down to a fraction of their full power. A flash recycles faster at less than full power. At 1/32 power, recycling may be nearly instantaneous. Also, recycling times can be reduced by your choice of batteries and are shortest with gel batteries, such as the Quantum Turbos, or with dry cells.

In contrast to the TTL system, where an *f*-stop can be used within a fairly broad distance range, the manual mode requires a given aperture for a specific distance. A manual flash emits a fixed quantity of light that isn't based on distance or subject reflectivity. With the SB26 flash unit set for full power at an 85mm setting with ISO 100 the flash-to-subject distance is approximately 10 feet for *f*/16 and 60 feet for *f*/2.8. In manual mode, an *f*/2.8 aperture can't be used at 10 feet or at 20 feet, just as an *f*/16 aperture cannot be used at 20 feet or 60 feet. The distances are fixed for the aperture in use, and at the wrong flash-to-subject distances would result in incorrect exposures.

Here's one more example. An aperture of *f*/8 requires a flash-to-subject distance of 20 feet. At distances closer than that, too much light would hit the subject and an overexposure would result. At distances greater than 20 feet, less light would reach the subject and an underexposure would result.

SHUTTER SPEEDS AND FLASH

In flash photography, the aperture determines the flash exposure. The shutter speed doesn't affect the flash exposure, although the choice of shutter speed could affect the ambient-light exposure. Proper flash exposure requires only that the shutter is open long enough for the flash to fire. This synchronization, or sync speed, varies with the camera, ranging from as fast as 1/250 sec. to as slow as 1/60 sec. in older cameras. Most cameras have sync speeds of 1/125 sec. or 1/250 sec., although any speed slower than this can be used, including the "B" or Bulb setting on some cameras. Depending on your system, however, certain exposure modes may limit your choice of shutter speeds to a particular range. For example, on Aperture priority or on Programmed Auto, the Nikon F5 can only be used between shutter speeds of 1/60 sec. and 1/250 sec. On Shutter Priority or on Manual mode, any shutter speed from 1/250 sec. to "B" can be used. It is important to remember that although cameras are limited to the fastest sync speed, you aren't restricted to that setting. You may find a slower sync speed quite useful in certain situations.

Choosing the proper sync speed can be important in wildlife and nature photography. If you use a sync speed that is too slow for the ambient light, you could overexpose the background, the subject, or both. A sync speed that is too fast will underexpose the background, although the flash exposure of the subject may be perfect. (Many flash photographs have this nighttime appearance where the background is black.)

You might, however, want to have both the subject and the background properly exposed or within one stop of each other. There are a couple of ways to do this. With many electronic cameras employing TTL,

built-in flash programs sense brightness levels. The sensor automatically reduces the flash exposure to be less than or equal to the ambient-light exposure. Still, be sure to choose an aperture within the TTL range of your flash unit and a sync speed that can also properly expose for the ambient light.

This is an important point, because you may start with a shutter speed that is faster than your camera's flash synchronization speed. When you turn your TTL flash on, many cameras automatically default to the fastest flash synch speed. If, for example, you were originally at 1/1000 sec. at *f*/5.6 and decided to use some TTL fill

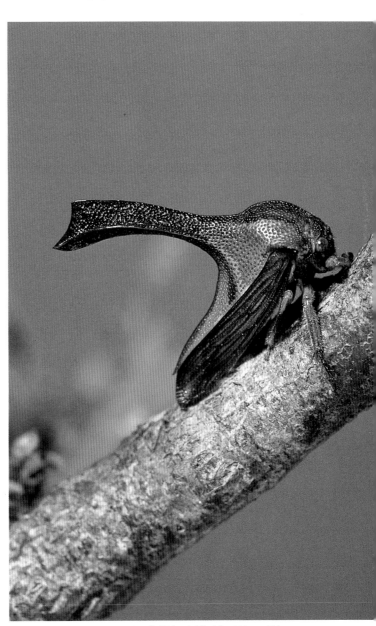

LOCUST TREEHOPPER, Sanibel Island, Florida. 200mm F4 macro lens, 1/125 sec. at *f*/16, TTL flash, Kodachrome 64

To avoid a black background, I placed a gray card behind this treehopper. By holding the flash several inches above the lens, the shadows cast by the flash fell outside of the picture frame. I placed a reflector below the branch to bounce some of the flash's light back and fill in the shadows that the high flash created.

flash, when you turn on the flash, your shutter speed may change to 1/250 sec. Now, depending on whether you're on an automatic mode or manual, you may or may not obtain a correct exposure. On an automatic mode—be it programmed, aperture-priority, or shutter-priority—the aperture may automatically adjust to the correct setting to compensate for the slower shutter speed. On manual it will not, and unless you change the aperture, you'll be overexposing the ambient light image by two stops! Conversely, if you do stop down, the smaller aperture may now be outside the TTL range for that *f*-stop. As a general rule, if I'm thinking of using flash, I'll take my meter reading at one of the flash synch speeds; then I can determine whether flash can, or should, be used.

Remember that the combination of shutter speed and aperture determines the ambient exposure, while the aperture alone determines the flash exposure. Let's say you choose a flash exposure of *f*/16 for a subject in deep shade, where the ambient exposure is 1/60 sec. at *f*/4. Normal sync speeds between 1/60 sec. and 1/250 sec. are too fast for the ambient exposure and will underexpose the background, if the exposure is based upon a flash set for an aperture of *f*/16. However, since a flash can sync below its maximum speed, down to 30 seconds (depending upon the exposure mode you're in), a slower shutter speed can be used. In this example, 1/4 sec. balances the flash exposure with the ambient light exposure at an *f*/16 aperture. Should you use 1/8 sec., the ambient light would be underexposed by one stop, and the flash image, correctly exposed by the *f*/16 aperture with TTL flash, would stand out from the background.

Use faster sync speeds when you need to balance flash light with bright, ambient light, especially if you're photographing moving subjects. Slow shutter speeds allow bright ambient light to record images on film, even as brief bursts of flash light "freeze" most motion. If you use a slow shutter speed and the subject moves, the ambient light image will blur or streak. Two images will be recorded: a sharp image that was made by flash, as well as a fuzzy image that was recorded by the ambient light. In these situations, the background frequently appears through the subject. Appropriately enough, this is called a *ghost image,* and the effect is known as *ghosting.* Ghosting can be minimized by combining a fast sync speed with a small aperture. The brighter the ambient light, the faster the shutter speed and/or the smaller the aperture you'll need. For example, if the background exposure is *f*/11 at 1/60 sec., a flash exposure of *f*/11 would balance with the ambient-light background. Remember, the flash exposure is constant, and any shutter speed within the sync range can be used. If, however, your camera syncs at 1/250 sec. and you use that speed, you would underexpose the background by two stops.

Conversely, if you wish to avoid underexposing the background, you have to use a sync speed of 1/60 sec.

Ghosting is particularly troublesome with day-active, fast-moving subjects. Photographing hummingbirds illustrates this perfectly. These birds move so quickly that a fast sync speed of even 1/250 sec. won't stop their movement in bright ambient light, thus causing a ghost of the bird to appear on film. How do you eliminate this ghost image and still maintain a bright, natural-looking background? Photographing the hummingbird when it is in shade—rather than in full sunlight—while keeping the bright background visible, might work, but there's still a good chance that the shadowed silhouette of the bird will appear as a ghost. Although it is normally difficult or impossible to control the ambient light that strikes a bird, that isn't the case with hummingbirds; if a hummingbird visits a sugar feeder, you could move the feeder into the shade. Then, by using the fastest possible flash sync speed, and balancing the flash exposure with that required for the bright background, you should minimize, or even eliminate, ghosting. At a fast flash synch speed there may be minimal movement recorded against the bright background.

A better solution is to place the feeder in the shade and use a background—either real or artificial—that's in the same light. You can then illuminate both the bird and the background with the same light, as I'll discuss at the end of the next chapter.

Sometimes ghosting occurs despite your every effort. This might not be unattractive if the blur leads toward the subject, as if the moving object were streaking across the frame. You can achieve this effect if your flash has *rear,* or *second-curtain,* sync to trigger the flash just before the shutter closes. Unfortunately, most flashes fire just after the shutter opens, which results in streaks that lead from, rather than to, the "frozen" flash image. This can also be minimized if you pan with your moving subject. Although panning hummingbirds isn't very feasible, panning could work with flying ducks or gulls, or other animals that move in a fairly predictable direction at speeds you can realistically follow.

FLASH, FILL, OR SYNC DAYLIGHT?

The effect you achieve with flash depends on the amount of ambient light. If the ambient light is low, you'll probably base your exposure on the flash exposure. However, if the ambient light is bright, you have a few options, depending on whether you're using TTL or manual flash. First, let's consider TTL flash. You can base your exposure solely on the flash exposure; a very short flash-to-subject distance might be necessary to employ a small enough aperture to overcome the brightness of the ambient light. Alternatively, you can balance the flash and the ambient light so that both

require the same exposure. Using this approach, you would have to determine the ambient exposure first. This effect is frequently called *sync daylight,* and although it adds "snap" to images, it doesn't always look natural.

You could also base your exposure on the ambient light and use the flash's illumination only to fill in shadows or contrast created by the natural light. Some TTL systems take bright ambient light into account as an exposure is made and will automatically reduce the flash exposure to compensate. Although this usually looks good, you may not want that effect. Alternatively, you could dial-in a minus compensation on your flash to accomplish the same thing. I generally do so, often using a -1.7 setting for a reduced flash fill. This fill-flash technique often produces very natural-looking images because it reduces the contrast recorded by film to a lighting ratio that more closely resembles how the human eye perceives contrast. How much fill you use is subjective, although

most photographers prefer using one or two stops less light than is needed for an ambient exposure.

Imagine a barred owl sitting in the shade of a tree, where the surrounding foliage and the background are in sun and the exposure is 1/60 sec. at *f*/16. The owl, in shade, is darker and requires a longer exposure. If you want your TTL flash exposure to be greater than the ambient exposure, you must position the flash close enough to the bird so that an *f*/22 quantity of flash illumination strikes the owl. By setting your lens at *f*/22 and maintaining the same 1/60 sec. shutter speed, the owl would be exposed correctly but be one stop brighter than the background. You could achieve the same result by keeping the aperture at *f*/16 but using a shutter speed of 1/125 sec. Getting the correct exposure is just as easy if you want the owl and the background to have the same exposure. Simply set the aperture to *f*/16; the TTL flash will automatically produce the

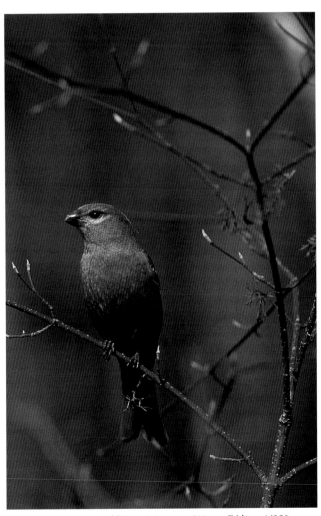

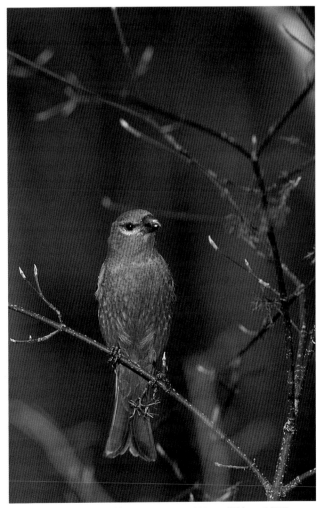

PINE GROSBEAK, Wild Eyes, Montana. 500mm F4 lens, 1/250 sec. at *f*/4.5, Fujichrome 100

This image and the one at right were made within seconds of each other. This one was made without flash, and the lower half of the bird lies in shade.

PINE GROSBEAK, Wild Eyes, Montana. 500mm F4 lens, 1/250 sec. at *f*/4.5. TTL teleflash at -1.0, Fujichrome 100

Using flash, the previously dark areas are filled in with visible detail, and the entire scene looks a little brighter due to the brightened red twigs, as well. Note that the flash casts a telltale shadow off the bird's perch, visible as a dark line directly below the twig. Which image is the best? It is up to the viewer to decide.

required quantity of light if the flash is within the distance range for the aperture you're using.

If you want to keep the background's ambient exposure brighter than the flash exposure of the owl, as you might if using a fill-flash technique, you would have to set your exposure based on the ambient-light reading. After setting your exposure based on that reading, use your flash's exposure compensation dial and "dial-in" either a -1 or -2 setting, depending on the effect you wish to achieve. Doing so, the flash will emit less illumination than is required for the *f*-stop you're using for the ambient light. Using the -1 setting, the owl would be underexposed by flash by one stop. With -2, it would be by two stops.

With manual units, the ratio of flash to daylight depends on the flash-to-subject distance and the flash's GN. The results are the same as they were for TTL, but you have to be exact about where you place the flash, in contrast to working with TTL, where you only need to be within the flash range for a particular aperture. Use a

DESERT IGUANA, Anzo Barego State Park, California. 200mm F4 macro lens, 1/250 sec. at *f*/11, TTL flash at -1.0, Fujichrome 100

Fill flash definitely improved this image. The sun was high and a little behind the iguana, whose front and belly were in deep shade. The flash filled in these shadows, provided an eye highlight, and added a bit of animation to the portrait.

variation of the GN formula to determine exactly how close or far back the flash must be. Earlier, the formula **GN = f-stop × flash-to-subject distance** was changed when you had to find a required *f*-stop for a given GN. You used the formula:

f-stop = GN/flash-to-subject distance

Switch the formula around a final time to:

flash-to-subject distance = GN/*f*-stop

Using this formula, you can find the distance required for any given aperture. If your flash has a GN of 160 for your ISO film and you want the background to balance with the flash exposure, position the flash unit 10 feet from the owl (160/*f*/16 = 10 feet). If you want the owl to be brighter by one *f*-stop, position the flash just about 7 feet from the bird (160/*f*/22 = approximately 7 feet). If you want a brighter background, position the flash farther back, to about 14 feet (160/*f*/11 = 14.5 feet).

Although this technique sounds complicated, especially when compared to TTL flash, it is sometimes necessary. I urge you to review this material and to learn it. Fortunately, TTL is available for many of your flash needs. If understood and used properly, the simpler TTL flash system will give you satisfactory results most of the time.

BALANCING FLASH WITH AMBIENT LIGHT

Understanding the relationships between ambient and flash exposures is critical for natural-looking flash exposures. Suppose you discover a morel mushroom in the deep shade of an orchard. The portrait you desire requires great depth of field, but the ambient exposure around the morel is only 1/15 sec. at *f*/4. Your camera's highest sync speed is 1/250 sec., but you probably won't use that fast a shutter speed if you hope to balance the flash exposure with the existing light. For a mushroom, you'll probably want great depth of field and to do so you'll need a small aperture. You choose *f*/16. An ambient exposure determined by an *f*/16 aperture requires a shutter speed of one second. Flash positioning is similar for both TTL and manual units. If you use a manual unit, determine the distance by dividing the GN by *f*/16. If you use TTL, check to be sure that the flash is within the distance range available for that aperture. With either flash system, be sure to use a shutter speed of one second when you fire the flash.

USING A TTL FLASH

Remember that you must be within the distance range provided by a specific aperture for TTL to be effective. There are some other considerations. You must ensure that the flash's illumination strikes your subject. For example, in macro photography, where working distances

LEAF-MIMIC KATYDID,
Amazon Basin, Ecuador. 200mm
F4 macro lens, 1/250 sec. at ƒ/22,
TTL flash, Fujichrome 100
*Working conditions can be
tough in the jungle and a TTL
flash made my life much easier.
TTL flash might be fooled
by a thin subject framed against
a distant black background;
however, because the subject
occupies so much of the frame,
I was confident that the TTL
would read only the subject, not
the background, and produce
the correct exposure.*

are short, a hotshoe-mounted flash could unavoidably be aimed over, and not at, a subject. You can correct this by directing the flash's illumination downward with a *bounce card,* either a white index card taped above the flash head or a special flash diffuser (available, for example, from Lumiquest). Both kinds of bounce cards work well. If you have off-camera cords, just take the flash off the hotshoe and either hold the flash or mount it onto a special macro bracket for correct positioning.

You can also misaim a teleflash. To check, test-fire the flash while you're looking through the viewfinder. You should be able to see if the flash strikes your subject. Don't fire the test button with the flash set on TTL. Though this will work, the flash will dump all of its energy, emitting the maximum amount of light because the TTL sensor isn't activated. Several seconds will elapse while the flash recycles, and in the meantime, your subject may move off. Instead, switch your flash to the

Manual mode, and dial in a low power setting; I'll usually start at 1/8 power. At a low power setting, the flash doesn't use up much energy, and I'm free to reposition the flash, if necessary. Of course, after I determine that I'm correctly aimed I must switch the flash back to TTL mode.

If you don't test-fire, the underexposure indicator on your camera should warn you that the flash is missing the subject. If it is, the flash probably dumped all of its energy in trying! As a matter of course, get in the habit of test-firing on a low-power manual setting to aim your flash.

Incorrect flash exposures also occur if your subject doesn't occupy or sufficiently fill the *flash-sensing*, or *metering*, area. In that case, the TTL may expose for the background, not for the subject. You might have to change the composition by shifting the subject to the central metering area, by moving in closer, or by using a longer lens to ensure coverage of the metering area. Some systems, such as Nikon's D lens technology, are supposed to take distance into account. In theory at least, an off-center subject at a specific distance should be correctly exposed if shot with a D lens. TTL, like any other metering system, is based on middle tones. If your subject isn't a middle tone, incorrect exposures will result as the flash tries to expend less light for white or light subjects and more light for black or dark subjects.

TTL often underexposes white subjects because the greater reflectivity of white prematurely shuts off the flash. Some systems treat whites quite accurately, so you'll have to test your flash to determine if that's so. If the exposures are too dark, use the flash's exposure compensation dial and dial-in to +1.

Conversely, TTL systems overexpose black subjects by emitting too much light. Again, use your flash's exposure dial and dial-in a -1 or lower compensation. I regularly use -2 for blacks, but I'd suggest you experiment to determine what works for you.

MANUAL FLASH AND NON-MIDDLE TONES

Compensating for non-middle-tone subjects is easy with manual flash if you keep in mind the basic exposure principles used for natural light. First, you must determine a base flash exposure. Use the GN formula, or read a flash chart or the dial on the flash head (if your flash has one). You could also use an incident-light flash meter. Then just close down one f-stop for white subjects and open up one f-stop for black subjects. This method is similar to using the sunny rules, where the basic exposure was sunny $f/16$. You used $f/22$ for white, closing down one stop, and

$f/11$ for black, opening up one stop. Of course, when you use a flash, your apertures won't be $f/11$ or $f/22$, unless your base flash exposure happens to be $f/16$.

If you're using a reflected-light flash meter, the process is the opposite. Like your camera's meter, these meters base their exposure readings on middle tones. After obtaining a reading with a reflected-light flash meter, overexpose white subjects by one f-stop and underexpose black subjects by the same amount. This is probably an esoteric point as few people use reflected-light flash meters for nature photography; those who do probably already know this.

When over- or underexposing the flash reading, keep in mind that you must do this with the aperture. Changing the shutter speed may affect the background exposure, but it won't influence the flash exposure of the subject.

For example, a subject that is properly exposed at $f/8$ at 1/125 sec. with flash is also properly exposed at $f/8$ at 1/250 sec. This, of course, assumes that the ambient or existing light is not playing a role in the exposure. But in daylight, changing the shutter speed will affect the result. If your subject is in shade, framed by a bright background, a fast flash sync speed could be used to "tone down" or underexpose the background. Progressively slower shutter speeds would brighten the background until, at some point, the background could be overexposed. Of course, brighter backgrounds increase the chance that a ghost image will register if your subject moves.

MANUAL OR TTL FLASH?

For all its advantages, there are times when using TTL flash doesn't work very well. Admittedly, those times are few, but as you already know, a TTL flash sensor can be fooled. Manual exposures are based on flash-to-subject distances and aren't affected by composition or background. I use manual flash with highly reflective subjects, such as frogs, salamanders, and wet vegetation. TTL may underexpose these subjects if too much light bounces directly back to the meter and shuts off the flash prematurely.

Although you can use TTL or manual flash in multiple-flash setups, manual flash is less expensive to use. Multiple-flash units are useful in many types of nature photography. In the field, plants, fungi, bird nests, bird feeders, mammal dens, and reptiles look best when illuminated by two or more flashes. In studio wildlife setups, multiple flash is necessary to produce natural-looking lighting ratios. With manual flash, changing the flash-to-subject distance or the power ratio changes the usable f-stop for each flash.

CALCULATING EXPOSURES WITH TTL AND MANUAL FLASH

Procedures differ when dealing with black, white, and middle-tone subjects. Consider the following recommendations for flash exposures with TTL or manual flash.

	TTL	MANUAL
Middle tones	Trust your camera.	use the guide number formula, flash meter, or flash exposure chart.
White tones	Two methods: 1. Decrease the ISO by two-thirds. 2. Set +1 or +2/3 on exposure compensation dial on most flash units or cameras.	After using any of the above methods, close down by 1 or 1.5 f-stops.
Black tones	Two methods: 1. Increase the ISO by one-half. 2. Set -1 or -3/4 to either the flash or the camera's compensation dial.	Same as above, but open up by one f-stop.

DAMSELFLIES (CAPTIVE), McClure, Pennsylvania. 200mm F4 macro lens, 1/250 sec. at f/16, manual flash, Fuji Velvia

I used two flashes for this image, positioning one flash behind the damselflies for backlighting and the other in front, aimed directly at the damselflies. The background, barely illuminated by the front flash, is nearly black.

DAMSELFLIES (CAPTIVE), McClure, Pennsylvania. 200mm F4 macro lens, 1/250 sec. at f/16, manual flash, Fuji Velvia

For this shot I used three lights. I kept the original lighting setup used at left but added a third light, which I aimed onto the background. I took flash-meter readings at the damselflies' position and at the background to determine the desired lighting ratio.

ADVANCED FLASH TECHNIQUES

I rarely travel afield without at least one flash unit packed in my gadget bag. Along with the flash, I'll have a TTL off-camera cable and a small teleflash system. Flash, I've found, can make the difference between a snapshot and a great photograph, sometimes just by adding a subtle eye-highlight and, more often, by reducing obnoxious contrast created by harsh natural light. Making great flash photographs isn't difficult once you understand the basic relationship between flash and ambient exposures, and in the last chapter I covered this relationship at length. You also must know your flash's limitations—a flash can't perform miracles like lighting up a football field from the last row of the stadium. In order to make effective flash photographs, you need to fine-tune your techniques as you apply basic flash to your wildlife and nature work.

OFF-CAMERA FLASH

Most TTL flash units mount on the camera's hotshoe. Although this is convenient, it can produce unattractive shadows behind or below your subject. Removing the flash unit from the hotshoe reduces or eliminates this problem. For example, in macro photography a hotshoe flash can create twelve-legged insects if each leg casts a separate shadow. *Off-camera flash* eliminates or at least reduces these harsh shadows because you can hold the flash unit close to the insect. Up close, the flash face covers so much area relative to the size of the subject

that it becomes a *diffused light source* (just as sunlight is diffused and scattered by cloud cover) instead of a *point source* like the sun appears on a clear day.

TTL flash requires using special off-camera cables and occasionally adapters as well, which are expensive. For some work, as you'll soon see, TTL isn't necessary, and almost any flash can be hardwired to a camera for far less money. You'll need generic hotshoe or PC adapters, sometimes for both the flash and for the camera, and perhaps a power cord (PC) to connect the two. A power cord and a PC or hotshoe adapter are generally far less expensive than a TTL cable, and can usually be used with any generic flash.

There are other advantages to using off-camera flash units. The aperture depends on your flash-to-subject distance, so by taking the flash off-camera you can position the flash close enough to have a small *f*-stop and a short flash duration maintaining a specific camera-to-subject distance. This is extremely useful at bird feeders or nests. A blind can be positioned some distance back while you enjoy the depth of field or the action-stopping speed a short flash-to-subject distance provides. Off-camera flash also simplifies using diffusion techniques. By providing space between the flash and camera, it lessens the chance that a homemade plastic diffusion screen will jut in front of the lens. It also gives you more freedom to position the flash for bounce-flash techniques.

This simple teleflash, manufactured by Visual Echoes, will increase a flash's output by at least 2.5 stops. When not in use, it folds easily into a shirt pocket.

SIDE-STRIPED JACKAL, Duba Plains, Botswana. 300mm F2.8 lens, 1/250 sec. at *f*/5.6, TTL teleflash, Fujichrome 100

Full flash casts shadows, and if a teleflash is mounted directly above a lens, there's nothing you can do to remedy this problem. Captured in the beam of a hand-held floodlight, I was just happy I could see these jackals well enough to focus.

ELF OWL, Madera Canyon, Arizona. 500mm F4 lens, 1/125 sec. at *f*/5.6, TTL teleflash, Fuji Velvia

Because of the very narrow shooting window, I had to mount my flash directly above the lens. This isn't the best idea when the owl is some distance from the camera, because there is a good chance you'll record red-eye. Had the owl looked away, instead of toward the camera, red-eye would have been reduced.

A hotshoe-flash unit increases the chance of *red-eye,* that unnatural-looking eye shine that appears in portraits of many animals. Red-eye describes the weird gold, green, or red produced when light reflects toward the camera off the *tapetum* (a layer of cells lining the retina). If you remove the flash from the hotshoe, you increase the angle between flash and camera lens and reduce or eliminate red-eye. This isn't always easy because the farther an animal is from the camera, the greater the flash-to-camera angle you need. For example, an owl perched 30 feet away may require 2 feet between the flash and camera to eliminate red-eye. At 60 feet, a separation of 5 feet between flash and camera may be necessary. It is difficult to eliminate red-eye when photographing large mammals with telephotos. The usual long working distance required to have a deer or moose full-frame demands an impractical gap between the camera and flash, unless you have an assistant who can hold the flash some distance away and aim it properly.

Although unnatural eye shine is more common with nocturnal animals, it may occur also with diurnal birds or animals. However, red-eye isn't noticeable with day-active animals, unless the day is dull or overcast, because the pupil contracts in bright light. On rainy days or at dusk, I have had eye shine with bald eagles, ospreys, and gray squirrels. At night, red-eye is especially noticeable with deer, owls, rabbits, raccoons, alligators, all cat species, and frogs. Day or night, the farther the flash unit is held off-camera, the less chance that eye shine will appear.

There are a couple of ways to support an off-camera flash. The easiest way is to use an adapter that attaches to the flash and to the tripod socket in the camera. Special macro-flash brackets that work with small flash units are available from Really Right Stuff and from Saunders.

I prefer the Really Right Stuff flash arms that are attached to all my lenses above 200mm in focal length. Larger, handle-mount flash units require a sturdier support. I've used lightweight studio light stands and tripods, but my favorite is the Bogen Magic Arm. Just as it can be used to brace a camera, the Magic Arm, when clamped to a tripod leg, can be used to position a fairly heavy flash.

DIFFUSION AND BOUNCE FLASH

One unattractive feature of flash photography is the harsh light it produces. You can soften, or diffuse, this light in many ways: You can fire the flash through a handkerchief, a white cloth, a plastic frosted panel, or through a commercial diffuser. There is some light loss, but the basic TTL exposure isn't affected. Compensation is required for manual flash. Use a flash meter, run a test roll first, or bracket to ensure a proper exposure.

Bouncing the flash scatters and diffuses the light. Use a white index card, the white side of a gray card, or a product such as Lumiquest's pocket bouncer. Again, there is some light loss, but this doesn't affect the TTL exposure. Use a flash meter to determine manual exposures accurately. If you use the GN formula, measure the total flash-to-subject distance, which includes the flash-to-reflector and reflector-to-subject distances. Working with bounce flash, you may lose a stop of light through absorption. Only by using a flash meter, bracketing, or previous testing can you determine how much light loss you'll really have.

FLASH AND TELEPHOTO LENSES

Few flash units offer a sufficiently high GN to be used at the distances often required with telephoto lenses. For example, at ISO 100 with a GN 160 flash, you can use a 300mm F2.8 lens only within 60 feet. Special flash heads or accessory Fresnel screens, which diffract light in such a way that the light is concentrated into a smaller area, can be added to some flash units to increase the GN and the usable flash-to-subject distance. Although there are a number of teleflash systems available, my favorite is one produced by Visual Echoes. This unit is completely collapsible and can fit into a shirt pocket when not in use. The Fresnel lens increases the GN of my hotshoe flash by a factor of 2 or 2.5. With it I can use my 300mm F2.8 flash to nearly 150 feet!

Teleflash can increase the chance of recording red-eye shine because it lets you use the flash at longer distances. To eliminate red-eye, you must use the teleflash off camera, just as with a regular flash system, but you must put an even greater distance between the camera and flash.

Teleflash isn't just for low-light photography; it is very useful at any time of day. For example, at high noon, the contrasty shadows found on the lower half of a bird or mammal can be filled in with teleflash. I frequently use my teleflash for fill light, especially when there is a great amount of contrast. Despite some opinions to the contrary, daylight fill flash doesn't upset most animals. Most completely ignore the brief burst of light.

I use TTL mode when using a teleflash because a manual flash requires measuring the flash-to-subject distance and dividing that distance into the GN. This process is too time-consuming to be practical in the field, especially when a subject is active and is constantly changing positions.

When making a TTL fill-flash exposure with telephoto lenses, remember to take an ambient reading off the brightest area of your subject. You'll probably want to use your fastest sync speed if you're photographing wildlife. Set your flash exposure based on the ambient-light reading for this shutter speed.

SNOWY EGRET, Everglades National Park, Florida. 500mm F4 lens, 1/250 sec. at ƒ/5.6, TTL teleflash at -1, Fujichrome 100

A teleflash filled in the shadows on this backlit snowy egret, giving the bird a whole different look than the natural light exposure at right. By dialing down, I preserved some of the rim lighting.

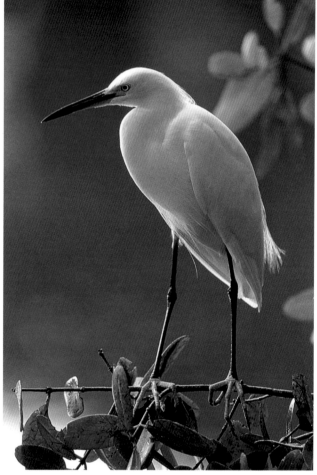

SNOWY EGRET, Everglades National Park, Florida. 500mm F4 lens, 1/250 sec. at ƒ/5.6, Fujichrome 100

Without flash, the rim lighting is more evident, and the image has a more somber, subtle mood.

isn't always very practical. You can, instead, balance the small aperture of the flash with the ambient exposure by changing the shutter speed. If your subject is moving you must be careful that ghosting doesn't occur when a slow shutter speed is used. Finally, you can illuminate the background with a second flash to decrease the contrast.

WORKING WITH MULTIPLE FLASH UNITS

Even with the best techniques, a single flash source may produce unavoidable contrast or flat, uninteresting lighting. Understanding the relationship between flash-to-subject distances and aperture makes it easier to use two or more flash units together. Multiple flash units can reduce the contrast between subject and background and cancel out or reduce the shadows each flash produces. I find multiple-flash setups especially useful at bird feeders, nests, or dens; in some camera "traps"; and in studio setups. You can position two or more flash units to create a very natural-looking lighting effect where and when the ambient light levels are too low for slow-speed films.

By using a couple of flash units, I can recreate the effects of natural light, for example, by producing rim-lighting or by filling in the sharp shadows a single flash can cast. Multiple-flash TTL exposures are easy, although expensive off-camera connecting cables are required to connect each flash unit. You can have different lighting ratios for the subject and background if you use bounce flash—aiming the flash at a reflector and having the light bounce from the reflector on to the background, or at a diffuser, to reduce the quantity of light that reaches the background. You could also, when using two flashes, set your main flash at 85mm and your fill flash at 24mm. The flash set to 24mm will have a lower GN and emit a less powerful light.

Manual flash exposures are the most practical to use for multiple-flash techniques. If you use a manual unit, you can easily adjust the flash distances to provide different lighting ratios for your subject and background. The *key light,* or *key flash,* is the principle light source and is usually the light used to determine your *f*-stop.

Above: **HAIRY WOODPECKER,** McClure, Pennsylvania. 300mm F2.8 lens, 1/250 sec. at *f*/11, TTL at -1.0, Fujichrome 100

Right: **DOWNY WOODPECKER,** McClure, Pennsylvania. 200mm F4 macro lens, 1/250 sec. at *f*/22, manual flashes, Fujichrome 100

From a blind outside my office, I sat in wait of the hairy woodpecker (left) visiting our suet feeder tree. One flash was positioned close to the bird as fill flash.
Trying for a different look (right), I placed a large background several feet behind the scene to block out the distracting trees, and positioned two flashes: one aimed at the bird, and another placed much closer, providing the rim lighting.

Fill flashes either fill the shadows created by the key light or illuminate the background.

When you work with manual-flash units sharing the same GN, your subject will always be brighter than the background if you make sure that the flash that illuminates the background is at a greater distance from it than the flash unit that illuminates the subject. For example, if the flash-to-subject distance is three feet, you must position the flash that illuminates the background at a distance greater than three feet. You can determine the exact lighting ratio by using the GN formula or a flash meter.

You can also use the Inverse Square Law to determine flash exposures and ratios. Since the intensity of light becomes one quarter as strong as the distance doubles, it follows that the light is reduced by half if the distance is increased 1.5 times. For example, if a flash at 8 feet requires an $f/16$ aperture, a flash at 16 feet needs an aperture of $f/8$. A flash-to-subject distance of 12 feet reduces the aperture by just one f-stop, to $f/11$. In the field, you can estimate or use your lens focusing ring to get these required distances.

There is no limit to the number of flash units you can use in a multiple-flash setup. I've used as many as five flash units to cover a large area in the studio, and to fill in shadows and create specific lighting effects for some high-speed flash work. My usual setup involves three units. Regardless of the number of flash units used, all must fire simultaneously. You can easily do this by attaching each flash either to a flash-sensitive device called a *slave unit,* or to a *multi-PC socket adapter.* When using slaves, the main flash connects to the camera and the other flashes connect to one or more slave units. The camera fires the main flash, which triggers the slave flashes. Each flash can be positioned independently because there are no wires or direct connections between the individual flash units. Although the flashes can be aimed anywhere, at least one of the slave sensors must be pointed toward the main flash. The other slaves can be aimed at that slave flash. In bright sunlight, some slaves don't work. They might short out and fire repeatedly, or not react at all. However, you shouldn't have that problem with a quality slave, one offered by a major manufacturer. When bright light may be an issue, I use a Quantum Master Slave—a high-end slave that is extremely sensitive to flash light. It will trigger a flash from over 100 feet away.

I also use a slave tripper to fire my studio flashes when I'm working with reptiles indoors. I'll mount my SB26 onto the hotshoe and aimed at the ceiling so that the flash doesn't influence the studio flash's exposure.

If you use a multi-PC socket adapter instead, each flash unit must be hard-wired together. In most applications,

A little photo-cell slave tripper plugs into one of the outlets of a multi-PC adapter. When a "master" flash fires, the slave will trigger the attached flash units to fire (in this setup there are three).

the camera and each flash unit connect to the multi-PC socket adapter via PC cords. You can use extension PC cords to separate flashes beyond the capacity of their built-in cords. Unlike a slave, there is no limit to the camera-to-flash distances that you use because the ambient light doesn't affect the other flashes. I frequently use the multi-PC socket system to avoid misfirings due to ambient light when I arrange multiple-flash setups outdoors. I tape each of the PC and flash-cord connections, too, to ensure a firm contact. Of course, you'll have to contend with the wires; be careful not to break or trip over them. (There are advantages to using slaves: Because wires aren't required to connect units, you are less likely to trip over a wire and pull down hundreds of dollars worth of flashes as you run around a studio dodging a rattlesnake or chasing a frog across an elaborate field setup!)

Alternatively, you can connect a slave unit to the multi-PC socket adapter to trigger a couple of flashes simultaneously with the camera's flash. This is very useful at a bird feeder or nest if it is too difficult or too expensive to hard-wire the camera to all of the flash units placed several yards from the camera. Base your exposure on either the flash units positioned close to your subject or on the ambient light, whichever exposure is greater. The camera-connected flash will probably be too far away to affect the exposure and will function merely to trip the other flash units.

Use your imagination to arrange key and fill flashes in any possible configuration. In the simplest setups, the key light casts a strong shadow that the fill light reduces.

Using three flashes, put one behind the subject to act as a rim light, as photographers doing human portraiture use a hair light. If the background is important, you can aim one or more flash units there.

The additive effect of two or more flashes striking your subject can increase the exposure that was determined solely by the key flash. If the fill lights are close enough to be within one stop of the exposure for the key flash, the combined light output of the flashes can increase the exposure by as much as one f-stop. If the fill flashes are far enough back that there is at least a two-stop difference between the key and fill lights, the additive effect of the multiple lights may be small enough to be ignored. Use a flash meter or bracket to ensure that you get the proper exposure.

Multiple flash can create multiple eye highlights in animals. One eye highlight is usually considered "normal," although I've seen two eye highlights in some animals in natural light. Two eye highlights can be aesthetically and commercially acceptable, but I discourage you from letting three or more appear; this looks artificial. By limiting the number of flashes positioned in front of your subject, you can easily avoid these highlights.

Similarly, avoid using ring flashes when photographing frogs, snakes, or other animals with large reflective eyes or with smooth skins because the circular highlight created by a ring flash looks unnatural. If you have a ring flash, use it with a 200mm lens. The reflection is minimal at the greater working distance this longer lens provides. Don't, after reading this, be tempted to toss out your ring flash. Ring flashes are useful for most insect and plant photography, and general macro work; they are also handy for subtle fill flash at longer distances, where the circular reflection in an eye is too small to be noticeable.

USING THE INVERSE SQUARE LAW TO DETERMINE MULTIPLE FLASH RATIOS

If you correlate the lens aperture numbers (4, 5.6, 8, 11, 16, etc.) to your flash-to-subject distances, you'll decrease the intensity of your flash by one f-stop at each distance. In manual multiple-flash techniques, if you use a second or third flash only as fill, simply position them farther back. For example, if your main flash is 4 feet from your subject and yields an $f/11$ aperture, a second fill flash with the same GN positioned at 5.6 feet will yield an $f/8$ aperture. A third flash, at 8 feet, will yield an $f/5.6$ aperture.

HIGH-SPEED FLASH

One of the most exciting features of electronic flash is its stop-action possibilities. With affordable, commercial flash units ranging in price between $80 and $200, you can freeze a bird or bat midflight, a mouse or frog midleap, or a rattlesnake midstrike.

Although even the slowest flash units emit a relatively short burst of light, a flash duration of less than 1/1000 sec. is too slow to stop action. Shorter flash durations are necessary. To stop various animals in action requires speeds of 1/4000 to 1/20000 sec. With most TTL flashes, very short flash durations require very short flash-to-subject distances because of their low GNs, and even then, sometimes only at larger f-stops. At increased distances, or with smaller apertures, the flash must fire for a longer period of time to provide enough light for a proper exposure. With a teleflash system, the flash concentrates the light into a smaller area, making it possible to use a smaller aperture at faster flash speeds.

Not all manual flashes can be used for high-speed flash. Some flashes are limited either to a full-power manual setting or to a high- and a low-power setting. The low may be 1/4, 1/8, or 1/16 power, depending on the unit. Better units have a variable power ratio that you can dial down to 1/32 power or less. I can use my Nikon SB26 at 1/64 power, emitting a burst of light of only 1/23000 sec.

Check your flash manual for the flash duration of your unit at its various power ratios. Using 1/8000 to 1/15000 sec. to stop owls or bats midflight provides a 2- to 4-foot flash-to-subject distance at apertures of $f/5.6$ to $f/11$, depending on the GN of the flash unit. For flying insects, 1/20000 sec. or faster is necessary. As I mentioned earlier, the low GN involved normally requires very short flash-to-subject distances, but teleflash brackets will increase those distances. Of course, short flash working distances won't be much of a problem with flying insects or with bats flying out of a small opening. If a greater working distance is needed, there are custom-made high speed units with high GNs that will do the trick.

The most difficult aspect of high-speed flash is not obtaining a usable f-stop. Instead, the challenge lies in catching your fast-moving subject within the frame and in focus when the flash fires. It is almost impossible to react quickly enough to fire when your subject appears in view; it is impossible to anticipate because the depth of field is too shallow to provide for any margin of error. Autofocus technology usually doesn't help. Almost any running or flying animal will pass through a plane of focus before a trap-focus mode can react and fire at the close working distances usually employed with high speed flash. Most animals move too rapidly for a

predictive focus or a tracking system to lock on and follow a subject until you fire.

Although this sounds discouraging, there is a solution. Various photo-electric cells or infrared trippers that can fire a camera or flash when a light beam is broken are available. I use a device called a Shutterbeam that fires either a camera or a flash when an infrared light beam is interrupted or when a sound trips the device. The Shutterbeam is indispensable for high-speed flash work, but you can also use it in ambient light along game trails or at feeders.

For wildlife photography, I use the infrared mode of the Shutterbeam to either trip the camera or to fire the flash. Although the Shutterbeam reacts instantaneously when the infrared beam is broken, there is a short response time in the camera as the mirror flips up and the shutter opens. This delay lasts between 1/10 and 1/30 sec. in most cameras. The delay is long enough for a fast-moving animal to travel past the point where it broke the beam. For that reason, I use an EOS 1N RS with a pellicle mirror for much of my high speed flash work, since its lag time is only 1/180 sec. That is fast enough that most flying birds, jumping frogs, and other subjects won't travel much past the trigger point before the camera fires.

There is no delay, however, if the Shutterbeam is wired to a flash and the camera shutter is open. When something passes through the infrared light beam, the flash fires, and if the camera shutter is open, a sharply focused image results. This requires the shutter to be set on "B" and you need to be working in a darkened

GIANT MARINE TOAD (CAPTIVE), McClure, Pennsylvania. 200mm F4 macro lens, 1/250 sec. at ƒ/16, manual flash, Fuji Velvia

Using a Shutterbeam to trip my camera, I had to anticipate a small change of focus as the toad hopped toward the camera (above). Exactly how big that change will be depends on the camera system. This will be minimal with lag times of 1/180 sec., and quite substantial at 1/10 sec.

Focus wasn't as much of a problem when the toad jumped parallel to the film plane (below). Lag time can still be an issue in terms of the subject's position, but by experimenting with the placement of the beam and reflector, it is possible to get the effect you want regardless of your camera's lag time.

GIANT MARINE TOAD, McClure, Pennsylvania. 70–200mm F2.8 lens, 1/250 sec. at ƒ/16, manual flash, Fuji Velvia

studio or at night. Otherwise, the film will be overexposed by the ambient light.

You can use a Shutterbeam in daylight if you wire it to a camera, but the distance a subject travels during the camera's lag time must be considered. This can be difficult. Depending on its speed, an animal or bird can travel anywhere from several inches to a few feet after passing through the beam. To obtain a sharp image, you must be in focus at that spot. This is possible, although it takes some guessing and some calculating. For example, if a bird is flying at an estimated 25 mph and your camera's lag time is 1/20 sec., you must determine how far it flies during that fraction of a second. For a sharp image, you'd have to focus 1.8 feet beyond the point where the subject broke the infrared light of the Shutterbeam.

Two practical field problems arise when using a Shutterbeam in natural light with fast-moving subjects:

knowing how fast an animal is moving (if the guess is incorrect, other calculations are worthless), and avoiding ghost images.

Clues to an animal's or bird's speed are to be found in unlikely places. Hunting books or magazines might refer to the speed of a bounding deer or cottontail rabbit; natural history books cite the flight speeds of some birds; and science journals are also helpful. In general, most birds fly between 25 and 40 mph, although some are much faster. Many animals at a dead run travel at 20 to 35 mph, depending on their size. Regardless of a bird's flight speed, before landing or immediately after take-off, it flies more slowly. This is most evident when a bird decelerates to land. A songbird can go from 20 mph to a dead stop in the last 12 inches of its flight.

If you're using flash, there is also the problem of ghost images. Because shutter speeds can be no faster

PANTHER CHAMELEON (CAPTIVE),
McClure, Pennsylvania. 70–200mm F2.8 lens, 1/250 sec. at f/16, manual flash, Fuji Velvia

I've made images like this using cameras with both short and fairly long lag times. For a long lag time, say 1/30 sec., I positioned the beam just in front of the chameleon's snout. The camera fired some time after the lizard's tongue broke the beam—long enough for the tongue to reach full extension.

than the fastest sync speed, ghosting may occur in bright ambient light. I have had my best luck eliminating ghosting by photographing on overcast days or in the shade and by using the fastest sync speed possible— 1/250 sec. with my cameras—and by using Velvia with apertures of *f*/16 or *f*/22. On a sunny day, the base exposure for a middle-tone subject shot with Velvia film would be 1/250 sec. at *f*/8. By using apertures of *f*/16 or greater, I'm underexposing the ambient light by at least two stops. On a cloudy or overcast day the difference is even greater. Of course, a natural background would go black with this much underexposure; to eliminate that, I erect a fake background a distance behind the bird and illuminate that area with flash as well.

There are other problems. Your subject can break the infrared beam anywhere along its path, which could result in a misframed subject or a missed photograph entirely. If an infrared beam spans four feet, and the camera covers the center two feet, one foot on either side will be out of the frame. Although the camera will fire each time a bird breaks the beam, you'll only capture empty airspace if every bird flies outside the coverage area.

The solution: Two Shutterbeams wired in a series eliminate this problem if the two infrared beams are crossed at right angles to one another. Determining the correct focus depends on what you connect to the Shutterbeam. Focus at the point of intersection if the flashes are wired to the Shutterbeam and the camera is set to "B." Focus somewhere beyond that point if the camera is wired to the Shutterbeam and a lag time is involved. You'll fire fewer frames when using two Shutterbeams wired in series because the tripping area becomes a very small target, but the likelihood of correctly framing the subject becomes higher. If your subject must fly or jump through a gap or a frame, you can use a single Shutterbeam to cover the space. Barn swallows can fly through the open window of a garage; a barn owl can fly through a gap in a barn wall; or a falconer's goshawk can fly through a specially built frame. Setting up one Shutterbeam for such an area should suffice.

This is the equipment arrangement for photographing bats in a barn using a Shutterbeam. Four flash units and the Shutterbeam were positioned around a barn opening by which scores of bats flew.

It is a bit unsettling working, often in the dark, on a scaffold as hundreds of bats whiz by.

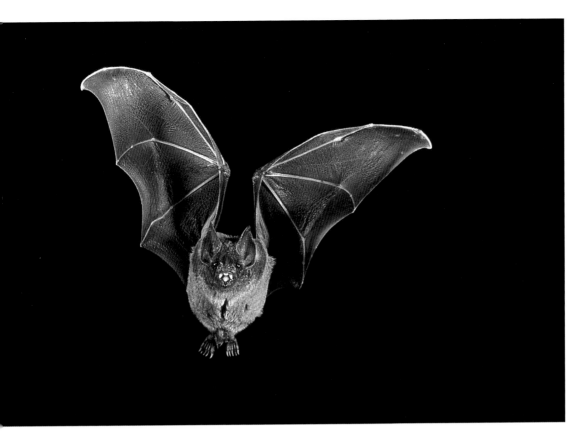

SHORT-TAILED LEAF-NOSED BAT (CAPTIVE), McClure, Pennsylvania. 100mm F4 macro lens, Bulb at *f*/16, manual flash, Fuji Velvia

Since bats fly in the dark, it was easy to simply put my camera on "Bulb" and wait until a bat broke the beam. Obtaining a sharp image was easy; I simply focused at the intersection point of the beam.

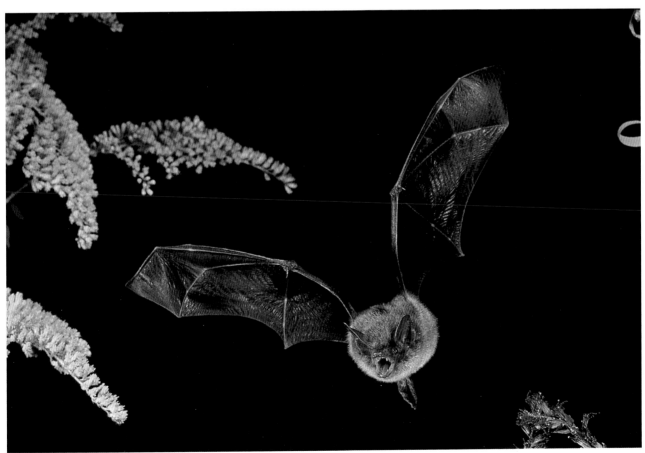

LITTLE BROWN BAT, Altoona, Pennsylvania. 100mm F4 macro lens, Bulb at *f*/16, manual flash, Fuji Velvia

Little brown bats fly over fields and ponds catching mosquitoes. To imply this behavior, we positioned some plants around the window through which the bat would pass.

PHOTOGRAPHING HUMMINGBIRDS

Hummingbirds are probably the most compelling wildlife subject for flash photography. Found throughout the United States, lower Canada, and throughout Central and South America, they are not only colorful but also master fliers, capable of hovering, dipping, rising, and even traveling backward.

They're also easy to attract close to a camera. Hummingbirds love sugar water and will, at times, endure almost any obstacle course to sip at a feeder. The birds grow remarkably tolerant of a flash and, sometimes, to a nearby photographer as well.

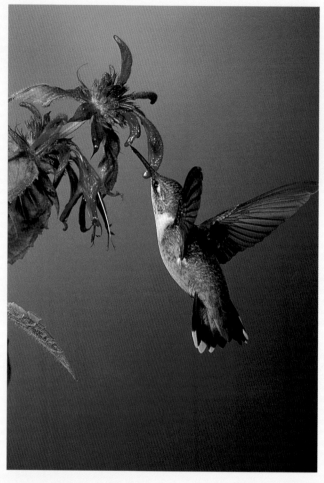

RUBY-THROATED HUMMINGBIRD, McClure, Pennsylvania. 70–200mm F2.8 zoom lens, 1/250 sec. at *f*/16, manual flash and Shutterbeam, Fuji Velvia

A Shutterbeam positioned directly over the flower caught this ruby-throat just as it dipped into the beebalm. It is unlikely that a hummingbird will visit a single flower repeatedly, so to ensure an image, I placed a sugar water feeder at this location for several days prior to the shoot. Once the hummingbird became a regular visitor, I switched to a flower and turned on the Shutterbeam.

BROAD-BILLED HUMMINGBIRD, Madera Canyon, Arizona. 500mm F4 lens, 1/250 sec. at *f*/16, manual flash, Fuji Velvia

Two thistle heads disguised the feeding tube in the upper left corner of the frame.

BROAD-BILLED HUMMINGBIRD, Madera Canyon, Arizona. 500mm F4 lens, 1/250 sec. at *f*/16, manual flash, Fuji Velvia

To avoid ghost images, I positioned the feeder, props, and background in the shade of a large tree. I directed two flashes toward the hummingbird, and two others at the blue posterboard background.

PART 3
COMPOSITION

MAKING SUCCESSFUL IMAGES

During my workshops, I'm often asked to review a participant's portfolio. More often than not, the work is impressive and creative, exhibiting both a knowledge of technique and an aesthetic sense that results in arresting images. However, occasionally, a less satisfying portfolio arrives. The images may be technically correct—sharp and correctly exposed—but they're lacking something, and this absence makes them uninteresting or even boring.

Ultimately, composition makes or breaks a photograph, and for some, composing an interesting image can be quite difficult. Luckily, the basic principles of composition can be learned. To some, creating great compositions comes naturally; some people have a natural sense of what works—of what looks attractive, interesting, or intriguing. In fact, your best compositions have probably happened when you had a preconceived idea of the way you wanted to depict a subject. Perhaps this simply meant knowing you wanted to photograph at your subject's level or that you wanted to use a shallow depth of field to isolate an animal against a blurred background. Sometimes, an image exists in your mind's eye that, if circumstances permit, you will recognize as you produce a photograph that interprets this image.

Then again, you may have a familiarity with a subject and an empathy toward it that you're able to convey on film. A friend of mine makes wonderful images of rocks, stones, and boulders. I commented on this once, and she said she just enjoys them. She feels their strength and their sense of timelessness, and tries to convey this feeling through her images. And she succeeds at

doing so. Sometimes an image simply evolves as you draw conclusions from studying your less satisfactory photographs and attempt to refine your efforts.

By studying photographs, you can learn to recognize what works in terms of the lighting, the framing, or the perspective. Although you'll learn from your mistakes, you're also more likely to repeat them unless you begin the recognition process of seeing. Begin by looking at the leading nature and wildlife magazines that publish outstanding images each month. Great photos are not only inspiring; they also share similar qualities that you'll identify and want to emulate. There are also excellent books dealing with composition. Some general guidelines follow that you can apply to your nature and wildlife photography.

PERSPECTIVE

Composition is a matter of *perspective*—how to convey the real, three-dimensional world in the flat two dimensions of a photograph. In wildlife photography, one of the most effective perspectives is photographing at your subject's level. A toad's-eye look at another toad is a view foreign to most people but visually interesting to many. Subject-level photographs often provide an intimacy—a sense of being close—that other views lack.

I photograph from my subject's level whenever possible. Since many animals and flowers are low to the ground, this frequently involves spreading the legs of my tripod flat, or taking the ball head off my tripod and resting it on the ground. Quite often, achieving this perspective involves my getting wet and muddy, I

HARP SEAL PUP, Magdeline Islands, Quebec, Canada. 20–35mm F2.8 lens, 1/250 sec. at *f*/16, Fujichrome 100

Being at the pup's level, in a low perspective, established a sense of intimacy, while adding color to the image by the inclusion of the pleasing blue sky.

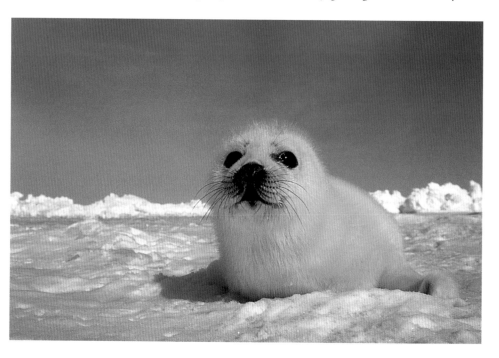

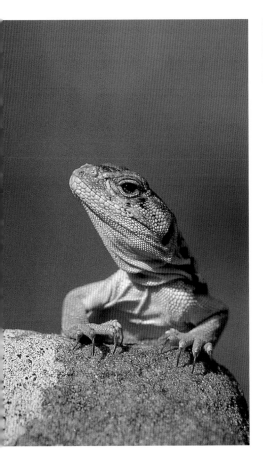

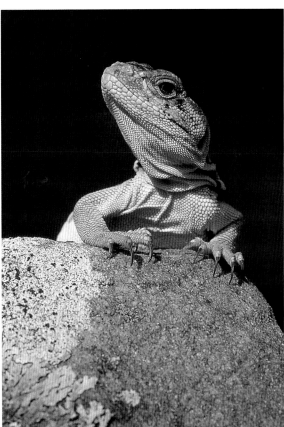

COLLARED LIZARD (CAPTIVE), McClure, Pennsylvania. 300mm F4 lens, 1/250 sec. at f/9, Fujichrome 100

Sometimes just a simple, slight shift in perspective from left to right makes a world of difference. With the narrow angle of view of a 300mm, I could have framed this collared lizard against any background I chose. Since a large black background might have appeared overwhelming, I changed my composition slightly—positioning the lizard higher up and more to the right in the frame—to include more of the lichen-covered rock.

often wear camouflage clothing, and once I dry off, the dirt merges with the pattern. Even when I look dirty, and I often do, it is worth the trouble for the drama and sense of closeness this low angle provides.

Obviously, it is difficult to film birds or arboreal animals at their level. You might need a scaffold or tree stand to position yourself above ground level. This requires work and physical strength beyond some people's abilities. Of course, in studio or in field setups, an arboreal animal's perch can simply be positioned at a comfortable working distance to suggest height. I often do this at bird feeders.

When it is impossible to photograph a tree-dwelling animal at its level, place your subject in the upper part of the picture frame. This makes sense visually, especially if branches or tree trunks lead toward the subject. Your eyes naturally follow a tree upward until you spot something, and frequently, our eyes travel no further. I've often discovered another animal higher up that I first missed because my attention was arrested at the lower point. Including branches or a tree trunk that interferes with the center of interest only fills the frame with unnecessary clutter. Use the tree to lead your viewer's eye upward to your subject. This more closely duplicates how we view the world and creates images that are balanced and appear natural. The same idea applies to animals living on steep or hilly terrain. Let the lines of the cliff or hill lead your eye upward to the subject so that you place your subject in a natural viewing position.

Moving up or down can dramatically shift your perspective. Sometimes you can frame a subject against a pleasing background by raising it above or by dropping it below a horizon line. I frequently find myself doing this on mountain slopes where, by dropping to a lower position, I'm able to frame my subject against blue sky. Conversely, in low wetlands, a higher angle may frame my subject against open water, and I can avoid bisecting a subject with a distant shoreline. This can make a simpler image, especially if it frames the subject with a more pleasing and uniform tonality.

Be careful not to cut your subjects in half with a distant horizon. This can happen if you don't look beyond your subjects. This is especially noticeable when photographing birds and animals near water. If the dark line of a distant shoreline frames a great blue heron at mid-body, try changing your perspective. By dropping lower, you might be able to raise the bird clear of the horizon line and frame it against the sky. Conversely, by extending your tripod's legs to their full height, you could frame the bird with water. Either way, you create a simpler and more attractive image than one in which the subject is split in two.

Left-right movements also shift perspectives. The old visual cliché of a pole sticking out of a person's head can be corrected by a simple lateral shift. This is quite easy to do when you're shooting in prairie country or similar open country, where distant telephone poles or fences

can visually skewer an otherwise wonderful-looking image of a pronghorn antelope or elk.

Remember, it is important to not only look at your subject but also to study the area in front of and behind it for distractions or competing elements.

When changing your perspective isn't possible, you may choose to change the "look" or to simplify the elements within a photograph by minimizing the depth of field. This can be done several ways, but the easiest way is to use a wider aperture. Although using a longer lens, or moving closer, for a greater image size will also reduce the depth of field, using a large aperture to eliminate troublesome or distracting backgrounds has the added benefit of increasing your shutter speed, which helps make a sharp image.

NATURAL LIGHT

The quality, direction, and intensity of the light dictates how you'll record your subjects. Beginners often overlook this, considering light only in its role in exposure. Light should also dictate how an image is composed, which is perhaps best illustrated when you shoot scenics. Every photographer has been motivated to visit a scenic location because of the beautiful photographs taken of that special area. Like me, you've probably felt frustrated when the vista before you differs from the photograph that brought you there. Except for the light, all the elements could be identical—but if the light differs, everything about the scene changes and the photograph you seek simply isn't there.

Too often, amateurs see only the subject and not the light. Their attempts at making calendar-quality scenic images are disappointing because the essential ingredient—the correct light—is missing. Even the best compositions can be dependent on the nuances of light. Professional photographers recognize this and may wait days for just the "right" light.

Often, the best light for scenics and for animal portraiture is not a brilliant sunny *f*/16. The shadows cast by direct sunlight can be very contrasty and harsh. If you're photographing landscapes in bright sunlight, use the lighting creatively. If the sun is behind you, use the foreground or a natural frame to convey a sense of depth. Change perspectives so that the sun is no longer over your shoulder but instead strikes your subject at an angle that casts an interesting shadow. This also helps when you are using a polarizing filter (see page 129), since these filters work best when the sun is perpendicular to your subject. By changing perspective and rotating the polarizer, you'll notice dramatic changes in the contrast between any clouds and the sky you place within your frame. Of course, brilliant sunlight is often helpful when photographing wildlife

when a fast shutter speed is required. However, even then, sidelighting or backlighting can make a more interesting image.

Learn to recognize the possibilities other light offers. One of my favorites is cloudy-bright light, which is ideal for mammal portraiture, wildflowers, or any other subject where distracting shadows can pose problems. Landscape photographs, especially fall-foliage scenes, enjoy a saturation and lack of contrast under cloudy-bright light not usually obtainable in direct sunlight. Remember, keeping a cloudy-bright sky out of your picture is a good idea because of the differences in exposure between the sky and subject. If that isn't possible, you may be able to use a graduated or *split neutral-density (ND) filter* to reduce the contrast in your scenic images (see page 129).

Inside jungles or woodlands, patches of bright sunlight and deep shade can ruin your images because of the great range in light values. In these areas, cloudy-bright light is ideal because the extreme contrast between sunlight and shade is reduced under this diffused light. Conversely, with seascapes, contrast isn't usually a problem because water often mirrors the bright sky and requires a similar exposure.

Heavily overcast skies can lend a brooding drama to landscapes. In this light, both sky and earth can have a similar tonality, which you can check by taking a spot-meter reading of each area with your camera. If there is more than a one-stop difference between the sky and land, you may choose to reduce the contrast. You can use a split ND filter for this or simply compose to eliminate the brighter, distracting sky. Very overcast light can also create a bluish cast to film when it filters through a canopy of leaves inside a forest. An 81A or 81B *warming* filter adds a light yellow cast to this blue-green, filtered light (see page 130).

Perhaps the most striking photographs are made under what I often refer to as "magic light": the golden light of sunrise, the orangish hue of sunset, and the peculiar quality of filtered sunlight following an afternoon thunderstorm. The quality of this light is both different and beautiful, and produces images not possible in any other type of light. You can visualize this magic light if you think of the formation of a rainbow, a magical combination of sunlight and moisture. When sunlight and mist or rain meet, a rainbow may form, although you may not see it. However, you can anticipate the location of a rainbow and position yourself to include one in your photograph. A rainbow forms in mist or water droplets at a point approximately 45 degrees opposite the position of the sun. If the sun is to your back, the rainbow will be at a 45-degree angle from your cast shadow, depending of course on where the moisture is in the sky.

A rainbow doesn't last very long, so exposing for one is often a cause of high anxiety. It is really not difficult. Simply pick a middle-tone area nearby, and take a reflected-light reading. You can make a rainbow bolder, too, by adding a polarizer. Rotate the polarizer until the rainbow is most distinct, and then take your exposure reading. Be careful how you rotate the filter! If you rotate the polarizer the wrong way, you can erase the rainbow altogether. Since there can be a difference in tonality between your middle-tone area and the sky, bracket by 1/2 or 1 f-stop on either side of your base exposure to be sure you get it right and that you have a well-defined rainbow.

Fog and steam can also add compositional interest, but they pose quite a challenge. First, consider the brightness of the scene. If the sun is completely obscured, fog and steam appear gray or middle tone. Landscape features are darker, often registering only as silhouettes. Since the fog is nearly middle tone under these conditions, meter the fog, and then open up or overexpose by 1/2 f-stop to add some brightness to the scene. Conversely, if the sun is visible, fog and steam

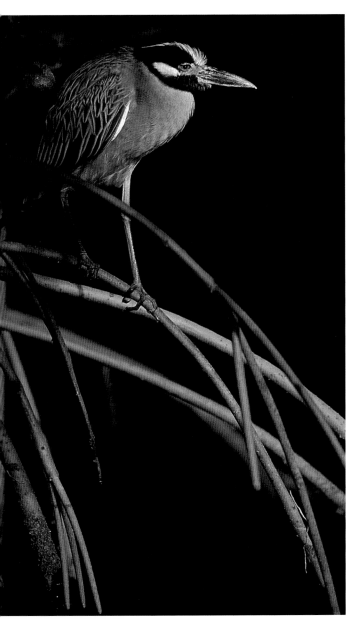

YELLOW-CROWNED NIGHT HERON, Ding Darling National Wildlife Refuge, Florida. 300mm F2.8 lens, 1/250 sec. at $f/4$, Kodachrome 64

This image works because of its simplicity. Soft, diffused light illuminates the night heron and the mangrove roots that lead directly to the bird, while the dark swamp water and deeply shaded mangroves in the background eliminate any potential distraction.

YELLOW-CROWNED NIGHT HERON, Everglades National Park, Florida. 300mm F2.8 lens, 1/500 sec. at $f/4$, Kodachrome 64

Here's an entirely different treatment of the same species. The light is much harsher, and the leaves in the background could be a distraction. However, there's a sense of animation as the heron preens, and the viewer's attention is drawn to this activity.

practically glow a bright white as the moisture reflects the sun. In this situation, base the exposure on the fog or mist, and then open 1 1/2 or even 2 *f*-stops to bring back the whiteness. Keep in mind that when you read white steam or mist, your meter will underexpose white and make it gray. Overexposing will bring the fog back to a more natural appearance.

Don't try for detail with animals in fog if they appear as silhouettes to your eye. Instead, follow these instructions and let the subject register as a silhouette. For close-ups, where the animal fills much of your frame, ignore the fog and base your exposure as you normally would by choosing a middle-tone area as a basis for your reading.

There are no set rules for making a great composition, and if there were, they would surely be meant to be broken. That isn't to say that anything goes, or that every composition is inherently interesting. This isn't true, as many of our own images attest. Nonetheless, many photographs share similarities or characteristics that generally define a pleasing image, and it is prudent to at least consider these as you work on a composition.

RECOGNIZING THE DECISIVE MOMENT

For wildlife, a fast lens, a fast-speed film, or an electronic flash unit is often necessary to photograph under heavy overcast or low light conditions, especially if your subject is moving. But these accessories aren't required if your

BAT-EARED FOX AND PUP,
Masai Mara Game Reserve, Kenya. 600mm F4 lens, 1/500 sec. at *f*/5.6, Fujichrome 100

You don't have much compositional leeway when you're using a long lens and sitting inside a parked vehicle. As this fox and its pup played, there were moments when the two moved close together; I fired off several motor drive bursts whenever that occurred.

RIVER OTTER (CAPTIVE),
Wild Eyes, Montana. 500mm F4 lens, 1/250 sec. at *f*/4, Kodachrome 200

Sometimes obstructions create a sense of realism, as if the shot was made during a very fleeting moment, such as the devouring of a meal. By dropping low and partially obscuring the otter with a large stone, I think I achieved that effect.

subject is still. Surprisingly, most mammals, reptiles, amphibians, insects, and many larger species of birds can be virtually motionless for varying lengths of time, ranging from the briefest instant to quite a few seconds. For example, even a walking deer or a preening egret may pause momentarily, and if you anticipate that moment, you can use a slow shutter speed.

In many wildlife situations, there is a *decisive moment,* either a point of peak activity or a momentary lull. Using a motordriven camera doesn't guarantee that you'll capture that moment, but a state of awareness and a sense of anticipation may. Sometimes an animal telegraphs its intended action; a change in expression, a tightening of muscles, a sense of alertness—any of these may warn you that action is imminent. Although it requires patience, try waiting for an activity to take place rather than coaxing it along. In other words, don't make a bird flush that might have flown if you had waited.

Impatient photographers may obtain one action—such as flight—but miss another—such as preening, stretching, or yawning—that may have occurred if they'd waited. Besides, frightening an animal to make it run or fly, or teasing it to catch an eye highlight, is unfair to the animal. It is also a disservice to other photographers who may find a formerly trusting animal now skittish.

FINDING A CENTER OF INTEREST

Most photographs have a subject or a center of interest, although this doesn't mean that your subject must be centered or stand alone. An entire field of flowers or a detail of fallen autumn leaves can be the subject, not just one single flower or one leaf. Although including a center of interest in your photographs seems obvious, this is something that photographers frequently neglect to include in many compositions. This is especially true with beginners who are trying to imitate a calendar or greeting-card-style photograph of a forest floor or a macro landscape of leaves or pebbles. To avoid this, step back from your viewfinder and ask yourself what you find appealing in your image. Decide if there is a center of interest that is either obvious or hidden, and whether or not it truly holds some interest.

Finding a center of interest when photographing wildlife is no problem, although the photographs you make may be boring because of the animal's behavior or the way you placed it in the frame. Still, most of the time, wildlife photographers at least know what they're supposed to be seeing. However, centered animals—regardless of their activity—often appear static. This is especially true of animals that are stationary, but also applies, to some extent, to animals that are running or flying.

When a rectangular format is divided into thirds horizontally and vertically, the points of intersection mark the points of power (see page 117).

I've found that focusing or framing flying birds or running mammals can be so difficult that most of my sharp images end up being centered, though I consciously try to avoid this. Sometimes, the action or drama carries the image despite its being centered. However, when I can, I try to avoid centering.

There are a few ways to do this. With some autofocus systems, you can position the subject at an off-center focusing point. With some cameras, there are five focusing sensors spread across the midline of the frame. In others, four focusing sensors are arrayed around a central sensor. Using any of these sensors, excepting the central one, will accomplish this goal. If you're using a manually focused lens, try prefocusing on an area and letting your subject fly or run into sharp focus. But, be sure to fire at the instant prior to the subject moving into the zone of sharp focus, because there's always a minimal lag time as the camera responds or you react. With practice—and a bit of luck—you'll find that you can anticipate the time and fire fairly accurately.

Sometimes implying motion is very effective, and the best way to do this is to pan. You can further imply motion while you pan by using a shutter speed slow enough so that the background blurs as you pan. You must pan smoothly. Slow shutter speeds often produce jerky images because the camera has time to wobble as you pan. Limit most pans to no less than 1/30 sec. Due to their greater speed, shutter speeds of 1/125 sec. may be sufficient for flying birds.

When panning, both you and your subject must be in motion. The subject will blur if the camera is still when the film is exposed. For sharp images and smooth pans, start tracking your subject long before you expect to shoot. As you snap off one or several frames, continue your swing as you follow its progress. You may find this difficult to do when the camera's return mirror is constantly flipping up and blacking out the viewfinder.

Practice helps. Try panning with bicyclists at a park or with a cooperative dog that you can coax into repeatedly running past you.

Panning is most effective when your subject is traveling perpendicular to you. Anticipate the position where you expect to fire, and plant both feet facing that direction. Twist in the direction from which the subject is coming so that you'll "unwind" into a more comfortable shooting stance that faces your subject at the moment of firing. Although I use a tripod when I pan with my 500mm lens, and usually with my 300mm, I frequently hand-hold smaller lenses when I pan. You may find yourself achieving smoother, less jerky pans when hand-holding than you do when your camera is mounted on a tripod. I find this to be especially true when I am photographing flying birds.

A sure way to make a "boring" animal interesting is to shoot a close-up. Frame-filling detail is always intriguing. Tight close-ups have other advantages, too; they eliminate contrast, distracting backgrounds, and such unattractive aspects of the subject as partially molted fur, bands on bird legs, or withered flower heads.

BOBCAT (CAPTIVE),
Wild Eyes, Montana. 300mm F2.8 lens, 1/60 sec. at f/5.6. Kodachrome 64

Your choice of shutter speed can dramatically influence an action shot. Panning with a moving subject while using a slow shutter speed creates a blurred background, which implies speed, even if, as in this case, the animal is only moving at a half-trot.

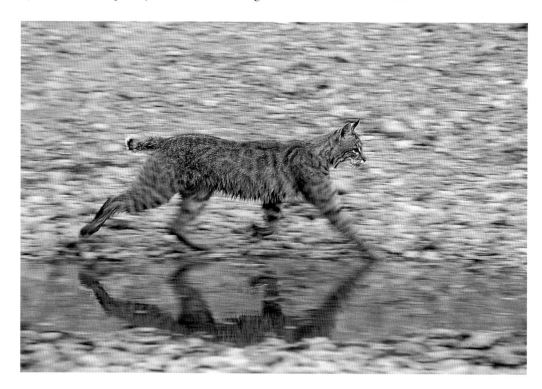

COMMON ZEBRA,
Masai Mara Game Reserve, Kenya. 600mm F4 lens, 1/500 sec. at f/8, Fujichrome 100

Fast shutter speeds freeze a moment in time—in this case, a galloping zebra with all four legs off the ground. This is only possible when an animal is moving rapidly. I was lucky to get the shot, as I didn't have time to make an exposure reading and had to rely on the sunny f/16 rule.

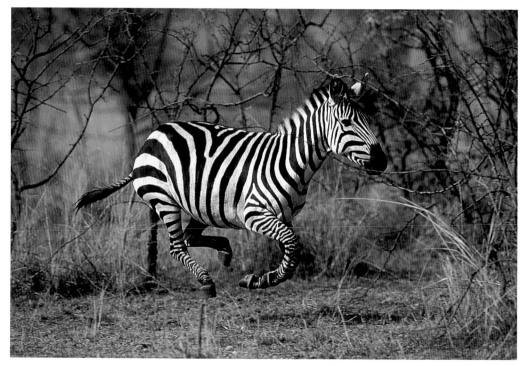

**RETICULATED
GIRAFFE,** Samburu
Game Reserve,
Kenya. 600mm F4
lens, 1/500 sec. at
ƒ/4, Fujichrome 100

*One could say I
was "over-lensed"
with the giraffe
more than filling
the frame. When
the giraffe ducked
behind a bush,
I caught it with
my 600mm as it
peeked between
the leaves.*

KING PENGUIN,
Volunteer Point,
Falkland Islands.
300mm F2.8
lens with 1.4X
teleconverter,
1/125 sec. at ƒ/8,
TTL flash at -2.0,
Fujichrome 100

*I was attracted to
the orange blaze
that forms a
mark on the king
penguin's neck.
Including the entire
mark introduced
an unwanted
background into
the image, but
by moving closer,
I eliminated
that distraction.
In addition, by
including a wedge
of white belly, I
balanced the two
brightest areas
on opposite sides
of the frame.*

If you can't fill the frame with your subject, consider positioning it at a *point of power*. These power points are easy to determine within a 35mm frame. First, divide the frame into three equal sections by visualizing two imaginary horizontal lines across your viewfinder. Then divide the frame into three equal sections by visualizing two vertical lines. The frame is then divided into nine equal subdivisions. The points of power fall at the intersections of the four imaginary lines (see page 113).

When you divide the 35mm frame into nine sections, you are utilizing a compositional device called *the rule of thirds*. According to this rule, a well-balanced picture is divided into thirds, such as one-third sky, two-thirds land. The classic calendar photo of blue sky/snowcapped mountains/cobalt-blue lake often incorporates this idea. Other divisions of the frame also work; for example, you might find that a dramatic sky covering three-quarters of your frame is the most attractive composition. The point is to not divide scenes equally, as an amateur might do, by placing the horizon line in the middle of the frame and dividing the photograph into half sky and half land.

By placing your subject at a power point, you create a sense of dynamic tension that a centered image often lacks. This positioning requires discipline on your part because it is very easy to center a subject, especially if you're using the center focusing rectangle of an autofocus camera. It is often wise to position animals that occupy only a small area of the frame at these power points. This tactic allows you to include more landscape in your photograph. Many potentially great images are ruined when the landscape is ignored, because the photographer concentrated only on the bird or mammal subject and ended up centering the image.

Incorporate this idea of power points when you're making close-ups of frame-filling subjects, such as animals or birds. Be sure to focus on the eyes; the viewer's attention immediately goes to the eyes of the subjects. If the eyes are sharp, the image has a "rightness" about it. If the eyes are soft, the image is usually ineffective or worthless. If you're doing a full- or partial-body portrait, place the head of the animal at a power point. Similarly, when you're photographing flowers, position either the entire flower or its center at a point of power.

FALKLAND THRUSH, Sea Lion Island, Falkland Islands. 300mm F2.8 lens, 1/500 sec. at f/2.8, Fujichrome 100

Sometimes a composition is obvious. When I looked through my viewfinder, the soft red grasses just naturally framed this thrush.

ALASKAN BROWN BEAR, Katmai National Park, Alaska. 600mm F4 lens, 1/500 sec. at ƒ/5.6, Fujichrome 100

If you can't make an interesting image, make a big one! Sometimes subject matter alone carries a shot. However, you should still try to keep the points of power in mind.

With landscapes, put a bright or contrasty color or the prominent feature at a point of power.

Don't follow these suggestions exclusively. Centered images can be pleasing or even striking if there is symmetry or a natural frame that leads your eyes toward the center. In fact, in a slide show or a portfolio, too many asymmetrical subjects can create a monotonous presentation.

AVOIDING DISTRACTIONS

Horizons can be distracting, especially if they're tilted. This might not be noticeable if the background is soft and nothing is discernible. Trees and well-defined horizon lines canted at an angle are usually noticeable, and the effect ruins a picture. Sometimes an image appears level to you while you're composing, but the finished slide or print isn't. This is a common problem in the field, because the placement of your tripod legs, the angle of the tripod head, or the lay of the land can create the illusion that your image is level.

There are a couple of ways to determine if your camera is level. Perhaps the most convenient way is to use an architectural or copy grid screen if accessory screens are compatible with your camera. Use the thin, inscribed marks on this type of screen to line up horizon lines and straighten backgrounds. If you can't change your focusing screen, consider adding a *bubble level* to your hotshoe. These are inexpensive and available in the supply racks of many camera stores. You can also check for straightness by simply stepping back from the view finder and looking at the back of the camera. If the camera appears crooked with the horizon, the picture will be, too.

Another way to check is to use a zoom lens. Try zooming to a longer focal length, one that will allow you to align some reference point (like the horizon) against the edge of the frame. Once you do this, zoom back to the focal length you need for your image. Of course, you may have to recompose slightly, and doing so runs the risk of tilting your horizon again, but the method works more often than not in a pinch.

While composing, it is easy to miss something that later appears in your photograph as an obnoxious distraction. If you visually sweep the edges of the frame for such distractions, you can also check that nothing has been left out of the picture. While you're preoccupied with getting close to your wildlife subject, you can visually cut off parts of a foot, an ear, or a tail. A simple change in perspective puts what you want back into the frame. Wildlife photographers sometimes have trouble backing off because usually they're trying to get sufficiently close to the subject.

Study the area both in front of and behind your subject. *Hotspots,* or unattractive bright areas within your image, distracting colors, out-of-focus objects, and foreground blurs can draw your eye away from the subject. Sometimes these distractions are visible only

THE LIMITATIONS OF DEPTH

How shallow can the depth of field be? With a Nikon 200mm macro lens focused at 2.3 feet, depth of field ranges from 1/16 inch at $f/4$ to about 1/2 inch at $f/32$. At 20 feet, depth ranges from 9 inches at $f/4$ to about 6 feet at $f/32$.

Based on the aperture for the wildlife equivalent for a mid-tone subject, at $f/5.6$, depth of field is only 13 inches when the lens is focused at 20 feet! With a longer lens, the depth of field is even less. For example, with a 300mm lens, depth of field is only 5 inches at $f/5.6$ when the lens is focused at 20 feet.

BLACK-BROWED ALBATROSS, Saunders Island, Falkland Islands. 20–35mm F2.8 zoom lens, 1/125 sec. at $f/11$, Fujichrome 100

Wide-angle lenses not only allow you to include habitat, they also have the potential to distort perspective in nearby subjects. This albatross's head appears much larger than it really is because the bird was leaning toward me.

when the lens is closed down. Always use your depth-of-field preview button to check for them unless you're sure that nothing is distracting within your frame. This is critical in macro photography, where grass blades or similar obstructions in front of the lens are invisible when the lens is wide open.

Foreground distractions are usually more bothersome than those in the background. Fortunately, these are fairly easy to notice; you tend to overlook the background ones. Think about it: You notice any pole that sticks up in front of the subject, but you often miss a pole that sticks out of the subject's head. Always make a special effort to look beyond your subject and to study the background, too.

USING SHAPE AND FORM

Repetitive shapes can be interesting and can offer a solution to the problem of where to cut off parts of a subject. In clusters of identical objects, none need be complete if there are enough parts of each to imply one whole object. For example, a close-up of a cluster of daisies might not include a single complete flower, but the partial, repeated shapes of several clearly convey the form of a single flower.

With animals, it is sometimes difficult to decide what parts of a subject can be cropped out of a picture. Don't arbitrarily cut off part of one animal just because another is completely within the frame. Instead, try to include significant portions of each. If a part of one is arbitrarily cut off and the others are whole, the image has a sense of incompleteness or imbalance to it. For example, you might be so intent on filling your frame with a wonderful portrait of a lioness that you ignore another one whose head and neck protrude into your frame. Your image will be stronger if you reframe to include both, which can require switching to a smaller lens or backing up, or by composing in such a way that both heads and necks are attractively included in a complementary, mirrorlike manner.

Be careful, too, about cutting off your subject due to tight cropping with cameras offering 100-percent viewfinders. Most professional cameras, such as the EOS 1N and the Nikon F series, show the entire field of view, in contrast to most amateur cameras that only show 93 to 95 percent. If you're using a 100-percent viewfinder and squeezing your subject just within the frame, chances are your slide mount will cut off portions of your subject! I've done this too many times—asking myself, "What was I thinking when I made this shot?"—and then ripped open the slide mount to discover the feet, tips of ears, or tail of my subject on the transparency, just not in view because of the slide mount.

Another way to create interest in an image is to create a diagonal line within your composition. These are often far more intriguing than straight lines, especially if there is no true orientation visible, such as a horizon line or a tree. This won't work with subjects for which you usually have a frame of reference, such as a group of trees, but it may work with close-ups that are basically abstract. A detail of a moss or lichen bed, or a close-up of a cluster of cattails can be more interesting when angled off a straight up-down orientation. Additionally, you can use diagonals and lines to draw the viewer's eye toward a center of interest.

Focusing sharply on the closest of several similar objects naturally draws a viewer's eye because our attention is frequently drawn to the nearest object. If I'm photographing a flock of shorebirds on a beach, I often focus on those closest to me, as I let the birds farther back recede into soft, blurred shapes. This is also practical because subjects at various distances might not be sharp even when you're using a small aperture. Remember, depth of field is dependent upon both image size and working distance, and the distance between objects can be too great to bring everything within focus.

The most effective way to deal with multiple subjects or with one subject that requires a great depth of field is to change your perspective so that everything important falls within your depth of field or within the zone of apparent sharpness. With a flock of birds or herd of mammals that spans a large area in your viewfinder, this usually requires a shift to the left or right to align the majority of the group at the same focusing distance. If you're filming just two or three animals, you could have to wait until one of the animals moves out of the frame.

With plants, scenics, or macro subjects, maximizing the depth of field can involve making vertical changes to ensure that both your film plane and your subject are parallel. Canon EOS tilt-and-shift lenses, in focal lengths of 24mm, 45mm, and 90mm, do likewise by incorporating the principles of a view-camera's bellows to maximize depth of field. Although all three lenses are handy for nature photography, the 90mm TS lens (coupled with a 2X teleconverter) is probably the most useful for wildlife photographers. The 180mm TS combination could be ideal for dragonflies, butterflies, beach creatures, and snakes, to name just a few of the subjects that have often troubled me with depth of field problems.

Most cameras have a small mark on the top of the camera body that indicates the film plane, but this has little applicability for determining whether your film is parallel to your subject or not. A far better way to determine this is to simply step to one side and note

AFRICAN LION, Masai Mara Game Reserve, Kenya. 80–200mm F2.8 zoom lens, 1/60 sec. at ƒ/13, Fujichrome 100

To convey a sense of the king and his subjects, I needed a small aperture for maximum depth of field.

the position of the camera back, or the front of the lens, to the lines of your subject. If the front of your lens or the back of your camera looks parallel to your subject, you'll be using your depth of field most effectively.

FRAMING THE IMAGE

Because film is two dimensional, composing silhouettes creates problems if one black form merges with another to create a featureless blob. Although your subjects are three dimensional, film can't record their different positions vis-à-vis the camera, which are, however, apparent to the stereoscopic human eye. Try as you might, you can't make a silhouette against a silhouette!

With your attention riveted by your subject, you may overlook distractions or merging elements within the frame. To eliminate these, simplify your composition by doing close-ups, using a shallow depth of field, or, if your subject is moving, by panning at slow shutter speeds to

blur stationary objects. By doing so, your sharp subject will stand out against the blur.

Some photographers take this idea of simplicity too far, moving subjects to the studio and using neutral-gray or colored backgrounds to eliminate background distractions. Instead of removing your subject from its natural habitat, study your image to look for distracting elements you could remove. Dried grasses, leaves, or light-colored twigs often reflect more light than a middle-tone subject, and these hotspots can draw the viewer's eye from your center of interest. Removing this distracting clutter, often called "gardening," simplifies many macro and plant photographs. If you do garden, don't remove living leaves or flowers, or otherwise destroy plants or habitats just to clean up a picture! Common sense and ethics demand that you treat every living thing with as much value as the subjects you choose to photograph.

You can use potential distractions in the foreground creatively. With a shallow depth of field, you can selectively focus on the center of interest. Out-of-focus areas become amorphous spots of color when a long lens, a shallow depth of field, and, in most situations, a short working distance are combined. Photographers frequently use this *selective-focus* technique in flower photography, but it can also be used with animals or birds when conditions permit.

In contrast, foreground elements that are sharply in focus can be used as natural frames. Tree limbs, rocks, or other "strong" elements are candidates. Be careful, however, that the object you use as a frame is visually interesting. A straggly, thin branch jutting into the top of your picture may look like a frame to you, but to everyone else it may be a distraction.

A CHECKLIST FOR COMPOSING EFFECTIVELY

1. Find a center of interest.

2. For easy compositions, fill the frame with your center of interest.

3. Follow the Rule of Thirds. Don't arbitrarily cut a scene in two.

4. Position your center of interest at a point of power on the Rule of Thirds grid.

5. Include all important elements of your subject within your frame.

6. Remember that you can't make a silhouette against a silhouette.

7. Use your depth-of-field preview button when positioning the subject in relation to the film plane.

8. Eliminate foreground and background clutter. Check the edges of the frame for distractions.

9. Simplify compositions, but if you "garden," do so selectively and ethically.

10. Use natural frames or selective focus.

YELLOW-BILLED HORNBILL, Samburu Game Reserve, Kenya. 600mm F4 lens, 1/500 sec. at ƒ/5.6, Fujichrome 100

The simple, diagonal lines in this image act as natural frames, drawing attention to the subject. In addition, long lenses and wide apertures tend to soften backgrounds, an effect that some refer to as "posterizing" or "blowing out." So, although the distant background trees and blue sky could have created a potentially distracting horizon line, these details are so muted that there's no discernible dividing point between them.

ANIMALS IN THEIR ENVIRONMENT

Part of the magic of wildlife photography is in the process of getting close and seeing—and sharing—an intimate view of a wild creature. For this reason, photographers are often driven to make frame-filling portraits that reveal every whisker, hair, scale, or feather that adorns their subjects.

However, animals in the wild are usually not so obvious. Instead, they blend in or seek concealment or move about at night. While the tight shot is often the most interesting, it doesn't always tell the whole story, and backing off to show the broader view has a definite place in our photography of the natural world.

MULE DEER, Waterton-Glacier National Park, Canada. 300mm F2.8 lens, 1/250 sec. at f/5.6, Kodachrome 200

When I made this image, a small bachelor herd of mule deer had retreated from a meadow into the cover of an aspen grove; at first, they were extremely difficult to see, even though they were in plain sight.

EGRETS, Myakka River, Florida. 300mm F2.8 lens, 1/125 sec. at f/8, Kodachrome 64

This scene is really typical of how we normally see a wading bird—not up close, but from a distance. Subjects that are small in the frame often don't work very well by themselves, but when coupled with unusual light or weather conditions, subject and atmosphere can combine effectively.

FINE-TUNING YOUR PHOTOGRAPHS

We see the world differently than how it is recorded on film. While the basic elements that make up a composition are the same, our eyes and mind also processes what we see. We'll call an object "white" because we know it is white, even if, when viewed under the dimness of a night sky, it appears merely gray. Film is more literal and, generally, records things as they really are, provided, of course, that we expose the film correctly.

What we see and what our film records are often most evident in the way contrasty light is processed by the eye and by your film. Unlike your eyes, which can instantly adjust to changing light levels, the slow ISO color-slide films favored by most nature photographers can't expose accurately for these extremes in tonality. If you base an exposure on a bright area, the dark areas will be underexposed. If you base an exposure on a dark area, the bright areas will be overexposed. Averaging the two usually results in unsatisfactory compromises.

Of course, any "correct" exposure is subjective. Visualize a lioness perched on a hill against a sunset. The animal should appear dark because it is framed by a bright sky. However, the image can be exposed several ways. By taking a reading off the cat, you can achieve detail in its otherwise dark shape, but the sky will be overexposed. Conversely, exposing for the bright sky produces a silhouetted cat that more closely resembles what you actually see. Averaging the two contrasting tonalities won't work because the range in exposure is just too great for both to be rendered properly. Many photographers would choose the exposure that produces a silhouette because it most closely matches what their eyes see. Which exposure you prefer is a matter of taste.

Frequently, contrast in your subject is subtle and more difficult to recognize. Imagine, for example, a bird perched in partial shade. You "see" the bird without recognizing that only part of it is in sunny $f/16$ light and is three f-stops brighter than the part of the bird that is in the shade. Your film records this difference in light, resulting in a contrasty photograph where neither of the two tonalities is properly exposed. Once you learn to recognize contrast, you can use it to your advantage, reduce it, or even eliminate it. These choices involve a few simple techniques that can improve your photographs.

REDUCING CONTRAST WITH REFLECTORS AND DIFFUSERS

You can reduce or eliminate the contrast visible in your subjects in a variety of ways. Remember that electronic flash can fill in shadows and dark backgrounds. You can also use mirrors, crinkled aluminum foil reflectors, and the white side of a gray card to bounce light into shaded areas. And frosted plastic panels are good for diffusing and scattering direct sunlight that falls on a

EASTERN BOX TURTLE (CAPTIVE), McClure, Pennsylvania. 100mm F2.8 macro lens, 1/125 sec. at $f/11$, Kodachrome 64

I placed several aluminum reflectors around this turtle to bounce light into all its folds and creases.

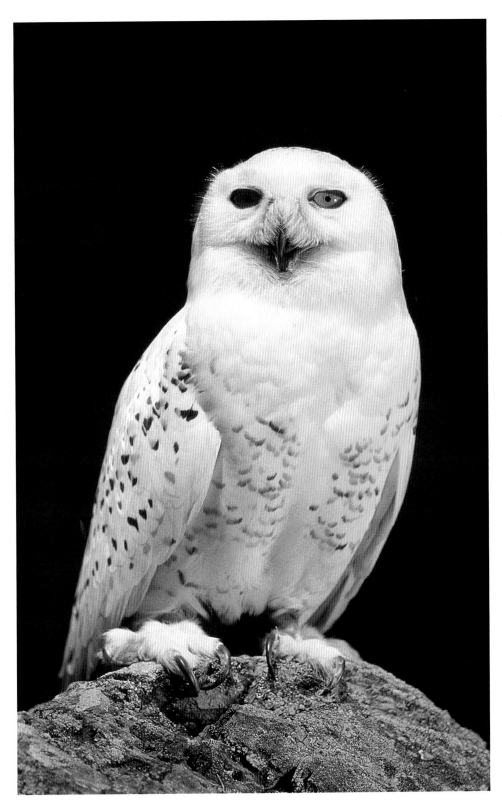

SNOWY OWL (CAPTIVE),
Raptor Project, British
Columbia, Canada. 500mm
F4 lens, 1/250 sec. at *f*/11,
Fujichrome 100

*The natural light was coming
from the left and almost
overhead, creating contrasty
shadows on the owl's breast. I
used a gold reflector to bounce
light into these shaded areas.
A white or aluminum reflector
would have worked just as well,
but I liked the look the warm
gold imparted to the image.*

subject. Each method produces a slightly different effect in lighting, and each has its special applications.

A mirror reflects light directly, creating a spotlight effect. In macro photography, a single small, concentrated square of reflected light can be used. Two or more mirrors, or mirrors and diffusers used together, may be necessary to produce even, natural-looking lighting over a larger subject or area.

Mirrors are easier to use than flash because you can see the effect you're getting. If you don't like the effect, you can simply rearrange the mirrors. With flash, you must rely on your own experience to previsualize the desired effect. Another advantage is that mirrors have many applications. I've used mirrors to illuminate snakes hiding inside rock crevices, to bounce sunlight onto the underside of mushrooms, to fill in the shaded cups of

EASTERN FENCE LIZARD (CAPTIVE), McClure, Pennsylvania. 100mm F2.8 macro lens, 1/125 sec. at ƒ/9, Kodachrome 64

Shooting from a low angle, the belly and throat of this fence lizard were obscured by shadows. To reveal the cobalt blue coloring of the male lizard, I bounced light back to the lizard with a 4 × 6-inch locker-room mirror.

drooping flower heads, and to catch the brilliant cobalt blue of a fence lizard's belly. You can work with smaller ƒ-stops if you use mirrors, even on an overcast day or in the dull light that immediately follows sunrise. I've used that extra light at dawn to add brightness to the color of dragonflies and spiders that were still torpid from the night's chill. This actually increased the contrast between the subject and its background, but still improved the final image.

Here is an unusual example of using mirrors in the field that involved an eastern bluebird nest. I aimed five small mirrors toward the bluebird's nest hole, which raised the light level there to just one stop less than sunny ƒ/16. This balanced well with the patch of sky visible behind the nest. Additionally, this directed sunlight revealed the male's brilliant blue plumage that had appeared dull when it was in the shade. The bluebird was completely oblivious to the change in light around the nest, which wasn't surprising, because the nest hole was exposed to direct sunlight at several times during the day. However, during the two hours I worked, I had to readjust the mirrors continually as the sun arched across the sky. The sunlight passed beyond the nest hole every 10 minutes and changed the *angle of reflectance,* or the angle that the sun reflected off the mirrors.

Small Plexiglas locker-room mirrors, which are available at school supply and grocery stores, work well in most cases. For larger subjects, safety mirrors sold for cribs or playpens are a good idea. Don't use glass for obvious reasons. A workshop participant suggested using polished squares of stainless steel because they are

unbreakable and are less likely to be scratched than a plastic mirror. A final precaution: Be careful when using mirrors to redirect sunlight at your subject. Keep in mind that you are aiming direct sunlight that can overheat or desiccate a subject in shade just as in direct sunlight. This can kill a flower, a reptile, or any heat-sensitive subject that is normally found in shade or that seeks shade when necessary. Reptiles may show their growing discomfort by opening their mouths and panting. Other animals and plants aren't so obvious.

Aluminum reflectors made of woven aluminum fabric or crinkled foil work in much the same way as mirrors, although the light cast is a bit "softer" and more scattered. If you make a reflector with aluminum foil, make sure that you crinkle it first, otherwise the smooth sheet acts like a mirror. I generally carry several homemade aluminum reflectors that I adhere to thin cardboard with rubber cement. These reflectors are flexible, so I can easily bend one to bounce light in a specific direction. A homemade reflector lasts about a year, but it is the cheapest piece of camera equipment I ever need to replace!

Several manufacturers offer collapsible reflectors in silver, white, black, and gold. The smaller sizes are most useful for nature work, the larger sizes for adding fill light for portraiture. Silver and white reflectors are excellent for general nature and wildlife work, functioning like white paper or aluminum foil. I use a gold reflector when I'm photographing people. The gold reflector fills in shadows and reduces contrast with a very "warm," pleasantly toned light. Black reflectors are also available.

These absorb rather than reflect light and actually increase contrast. Photographers interested in portraiture find this useful for *Rembrandt lighting,* a contrasty light style in which the shaded area lacks all detail.

White paper or white plastic can also be used as a reflector to create a softer illumination than an aluminum reflector casts. I often use the white side of a plastic gray card for this because it reflects almost the same quantity of light as a crinkled aluminum foil reflector. Where aluminum may cast *specular highlights,* or bright spots, on subjects such as turtles or frogs that have wet or otherwise highly reflective surfaces, white reflectors are less likely to do so.

You'll have less fill light the farther you hold a reflector from the subject. In contrast, a mirror reflects usable light a much greater distance. You can actually increase the ambient light to greater than sunny $f/16$ (the brightest natural light that falls on a middle-tone subject) by using a couple of aluminum reflectors and mirrors together.

Diffusion screens also reduce subject contrast by scattering direct sunlight. I use lightweight plastic

PINK-SPOTTED SPHINX MOTH, Homestead, Florida. 200mm F4 macro lens, 1/250 sec. at $f/6.3$, Kodachrome 64

The light striking this resting moth was extremely contrasty. To lessen this contrast, I placed a large white card to the right of the moth; this was sufficient to fill in the sharp shadows.

fluorescent panels, which are available at most hardware or home-supply stores. These diffusers have some flexibility, so by bending the plastic I can change both the direction and the intensity of the transmitted light. The exposure is reduced by 1/3 to 1 full f-stop, depending on how I hold the diffuser.

To determine your exposure when using these accessories, take a reflected-light reading off your subject when the diffusers, reflectors, or mirrors are in place. If you're using an incident-light meter, hold the meter close enough to the subject so that the bulb or metering face is in the same light. Don't use any of the sunny rules when you work with reflectors and diffusers. I find it too difficult to guess accurately how much light is being reflected or bounced onto a subject.

FOREGROUND AND BACKGROUND CONTRAST

You may wish to simplify a composition by reducing the contrast in the foreground or background, too, because hotspots or multiple highlights in these areas can draw the viewer's attention away from the subject. By eliminating these hotspots, you simplify the composition and the subject stands out. You can do this a couple of ways. You can "garden out" the bright area, or you may be able to shade these bright, competing areas with a cloth, a tarp, or an article of clothing. If you shade the hotspots, your viewers' attention will be directed to the brighter subject.

Conversely, your choices of lens and perspective can also increase the contrast between a subject and its surroundings. It is possible to frame your subject against a dark background by using a long lens' narrow angle of view. When there is no natural dark background, substitute one by using an item of clothing, a camera pack, or a log or rock as a shaded background. Similarly, a longer lens and a sufficiently shallow depth of field can soften a busy, contrasty background as highlights and shadows merge into one pastel blur. The sharply focused subject stands out.

Some photographers take this one step further by framing macro subjects against artificial middle-tone backgrounds. Macro subjects, especially insects and spiders, are frequently shot with flash, and backgrounds often appear unnaturally black. Occasionally, green, blue, or gray cardboard is used to provide a light, "natural" background to eliminate this effect, but I think the results of using these colors often looks contrived. Use a natural prop, such as a flat piece of bark, a large leaf, a rock, or log, so that an artificial background isn't necessary.

For another effect, some photographers sometimes use enlargements of out-of-focus flowers or plants as backgrounds for macro subjects. Others use posterboard, but add the effect of out-of-focus vegetation by using a

WHITETAIL DEER, Glacier National Park, Montana. 500mm F4 lens, 1/250 sec. at $f/6.3$, Kodachrome 64

Sometimes contrast can be helpful, if for no other reason than to set the subject apart from the background. In a field of brown grasses, this shy whitetail would have been lost.

matte spray paint. It may take some practice to get the effect you want, and you'll probably find that soft edges, rather than sharp blotches of color, work best. If you use a background, be careful that your subject's shadow isn't cast onto it. The photograph will look artificial if this happens. To avoid this, either aim the flash so that the shadow casts downward and misses the background, or use two flashes—one aimed at the subject and the second directed at the background—for natural, even lighting.

Black backgrounds do look natural with nocturnal, or night-active, animals, such as skunks, opossums, flying squirrels, and owls that are illuminated by flash. But in the field, a single flash unit can cast a visible, unattractive shadow against a nearby background. Although you might not be able to see this, you should assume that a shadow will be visible if your background is within a couple of feet of your subject. To reduce this shadow, position the flash so that any shadow is cast downward or away from the background, or use two flashes on opposite sides of the camera to fill in the shadows a single flash casts.

In a studio setup, use a black, nonreflective cloth for a natural-looking background for nocturnal animals. Hang the cloth back far enough so that it receives less light than the subject. Use the Inverse Square Law or a flash meter to be sure that the background receives at least two stops less light. If the subject's exposure is $f/11$, the black background should be $f/5.6$ or less. The background will appear a "natural" black and not gray. To convey a sense of depth and authenticity in the studio, include leaves, branches, or logs as props. Place them far enough back so that they're also underexposed by a stop or two less light.

CANADA GOOSE, Faler Lake, McClure, Pennsylvania. 500mm F4 lens, 1/125 sec. at $f/4$, Fujichrome 100

Low angles are always effective, but I worried that the bird's black head would merge with the dark, shadowed areas in the upper third of the frame. Fortunately, the bird's feathers caught enough of the overhead light to create a rim that separated the tonalities.

CONTROLLING CONTRAST WITH FILTERS

Contrast is a particularly common problem with landscapes under overcast or cloudy skies. A cloudy-bright sky sometimes reflects two or three stops more light than the land below, and even a heavily overcast, gray-looking sky can be a stop brighter than the earth. Photographing under blue skies can also create extreme contrast problems: for example, when photographing a stream bottom or canyon where one side is in the sun and the other is shaded. This type of contrast can be handled two ways. The easiest way is to simplify the composition by using a longer lens to exclude the bright sky or the bright side of the canyon or stream. By excluding the area of higher contrast, the image gains a more uniform tonality and a more pleasing exposure. You could end up with a more interesting, closer view of the scene, too.

How do you include the entire scene, both the earth and the sky, within the frame, even if there is a three f-stop difference between the two tonalities? A "normal" exposure will produce unsatisfactory results; however, there is a solution. For extreme contrast problems, use a split or graduated neutral-density (ND) filter to reduce this contrast. These filters are divided into two sections, one clear and one tinted. The tinted half of the filter cuts down on the light passing through it, and you position this over the brightest area of the scene. The clear half of the filter, which does not affect the exposure, is positioned over the darker area of the scene.

Split-density filters are usually round, and most are divided equally into two hemispheres of clear and tinted areas. Using one means you must compose a scene with either the horizon or the line between the light and dark areas centered in the frame, which could compromise your composition. Split-density filters screw onto a lens like any normal filter, and they are usually less expensive than graduated filters.

Graduated filters, as the name implies, provide a gradual transition from the clear to the tinted areas. They are available in two shapes, round or rectangular. Both can be rotated on the lens for vertical compositions and subjects. To accommodate your composition, the square or rectangular filters slide up or down inside a special bracket that is attached to the lens. Cokin makes a bracket that fits lenses up to 77mm in diameter, and Tiffen's glass filters (as well as Cokin's plastic filters) will fit inside. By the way, glass filters are several times more expensive than plastic filters, but the glass is optical and no distortion occurs. Plastic filters can scratch, but of course glass filters can break. Whichever filter you use, try to line up the gradation line at an obvious division within your composition, such as a shoreline or mountain ridge.

Both split-density and graduated filters come in a variety of colors and tonalities. ND filters reduce contrast without affecting the true color of your scene.

In most cases, a two f-stop graduated ND filter can lower the contrast between earth and sky so that it falls within the exposure latitude of your film. You can use two or more filters together to increase the amount of reduction needed.

Depending upon the filter or the combination of filters you use, the reduction of light is usually between one and four f-stops. To determine your exposure, read the darker area of the scene, the part that will be covered by the clear glass. Set the exposure based on that reading. Then position the filter so that the filtered half covers the brightest area of the image, and the bright area will be toned down accordingly.

ND filters are also useful when a slow shutter speed is needed for panning or for deliberate blurs. Additionally, you can use ND filters to produce *angel hair* on rapids or waterfalls when the ambient light is too bright for you to use a sufficiently slow shutter speed. This effect is the creamy white or cottony look that is created when you photograph moving water with a slow shutter speed. This technique can also be useful to isolate a stationary subject against moving water. At a fast shutter speed, rapids or waves may take on enough form to compete with your subject. At a slow speed, however, the cottony, smooth look that results allows your subject, with its sharp, defined lines, to clearly stand out.

Polarizers can also be used as ND filters. You'll lose one or two stops, depending on the rotation of the filter, by mounting one on your lens. If your main interest is wildlife photography, don't keep a polarizer permanently attached as you might do with a *skylight* filter. The one or two stops of light you lose could have been used for obtaining better depth of field or for using a faster shutter speed.

Some photographers regularly shoot through UV and skylight filters, while others do not. These filters, which don't affect exposure, are designed to reduce haze and improve contrast. Although most of my lenses have a skylight filter attached, I don't shoot through them but use them as very reliable lens caps. My lens caps often pop off, and the front lens element could be scratched when bouncing around inside my pack. Filters stay on, and my lenses are safer with them. Of course, these filters become smudged and scratched, and you must remember to remove them before you shoot. Occasionally I forget, and the images that result reflect this.

Of course, the usual job of a polarizer is not as an ND filter. Their most common usage is in scenics to emphasize clouds. However, to be effective, the sun should be in a perpendicular position to the subject. As a guide, point your index finger at the subject and your thumb toward the sun. The polarizer works best if your thumb forms a right angle to the line of your finger, as if you were pointing an imaginary pistol. Skies will

appear darker or bluer and clouds will "pop" out. (Be careful with Fuji slide films. Many photographers agree that Fuji's blue skies look better without polarization.)

Polarizers can remove reflections from water or glass. When photographing streams or lakes, I've used them to reveal fish by eliminating the glare of the reflected sky on the water. In swamps, this produces inky black water, which creates a striking contrast with the surrounding vegetation. Polarizers also eliminate the waxy, reflective sheen on leaves, thereby producing snappier colors and greater saturation in scenics, plants, and macro landscapes. They can also increase contrast in scenics where you want to emphasize the ruggedness of terrain by eliminating some of the fill light in shadows.

MASAI GIRAFFE, Masai Mara Game Reserve, Kenya. 600mm F4 lens, 1/500 sec. at f/5.6, Fujichrome 100
Simplification is often the key to a great image. The uncluttered silhouette of this feeding giraffe is what makes this image succeed.

Polarizers also come in handy at zoos, aquariums, or in-home setups when you want to avoid reflections from glass. Photography in these locations usually involves flash, but the correct polarizer for your camera system won't affect a TTL flash system. Manual flash requires compensation, so bracket by a stop or two to be sure of a good exposure. Be careful how you position the flash when shooting through glass. The flash must be set at an angle—that is, taken off the hotshoe—or the flash illumination will reflect directly back from the glass. Polarization cannot remove this!

Polarizers can be your most useful filter, and I recommend that every photographer have at least one. Tiffen makes a warming polarizing filter that adds a little of the "warmth" of an 81A filter to the standard polarizer. The effect does indeed create a feeling most aptly described as warm. Because all polarizers are expensive, buy a filter that fits your widest diameter lens, and then use step-up rings to fit this large filter to your smaller lenses. Two types of polarizers are available—*linear* and *circular*—and the metering and autofocus systems of many autofocus and electronic cameras require the more expensive circular filter. Most manual-focus cameras use linear filters. Either filter can be used on either camera, although this may require using manual focus and making exposure readings based on an incident-meter reading. A linear polarizer may confuse an autofocus sensor, or the metering system, or both. Consult your camera's instruction manual for details. Remember, too, that an incident-meter reading won't reflect the one or two f-stops lost to polarization. You'll have to open up off the incident reading by one or two f-stops. To be sure of your results, I'd suggest you bracket several exposures.

A variety of color filters is available, virtually covering the colors of the rainbow. Some photographers consider their use manipulative and artificial. Others enjoy the creativity that the added color provides. Whether you choose to do so will depend on your own style of photography.

Finally, I often use an 81A or 81B as a warming filter when I'm photographing in a deep forest. Light passing through a canopy of leaves may look bluish or greenish on your color film, and a warming filter helps to eliminate this. Some films have a natural warmth to them as well. You might try the Ektachrome SW when shooting under these conditions. I also use an 85A, a yellowish-orange filter, to add extra punch to a sunrise or sunset. When I film reflections of the sky or sun, I sometimes use a graduated orange or sunset filter to add extra color. The results are attractive, even if the color has been enhanced.

In addition to controlling contrast by using filters, you should also use a lens hood to shield the front of a

CHEETAH, Samburu Game Reserve, Kenya. 35–350mm F3.5–5.6 zoom lens, 1/125 sec. at ƒ/8, Tiffen warming polarizing filter, Fujichrome 100

Polarizers either enhance or remove a rainbow, so it is important to rotate the polarizer until you obtain the maximum effect. The warming polarizer also added a touch of color to the drab rocks and earth that comprise this desert landscape.

lens from direct light, be that either sun or flash. Direct light scatters and causes flare when it strikes the front element of a lens, or it may concentrate into weird ghostly shapes that are light shadows of the aperture. Either one ruins a picture.

A lens hood is unnecessary if your light source is behind the camera. Even so, it is better to always keep a hood attached and extended because the hood offers some protection against dust or scratches and may act as a cushion if you should drop a lens. I remove my lens hood if I'm photographing in high winds, since a long lens hood increases the surface area exposed to the wind and increases the chances of having camera shake. However, if blowing salt spray, sand, dust, or direct sunlight might strike the front element lens, I keep the lens hood on and attempt to weigh down the camera and lens assembly to provide extra weight and stability.

Both metal and collapsible rubber hoods are available. Metal hoods provide more protection if you should drop a lens, but rubber hoods are easier to carry because they flip back over the lens when they're not in use. Different focal lengths require different lens hoods. You can use long telephoto lenses, with their narrow angles of view, with very deep hoods. Wide-angle lenses require shallow and very wide hoods, so that the hood doesn't show up as dark corners in your image. This problem, called *vignetting,* can also occur when you use thick filters, or a lens hood and a filter together. You can check by using your depth-of-field preview when the lens is stopped down to its smallest aperture. If vignetting results, remove either the filter, the hood, or both. If you don't have a lens hood with you, try shading the front element by holding your hand out of view above the lens. This works just as well as a lens hood in preventing lens flare. Just be sure that your hand doesn't appear in the picture!

COMPOSING IN THE FIELD

It is often difficult to keep compositional considerations in mind amid the excitement of coming face to face with a wild animal. However, make an effort to pay attention to the composition of your images as you make them; you will be rewarded with a greater sense of satisfaction with your photographs.

COLUMBIA GROUND SQUIRREL, Glacier National Park, Montana. 500mm F4 lens, 1/250 sec. at ƒ/8, Fujichrome 100

Sweep the edges of your image! Admittedly, you don't always have time, but I still urge you to try. Had I raised my tripod higher, I could have framed this ground squirrel against a uniform gray background.

CANADA GOOSE, Faler Lake, McClure, Pennsylvania. 500mm F4 lens, 1/500 sec. at ƒ/5.6, Fujichrome 100

I composed the image in this way because of the clutter of vegetation just above the bird's head. Doing so gave the image a harmonious tranquillity.

Opposite: **DWARF CAIMEN (CAPTIVE),** McClure, Pennsylvania. 300mm F4 lens, 1/125 sec. at ƒ/5.6, Fujichrome 100

Still water yields great reflections, but sometimes in the excitement it is easy to forget to make sure the entire reflection is within the frame. Always check for this. To maximize the image's effectiveness, I made sure I focused on the caimen's eyes.

AMERICAN EGRET, Venice, Florida. 600mm F4 lens, 1/125 sec. at *f*/4.5, Fujichrome 100

The backlit feathers of this displaying egret glowed warmly, and by including a small portion of the dappled bright sky background, I've shown the source of the color.

BISON, Yellowstone National Park, Wyoming. 35–70mm F2.8 zoom lens, 1/125 sec. at *f*/8, Fujichrome 100

When this bison trudged through the snow only a few yards from me, I grabbed my wide-angle lens and dropped low to include both the bison and the snow-obscured sun within my frame.

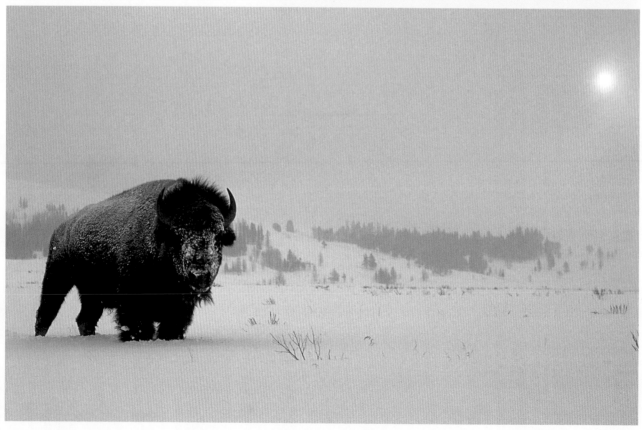

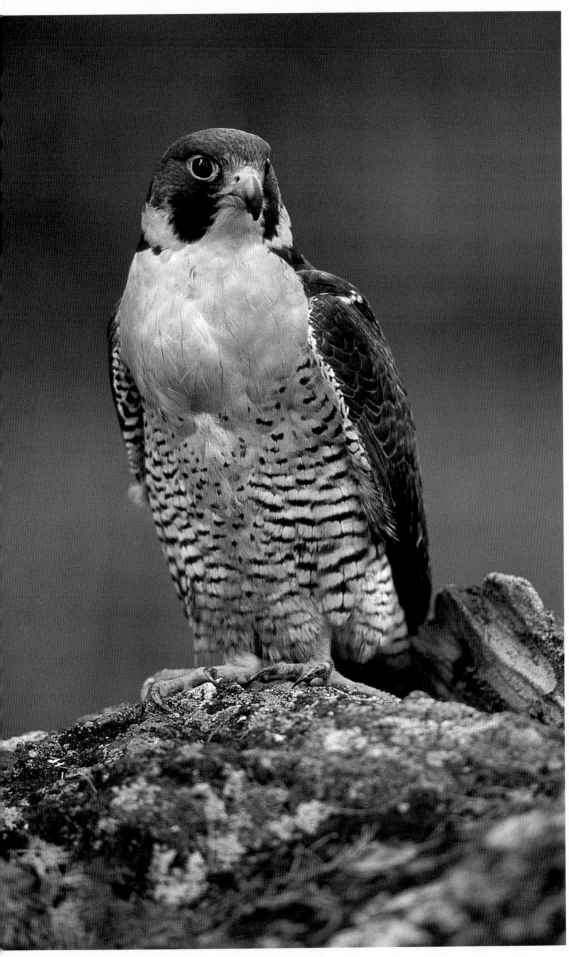

PEREGRINE FALCON (CAPTIVE), Raptor Project, British Columbia, Canada. 500mm F4 lens, 1/250 sec. at f/5.6, Fujichrome 100

I could have photographed this falconer's bird just as easily with a 50mm lens. However, the narrow angle of view of the longer 500mm lens eliminated the bright patches of sky between the trees and also softened the background into a pleasant, muted frame.

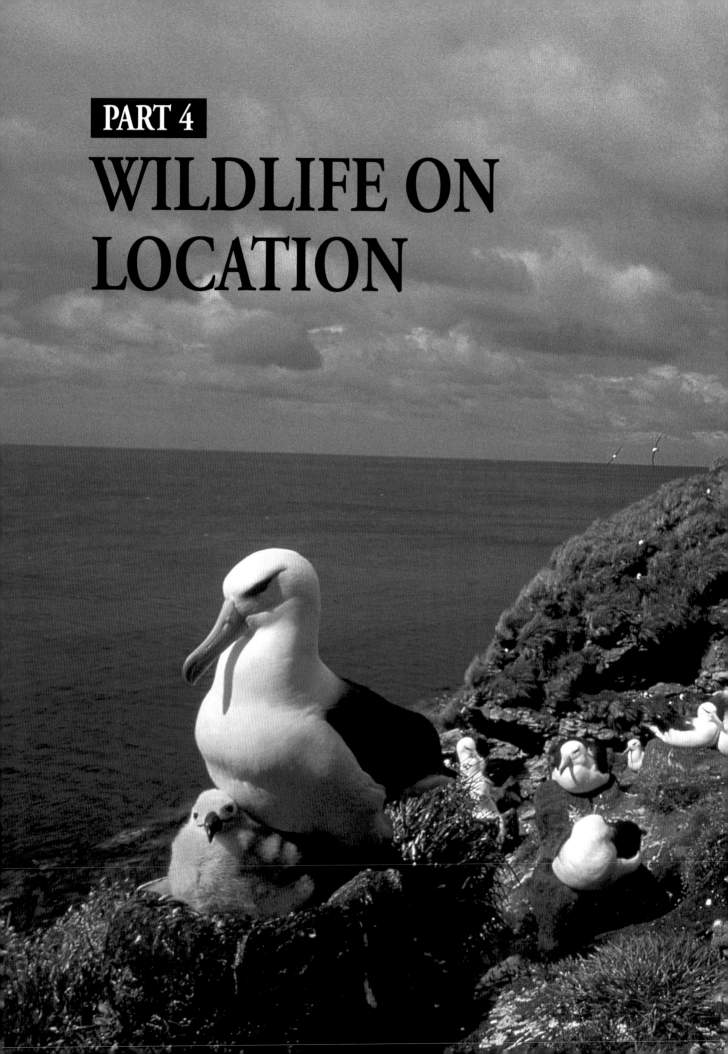

PART 4
WILDLIFE ON LOCATION

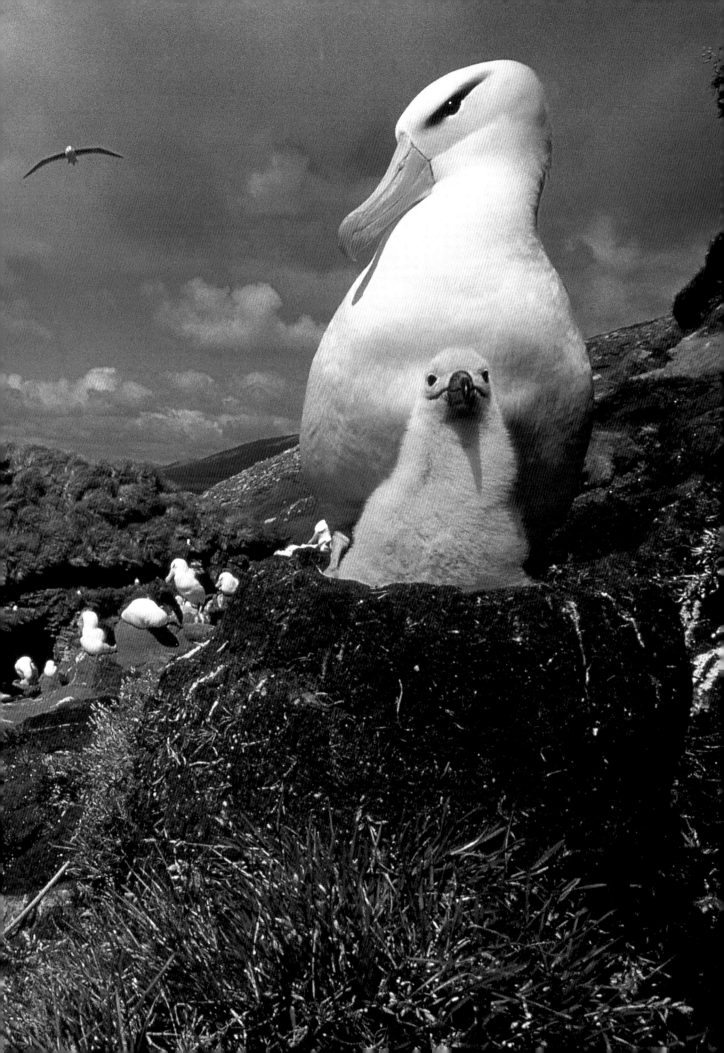

GETTING CLOSE

A fisherman, while working a stream for a hungry trout, watches with amazement as a river otter swims close by. A hiker, deep in an eastern forest, is surprised by a black bear that lumbers across his path. In the southwest, a cougar runs across a highway, spotlighted by a car's headlights. And for each encounter, you can bet the witness said, "I should have had a camera!"

Oh, if it could only be as simple as that. To a non-photographer, these fleeting encounters with a wild animal seem like the perfect opportunity for making a great photograph. Indeed, just such an encounter may have triggered your own interest in wildlife photography. But then you try it, and you find that making a photograph isn't as easy as you had expected. In Yellowstone, you're lucky enough to find another otter—but not when you're using the right lens. A black bear crosses your path—but the light is a contrasty nightmare of sunlight and dark shadows, and it's hard to make an adequate exposure. In the high country of the desert southwest, you drive backcountry roads for hours, even days, and never see a cougar.

This is the reality of wildlife photography: It is not as simple as it seems. Wildlife photography can be rewarding in immeasurable ways, but it can also be extremely frustrating. You may have the best gear, the longest lenses, and more technical information than you'll ever use, but if you can't find suitable subjects, the rest doesn't matter.

Getting close to wildlife needn't be so difficult, however. Sometimes, the easiest solution is simply to go to places where animals are common or are accustomed to man. The captions in this book should certainly point you in the right direction. But even close to home there are plenty of opportunities. Think about the area where you live— it is quite likely that some of your best opportunities to photograph wildlife are probably nearby. Perhaps they're just outside your window, if you set up bird feeders to attract wild birds or chipmunks and squirrels—animals that you sometimes overlook, but that nevertheless can make great wildlife images.

Ideally, we'd all like to live next to a great wildlife refuge or national park where animals are protected and tame, but most of us aren't so fortunate. I certainly am not, but I've developed my home surroundings so that I have a mini-refuge just outside my doorstep, and as you've seen in this book, many wonderful images were made without traveling anywhere but outside my door.

Whatever your personal circumstances, whether you're lucky enough to have a refuge or just a small woodlot or pond nearby, by photographing close to home you can visit an area repeatedly and during the best light. You'll get to know your subjects, when they're present, and what they'll do.

Even the smallest pond, meadow, or woodlot offers nearly unlimited picture opportunities once you become sensitive to its potential. When you visit an area frequently, animals may grow accustomed, or *habituated,* to your presence. You can facilitate this process by building feeding stations or bird feeders that, as a bonus, set the stage for more photographic opportunities.

RACCOON (CAPTIVE), Wild Eyes, Montana. 500mm F4 lens, 1/250 sec. at *f*/5.6, Fujichrome 100

Raccoons are usually nocturnal, although some may be active on an overcast day or late in the afternoon. Regardless, with a wildlife model, I was free to film the raccoon at an auspicious time and in an attractive, natural-looking location.

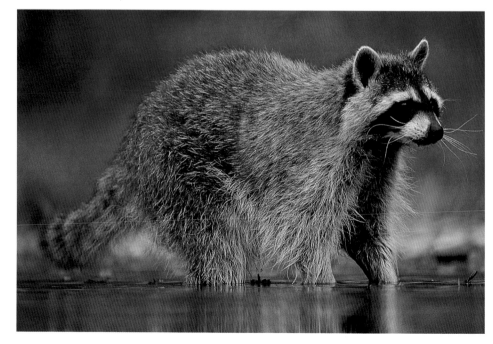

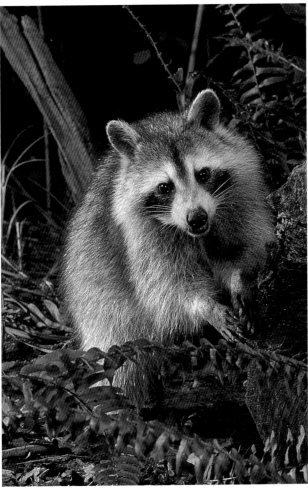

RACCOON, McClure, Pennsylvania. 300mm F2.8 lens, 1/250 sec. at *f*/16, manual flash, Fuji Velvia

Just outside my studio I baited a raccoon that regularly visited our bird feeders. The "forest floor" was a large plastic sheet covered with sandy soil, a few nearby ferns, and some logs. I set up three large studio lights around the area, using the strobe's built-in modeling lights to check out my lighting ratio. The raccoon, accustomed to the area, was undisturbed by the lights or my presence just 12 feet away.

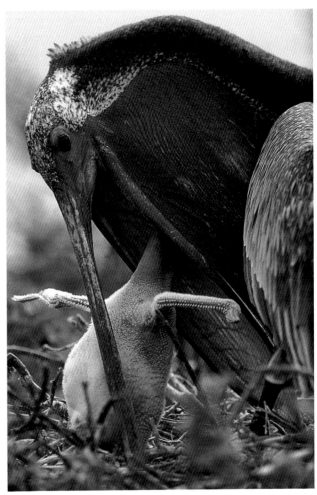

BROWN PELICAN, Galapagos Islands, Ecuador. 500mm F4 lens, 1/250 sec. at *f*/5.6, Kodachrome 64

The wildlife of the Galapagos is extremely tame, and this bird flew to its nest and began to feed while we were only a few yards away. Be careful not to leave your equipment unattended in areas where animals are exceptionally tame; once I saw a pelican land on an unattended camera and 500mm lens, sending them crashing to the ground.

Anyone who regularly photographs wildlife agrees that habituation isn't always easy. In fact, it can be difficult, frustrating, and often completely unproductive, especially if your subject is elusive. For example, since the eastern United States boasts a huge population of whitetail deer, you might expect that photographing deer in forests or other suitable habitats would be simple. But the truth is quite the opposite, because to survive, the species of mammals and birds that are hunted in North America must be wary. It is very difficult to photograph these animals in unprotected areas, since their lives often depend upon eluding humanity. I'm not trying to discourage photographers from attempting to photograph such game as deer or geese outside protected areas. This is just more difficult with animals that are unprotected and hunted. Fortunately, in parks or refuges, game animals are often approachable. The number of people visiting these areas ensures repeated and safe contacts. Not surprisingly, most great game-animal photographs are made here.

Whether you're seeking the most elusive animal or one that is common or tame, you can rely on a number of techniques to increase your chances of success. Which one you'll use depends on the type of animal you're trying to photograph, the amount of time you have, and the energy you're willing to expend. I've found that, in the course of a year, I usually use every technique I know. I suggest that you give all of the following techniques a try to see what works best for you.

STALKING WILDLIFE

No matter where you find animals, it seems as if they're never as close as you'd like them to be. Although using a longer lens helps, you'll probably want to move or sneak in for a better shot. This requires some skill and some common sense.

It is extremely difficult to sneak up close to any animal or bird, because its senses of smell, sight, and hearing usually far exceed people's ability to stalk. To increase your chances, walk slowly and quietly, and pause frequently for at least 30 seconds. Move only when the animal or bird isn't looking. When stalking a deer or woodchuck, the best time to move is when the animal is feeding and its head is down. When an animal looks up, you must freeze, even if you're in the midst of taking a step. With sharp-eyed birds, use natural cover—a rock or tree—to keep yourself out of view. Birds are generally too alert to allow you to move in when you think they're not watching. Be careful where you step when stalking, because leaves or twigs can snap underfoot and frighten your subject.

Since most mammals have excellent senses of smell and hearing, stalk *downwind,* with the wind blowing from the animal to you. When you're close enough, wait for the best pose since you may only get one chance. The first click of a shutter or a burst of a motordrive can frighten off a wary animal. However, you'll lessen the chances of this happening if you use a manual film advance or the single-shot mode of an electronic camera. These make less noise and might not alarm the animal.

Stalking can appear menacing. Sometimes, moving in at a slow amble is more successful with animals that aren't terrified of people. During this type of approach, I make no effort to conceal myself; instead I simply move slowly and quietly within full view of my subject.

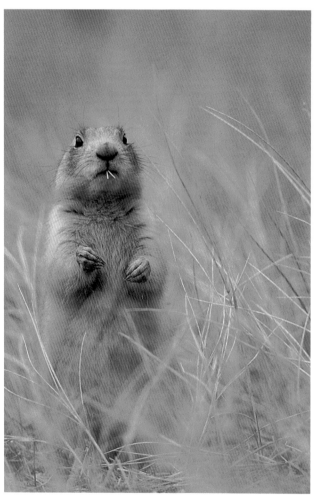

WHITETAIL PRAIRIE DOG, Bryce Canyon National Park, Utah. 500mm F4 lens, 1/250 sec. at f/4.5, Lumiere 100

One of the best locations to see the rare whitetail prairie dog is Bryce Canyon. However, due to the number of tourists that tramp over the prairie dog colonies, most areas are off-limits. Occasionally in spring, some of the prairie dogs are close to the roads and close-up shots are still possible.

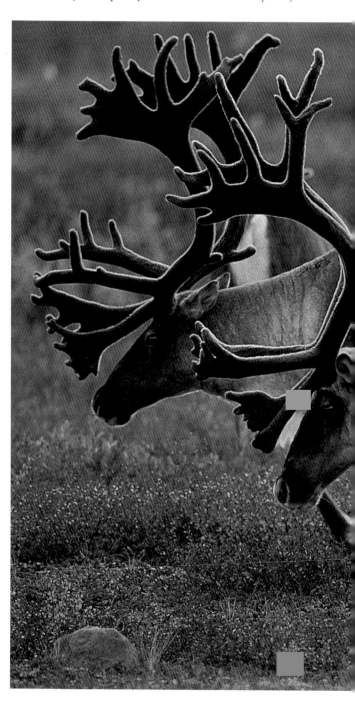

I stop frequently "to smell the flowers," which gives the animal time to accept my presence. Some people call this technique the "lost key" method, and it is an apt label. Imagine searching an area for a set of dropped keys, where you meander back and forth over a small area before moving on. Essentially, that's what you're doing with this type of approach, although you'll want to pause now and again rather than being constantly on the move.

This slow ambling doesn't work very well with animals unaccustomed to people; they require a slightly different approach: I stay as low to the ground as I can, moving slowly forward a foot or so at a time. Although I make no effort to hide, by advancing in a belly-crawl or sliding

forward in a sitting position, I present a very small profile that seems to be less threatening. I've had incredible success getting close to various skittish animals, especially along coastlines where I've been able to approach them within the minimum focusing distance of my 500mm lens. With this method I've photographed seals, shorebirds, and even sharp-eyed egrets (animals that always flee if stalked).

I've found that the most difficult aspect of "moving slow and staying low" is dealing with a tripod-mounted camera. Sliding a heavy Gitzo tripod across a mudflat is difficult when you're creeping forward on your belly. While filming harp seals on the ice in the St. Lawrence Seaway, I solved this problem by lying on my back,

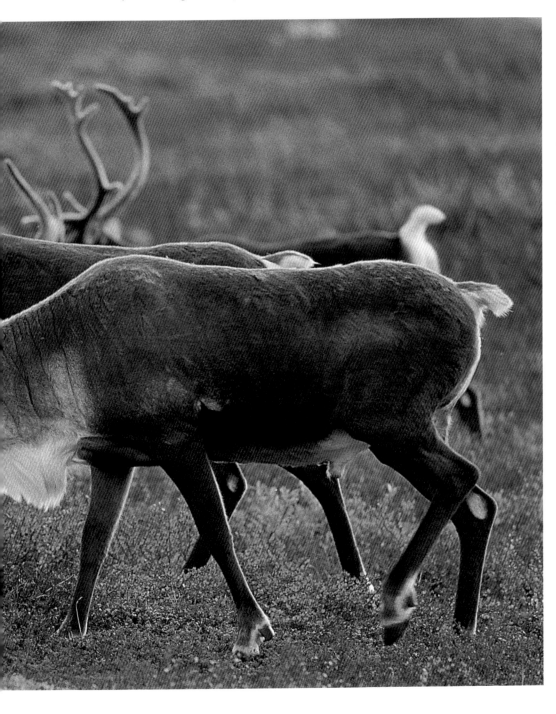

BARREN-GROUND CARIBOU, Denali National Park, Alaska. 300mm F2.8 lens, 1/250 sec. at ƒ/8, Kodachrome 200

Denali is known for its great wildlife, but the park is extremely hard to work in. In the far north, animals are dispersed, and for a photographer on foot, entire days could pass without seeing a large mammal. The bus system, however, is not photographer friendly, and despite the extra effort required, you'll usually do better on foot.

COUGAR (CAPTIVE),
Wild Eyes, Montana. 300mm
F2.8 lens, 1/500 sec. at ƒ/9,
Fujichrome 100

*Whether wild or captive,
a cougar always makes an
exciting subject.*

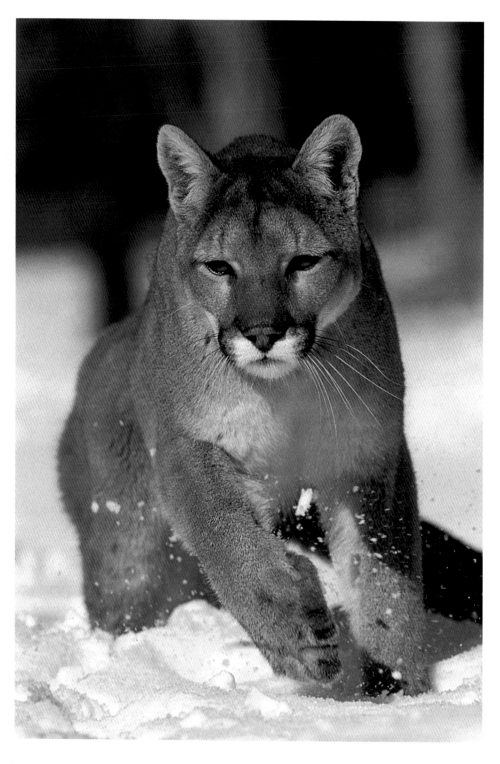

resting my camera and tripod across my chest, while I pushed forward, digging my heels into the ice. Moving along literally at seal level, I presented no threat and slid quite close to the usually wary adults. Sometimes I solve the problem of dealing with a bulky tripod by using a small-angle iron bracket tripod that is sturdy enough for my Arca-Swiss ball head and 500mm telephoto lens whenever I anticipate any beach crawling or low-to-the-ground work.

When approaching an animal, it is important to know how close you can get before you frighten it. All animals have a *fight-or-flight zone,* a minimum distance from humans beyond which an animal shows some type of stress. The distance varies with the animal, ranging from hundreds of yards for a hunted species, to perhaps only a few feet for one that has been fed by people and is tame. The reaction varies with the animal, too. Birds, reptiles, and most mammals simply flee if you're within the flight zone. Large mammals may run away, or they may attack out of fear. It is madness to step anywhere near this zone with a grizzly bear, especially if you have surprised it.

Furthermore, individuals within a species react differently, and a species' behavior can change with the seasons. A bull moose in velvet, when its antlers are still growing and covered with a sensitive layer of skin, might run off or only make a false charge if approached too closely. A moose in the fall rut, when its hormones are wired for fights with other males, is a different, very dangerous animal. A placid cow moose becomes one of the most dangerous animals in the north woods when she is with a young calf.

It is imperative that you stop before you reach this fight-or-flight zone. Even if the animal is harmless, you should avoid frightening it. Once you've frightened an animal, it is almost impossible to regain its trust. If you pay attention to your subject, you can recognize when you are approaching too closely. Birds stop feeding or begin to bob their heads. Hoofed mammals may stare, paw, or snort. Although behavior varies, you can count on an animal's behavior to change when you enter its zone of fear.

Unfortunately, some overzealous photographers don't stop at the fight-or-flight zone. Although they risk personal injury by pushing an animal, they're also causing the animal stress by moving closer. Not only is this unfair to animals, but this behavior initiates changes in park and wildlife refuge policies that affect everyone. With the increasing popularity of wildlife photography, it is imperative that wildlife subjects be treated with respect. And, no matter how you get close, don't ruin the experience when you've finished photographing by frightening the animal as you leave. Use as much effort and caution when leaving as you use during your approach.

If you stay out of its fight-or-flight zone, your subject should relax, even if it originally showed some nervousness when you approached. As it accepts you, it will resume its normal behavior, perhaps even come closer to you, as it grows more confident and accustomed to your presence. Sometimes this takes only a few minutes. When an animal accepts you, photographing becomes magical, as you are given an intimate glimpse into your subject's natural world. You can talk quietly and even move about with a surprising amount of freedom if you don't stand up. That almost always causes alarm.

Sometimes photographing habituated animals poses unique dilemmas. Shorebirds wintering at beach resorts are accustomed to people who walk by at very close distances and pay the birds no attention as they pass. Photographers deviate from this normal behavior when they stop to photograph the birds or inch toward them with their tripods. The birds recognize this and get nervous. It is frustrating to watch a plover or godwit that is running away from you pay no attention to a beach stroller who walks right on by. To get close in such cases, I've tried crawling in slowly, inching forward on my belly. At other times, I've casually walked a certain distance, pretending I was just a stroller, before I began my final approach, slowly advancing in small increments. Occasionally, I've simply sat down in the sand and waited, letting the birds move toward me as they fed.

Animals often stray nearby as they feed or move about. In parks and refuges, many species come much closer to you of their own volition than they tolerate if you try approaching them. In fact, a bison or elk can walk into its fight-or-flight zone and require you to retreat. I enjoy this stationary method best because the animals are making the decision to approach as they continue with their natural behavior.

CARIBOU AND PHOTOGRAPHER

Telephoto lens compression creates the impression that this photographer is much closer to this bull caribou than he really is. Still, photographers must use common sense when working with wildlife, especially with large animals that can be dangerous.

WORKING WITH BLINDS

Photographing from a blind, a hiding place for you and your camera, is another way to shorten your working distance to wary or elusive subjects. For a blind to be effective, you must place it where your subject is likely to be. Bird feeders, feeding stations, nests, watering holes, and game trails are all obvious sites.

Be careful that you don't disrupt an animal's normal activity as you set up a blind. If a blind abruptly appears at a nest or den, the animals using them may abandon their young. Photographers have an unfair advantage when photographing birds at the nest. The parents' instinct to care for the young is strong, forcing birds to return to an area that under normal circumstances they would avoid. Some birds tolerate little disruption at their nests, while others, such as house wrens or robins, are very tolerant. After carefully reading this section on working from a blind, stop and consider this: Nest photography has been done for ages. The chance that you'll obtain anything new or unique is slim. *Don't disrupt a nest, perhaps causing nest abandonment, if you must photograph one.* Make every effort to ensure that your activity doesn't hinder nest success in any way. Watering holes or feeding areas are only slightly less critical. I urge you to use common sense to avoid any chance of disturbance here, too.

When you've decided where to put the blind, slowly move it into position. At a nest, den, or water hole, installing the blind without disrupting the animal's routine could take a few days to provide it with enough time to accept the new structure. A lightweight, portable blind works best because the entire blind can be moved at once. If you're building a stationary blind, set it up in sections to give the animal time to accept it and to minimize how long you are at the site at one time. At feeding stations or bird feeders, conditioning might be unnecessary, so a blind could be erected immediately. Of course, the amount of tolerance varies according to the species.

The type of blind you need also depends on your subject. Some animals are very wary, requiring a blind that not only conceals you but also blends in with the environment. Ducks and eagles, for example, sometimes avoid unfamiliar structures that appear in their territories. Then you need a blind made of natural materials or one that is heavily camouflaged with brush or leaves. The camouflage-net material sold in many sporting-goods stores and catalogues is perfect for this, as it breaks up the outline of everything it covers. You can place sticks or branches into the net's loose weave to complete the cover.

Some wary animals don't accept any unfamiliar structure in their territory. To photograph such animals, I've worked with natural hollows in boulder fields or I've dug *pit blinds* for concealment. You can dig pit blinds almost anywhere there is soil; they permit a very low

L. L. Rue's Ultimate photo blind is fast and easy to set up. I had to make a plywood platform here because the blind was positioned on a fairly steep hill, and without a level platform, I was in danger of tipping over.

camera angle and a very inconspicuous profile. But you must be careful that people or animals don't fall into the pit when you're away, and that you're safe when you're inside the blind. Because pit blinds are dirty and damp, you must give special attention to your gear. Wrap everything you bring inside the blind in plastic bags, removing items only as they're needed.

Float blinds are another way to get a low perspective on difficult-to-reach subjects. Some photographers use the float rings sold in fishing stores as foundations for their blinds; you can also construct your own using a square of plywood and either a truck tire's inner tube or Styrofoam blocks. I'd recommend the latter since a stick poking into a Styrofoam block won't affect flotation. Cut a seat through the plywood platform, then attach a canopy made of heavy gauge wire fencing or PVC plastic pipe to the top as your frame for the camouflage. Next, add a camouflage cover, a net, or a collection of natural materials to the wire mesh to camouflage the blind. When completed, your blind could resemble a muskrat lodge, a disheveled heap of cattail reeds and bulrushes floating in a pond, or just something that keeps you concealed.

If you try this, wear hip boots or a wetsuit. The thermal-conducting properties of water quickly chill you in all but the warmest water. Unlike other photography blinds, float blinds are designed for movement so you can approach an animal closely by slowly creeping forward. Follow the same precautions used for stalking, and move smoothly; a duck, for example, would become alarmed if a muskrat den began jerking toward it. Finally, be sure to wear swim fins if any deep water is nearby. A wind might blow your blind into the middle of deep water and leave you

stranded. Perhaps this sounds comical, but it won't be if you're using a float blind made from an inner tube and it springs a leak—it has happened to me.

Some animals exhibit no reaction to blinds in their area and quickly accept new structures. For these animals, almost anything can be used as a blind. I frequently use L. L. Rue's "Ultimate Blind." It is lightweight, camouflaged, and easily erected. If I'm working a few areas simultaneously, I also use homemade cloth, plywood, or canvas blinds.

If you must leave a blind standing for days someplace where it might be stolen or vandalized, use a washing machine shipping carton instead of a real blind. These boxes are large enough to fit most people, and most appliance stores will save a box for you if you ask. I cut a porthole for my lens with a utility knife and use a plastic bucket as a seat. If the blind is damaged or stolen, I'm not too devastated.

Some animals won't approach a blind if they've seen you go inside it. To fool them, bring along a decoy assistant, someone who goes to the blind with you and leaves after you've entered. Most animals can't count and will return to the blind after seeing one person leave. Some animals apparently *can* count, so you might need two or three people to confuse your subject. A friend of mine keeps a mannequin in his tree blind to fool nesting red-tailed hawks. After climbing up into the tree, he lowers the mannequin to a helper who walks out of the woods talking to the dummy.

If I'm using game calls to draw predators, or attracting birds with an owl tape (see page 146), I need an easily transportable blind, because for these activities, mobility is as important as total concealment. I use camouflage clothing, a camouflaged face net, and a *camou-net cover*— a 4 × 8-foot sheet of camouflaged netted cloth that takes the shape of anything it is draped over—instead of an actual blind. By squatting down into a bush, I can then practically disappear within seconds. Action generally takes place within half an hour of calling subjects, and unencumbered by a "real" blind, I'm free to move to another calling site whenever I'm ready.

Your car makes an ideal mobile blind, too. Many roadside animals are familiar with vehicles, although they're probably accustomed to moving, not stationary, cars. It is frustrating to watch vehicles pass within yards of hawks or eagles, roosting or feeding along a busy highway, only to have them fly off as soon as your car slows down. You'll have better luck using your car in areas where the wildlife is accustomed to cars that frequently stop. Drive up slowly and, as you get within range, turn off the engine and coast to a stop. Position your camera beforehand, as you may only have a few seconds to shoot before the animal runs or flies away.

The engine should be off when shooting from any motor vehicle, be it a car, truck, or boat. The vibration of the motor causes a tremor that your camera will record. Be sure that everyone inside the vehicle is absolutely motionless when you're shooting. I generally remind passengers several times to be still, which I reinforce by telling them when I'm about to shoot. Although it is common sense, be sure you're completely off the road and clear of traffic; otherwise, you may risk an accident.

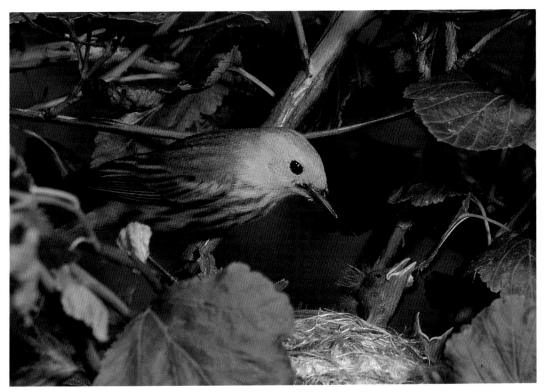

YELLOW WARBLER, Faler Lake, McClure, Pennsylvania. 300mm F2.8 lens, 1/250 sec. at *f*/16, manual flash, Fujichrome 100

I rarely photograph at nests because of the danger posed to the birds. However, this nest close to a trail, and without leafs or branches to move, was perfect for a quick shoot. I waited until the baby birds were about half-grown before I set up my blind; had I set up when the chicks were any younger, the adults might have deserted the nest if disturbed.

When I shoot from a car, I use either a beanbag draped over a windowsill or a beanbag resting on top of L. L. Rue's Groofwin Pod. Although you can make your own brick-size beanbags, Kinesis, The Vested Interest, and Ben-V Beanbags all make bags that fit well on the Groofwin Pod. I keep the Groofwin Pod attached to the window frame if I'm driving through a refuge or a park where an opportunity can arise at any time.

GAME CALLING

Two types of natural or simulated animal calls are good for attracting some species of mammals or birds to you. A *mouth call* is a device that attracts predators by imitating the cries of an injured rabbit or similar prey animal. Using a mouth call properly requires practice. *Electronic calls* are easier to use because they are tape recordings of real animals calling or screaming. Electronic callers are used to attract predators, owls, and certain species of birds. Johnny Stewart Wildlife Calls, of Waco, Texas, offers a large variety of animal sounds specifically designed to attract animals for photography.

Screech-owl tapes attract other screech owls, as well as many species of songbirds. Many songbirds have an almost human sense of hatred for owls and harass any that they discover. A variety of songbirds have been known to gather around a hidden speaker for as long as 20 minutes as they seek out the calling owl. Screech owls, of course, usually respond and investigate only at night. Game calling doesn't work with every species or every individual; however, it can be a useful way to attract active species that are wary, nocturnal, or difficult to find. Coyotes, bobcats, foxes, hawks, and owls often respond to the dying rabbit or squealing woodpecker tapes. This variety shouldn't be surprising because many predators are opportunistic and will steal a meal from a smaller animal.

However, using any type of game call can be stressful or even harmful to your subjects. Predator calling is perhaps most effective in winter when food is scarce, but this ploy costs your subject valuable energy as it follows your false leads to food. Late summer or early autumn is a better time for game calling because food is abundant then, and any animal that investigates is probably doing so out of curiosity, rather than because it is starving. For similar reasons, don't use an owl call to attract songbirds during the nesting season. Although most songbirds spend only a few minutes hunting for the owl, this is time the birds could be using to find food for their young or to keep watch for real predators. Before the nesting season begins, and in late summer and autumn after nesting is completed, are better times because it is unlikely that you'll harm your subjects by calling.

Many birds also respond to tapes of their own species, especially before or during the nesting season. In fact, bird watchers often use tapes to lure rails or other elusive species into view, but they generally don't play a tape as long as a photographer might because they are trying only to see the bird. Many people have expressed concern that using bird tapes can stress animals and drive a bird from its nesting territory. This is a valid point. And using tapes or game calls is prohibited in most parks and refuges because it alters the normal routine of an animal or bird. If you must use bird songs to attract your subjects, don't use any recording of a songbird at high volume because this can drive the species you seek off its territory, and never play an owl or other bird tape during the nesting season for longer than five minutes.

Treefrogs, toads, and true frogs also call in the spring to attract mates. Although the expanded vocal sack of a singing frog or toad makes an attractive photograph, many amphibians stop calling when you approach them. Tapes can coax these shy amphibians to resume singing. Unlike the possible harm caused by tricking birds with recordings, amphibians aren't affected in the same way because they don't set up territories. You won't stress an amphibian by playing a tape. Instead, you might help them to draw in mates by coaxing them to resume calling.

When you are game calling for birds and mammals, wear camouflage clothing and remain absolutely motionless while waiting for game to approach. Remember, any animal you attract is looking for the source of the call, and their senses are far superior to yours. A songbird's vision is so acute that it can see you blink from more than a dozen feet away, even when you're completely camouflaged. However, a face net and a camou-net covering that drapes over you and hangs a few inches out in front of your face helps disguise any facial movements you may make.

PHOTOGRAPHING AT BIRD FEEDERS

Many species of birds feed on or near the ground. If you find it difficult to get down to their level, you can bring the birds up to yours. Birds will accept a table or platform feeding tray that you can raise to a comfortable working height. For birds that feed in trees, you can simulate height by using the tops of branches or sawed-off sections of tree trunks as backgrounds or as locations to hide your bait.

Flash isn't necessary, although it can provide an attractive "snap" to your pictures, add an eye highlight, or stop the motion of a bird flying to a feeder. When using flash, be sure to balance the flash exposure with the ambient exposure. Otherwise, you'll have a "nighttime" bird shot. Use the fastest sync speed possible to reduce the chance of a ghost image.

BAITING AND FEEDING

Many animals accept free meals and providing them can be an easy way to set up and capture exciting close-ups. Use natural foods as bait. Although once they're accustomed to handouts most mammals eat just about anything you provide, an unnatural food source makes a disappointing picture. Commercial bird seed is perfect bait for many small mammals and birds.

Feeders are good attractions for small birds and allow you to photograph them easily. Most species that regularly visit a feeder quickly grow accustomed to a blind, a camera and flash-remote setup, or even to an unconcealed photographer who sits quietly nearby. Although many photographers exclude the feeder to create a "natural" image, include the feeder in some of your pictures. These photographs might not be calendar quality but are useful for identification for use in field guides, textbooks, or slide programs. To make natural-looking shots at feeders, photograph birds or animals before they arrive at the bait. I frequently set up natural perches a short distance from the feeder. Most birds perch there briefly before flying on to the feeder. You can change the perches weekly for visual variety; for example, alternate teasel, corn stalks, cattail reeds, and assorted seed heads as perches in the areas around the bird feeders.

Animal feeding stations are most active in the autumn and winter months, when natural food sources are scarce. If you start a feeder in the autumn, be sure to continue to supply it until spring. A well-stocked feeder can stop a bird during its migration. If the food supply suddenly stops, the birds may die. Fortunately, feeders provide the greatest amount of photographic opportunity when

GRAY SQUIRREL, McClure, Pennsylvania. 600mm F4 lens, 1/250 sec. at f/5.6, Fujichrome 100

To catch a squirrel hanging upside down, I baited a knothole with pecans. After climbing into the hole for a pecan, the squirrel would dash out to eat, then slip back inside for another.

EASTERN CHIPMUNK, McClure, Pennsylvania. 500mm F4 lens, 1/250 sec. at f/16, manual flash, Fujichrome 100

To make a portrait of a chipmunk on an unusual perch— a cow's skull in our yard—I baited the skull's nasal cavity with seed.

EVENING GROSBEAK, Wild Eyes, Montana. 300mm F2.8 lens, 1/250 sec. at f/5.6, TTL flash at -1.7, Fujichrome 100

There is a feeder below this grosbeak, but it wasn't very photogenic. So, it made sense to set up an attractive prop above the feeder on which I hoped a bird would land.

the weather is at its worst. This is added incentive for you to operate a feeder during the winter.

Keep in mind that water attracts birds and animals in dry areas, and often works better than any food source. I regularly set out pans of water and slices of grapefruit or orange when I'm set up in a desert campsite. Quail, woodpeckers, and a variety of songbirds are quick to find the water source, but you can hasten their search by suspending a can filled with water with a small pinhole in the bottom over the pan. Water slowly drips from the can, creating a ripple and noise that quickly draws in birds.

Sometimes using carrion to bait such birds of prey as vultures, some hawk species, and bald and golden eagles is effective. These birds are extremely alert and frequently skittish. Along with the bait, perhaps a pit blind or a blind that blends in perfectly with the landscape will be necessary to photograph these wary birds.

Baiting and feeding stations work best on private land. In fact, this may be the only location where you can legally set them up, because feeding wild animals is illegal in most parks and refuges. Ironically, many animals in these locations are accustomed to receiving handouts from campers. Don't add to this problem— "tame" animals often become nuisances that are destroyed. Still, it doesn't hurt to spend time around a campsite, trash heap, or dumpster, because some animals may come by looking for food. Despite the laws, some campers feed animals; at trash cans there are usually scraps about, and hungry animals are always quick to exploit any food source.

Along with songbirds, other animals can be brought to bait, including wild turkeys, deer, bears, ducks, raccoons, foxes, flying squirrels, opossums, and skunks. Many mammals visit stations only at night, so you'll need a flash. Use a multiple-flash setup with two or

three units to provide a more aesthetic balance among the flashes.

If possible, photograph animals at baits or feeders from behind the camera, rather than by using a remote system. You have a greater chance of obtaining sharply focused, well-composed images when you're looking through the viewfinder. Remotes can free you for other things, but they offer little or no control over your composition. Use remote photography only as a last resort.

REMOTE PHOTOGRAPHY

Sometimes unmanned or remote photography is required. I've found this technique useful when unusual perspectives, lengthy periods of time, or impossible reaction times are involved.

I often use a Shutterbeam to fire a remote camera. For example, I wanted to photograph a screech owl as it left its roosting box. I used two Shutterbeams wired in series so that the camera fired only when the owl crossed the intersecting point of the two infrared beams. One flash was activated by the camera, and two other flashes were connected to individual slave trippers. The most difficult problem in this type of setup was estimating the distance the owl would travel after it crossed the beams and tripped the camera. A little luck was needed to determine the proper focusing distance. I was lucky because I obtained a sharp image each time the owl broke both beams. This setup was completely automatic and operated throughout the night; a motordrive advanced the film after each shot.

I've used a slightly different technique at little brown bat colonies. With the camera's shutters set on "B," I tripped a single Shutterbeam wired to a flash. I used the "B" setting because I was filming at night when there was no danger of exposing the film through ambient light. I held four different cameras open with separate releases until a bat passed through the infrared beam and fired the one flash wired to the Shutterbeam. Its light activated the other three flash units I had wired to a multiple PC socket. After each flash, I used the releases to close the camera shutters. The motordrives advanced the next frames.

Electronic flashes can be used for remote work. Ironically, many releases are inconveniently long when operated as camera trippers but are too short for remote photography. Some manufacturers make extension cables; you may be able to make your own by cutting the cable midway and splicing in an extension wire. An electronics store can supply the wire. You can do this easily with some older cameras, which use standard microphone-jack releases. Rewiring a cable for an electronic camera can result in loss of the data displayed in the viewfinder, even if the camera fires. The most difficult aspect of cutting an electronic release is coping with the fear that if the splice doesn't work, you've wasted an expensive release!

You can also apply the trap-focus feature (see page 48) of some electronic cameras to remote photography. Several other "camera traps" are occasionally described in camera magazines or photography books. These range from mousetrap triggers to footpad electronic releases, but I've never used any of these. The methods described above have worked well enough for me that I haven't tried other techniques.

A final caution regarding remote or unmanned photography: Equipment left unattended is subject to destruction by animals, to theft, or to changes in weather. Although I haven't had the opportunity, photographers who have used camera traps to photograph bears have

EASTERN BLUEBIRD, McClure, Pennsylvania. 500mm F4 lens, 1/500 sec. at *f*/5.6, Kodachrome 64

A cup of mealworms is inside the knothole of this log.

had equipment destroyed when curious bears played with camera or flash systems. There is little you can do to prevent a camera from being stolen, other than to camouflage it so well that it is difficult to see. Even then, any passerby can trip the camera and flash, which could prompt a search that concludes with your gear being stolen.

Weatherproof any camera that is out of sight for more than a few hours, especially one left out overnight. To weatherproof it, simply wrap the gear in plastic garbage bags and tightly bind the plastic around the gear with string or tape to prevent it from flapping and frightening your subjects. You can use clear, gallon-sized plastic bags over flash units that fire through the bag without any loss of light. The camera lenses, of course, must be kept clear. Cut a lens hole in the bag and use a rubber band to secure the edge of the plastic to the very edge of the lens. Protect the front of the lens with a filter instead of clear plastic because plastic can tear, peel back, and expose the lens glass to the elements.

STUDIO SETUPS

Sometimes photographing animals undisturbed and in the wild is nearly impossible. Occasionally, constructing a setup is the only practical way to film elusive wildlife. Ideally, even this can be done in the field. Some species, such as salamanders or frogs, can be collected and placed on a rock or log within feet of the capture site. After the picture is made, the animal can be released. Unfortunately, some animals can't be filmed in the field, at least not by most photographers. A few of my friends keep exotic venomous snakes from the jungles of Central Africa or the Amazon. Although I've been to most of these wild, remote areas, I've never seen any of the snakes my friends keep as pets. Nonetheless, they make fantastic nature subjects.

A studio setup can be as simple or as complex as your subject requires and your energies permit. For example, an animal rehabilitator's injured owl can be photographed in the studio with a black cloth background and one flash if you're only taking head shots. To capture an owl in a natural-looking habitat requires much more material, including branches, a sufficiently large background, and enough lights to provide even illumination. The goal of a studio setup is to recreate a habitat as simply and as realistically as possible. Study the habitat of the animal you're going to photograph, not only to get ideas about props, but to discern the key elements that comprise the habitat. Sometimes you need only a couple of very simple props.

Natural-looking backgrounds can be difficult to make, especially with day-active, or diurnal, animals. Artificial blue-sky backgrounds rarely look natural, and I seldom use them unless I'm filming hummingbirds. For most

HAIRY TARANTULA (CAPTIVE), McClure, Pennsylvania. 200mm F4 macro lens, 1/250 sec. at ƒ/16, manual flash, Fuji Velvia
Don't ask me why people keep tarantulas as pets. This one, annoyed by my stopping it from walking off the set, reared up in a threat posture.

subjects, I'm more likely to use rocks, logs, tree stumps, or leaves to frame my subject against the habitat, and to use a longer lens to minimize the background.

In most indoor studio setups, I use electronic flash. I almost always use at least two flashes, and I frequently use four. I try not to aim more than two flashes at the subject, in order to avoid multiple eye highlights. I use the other flashes for backlighting or for the background. In the studio, I use slave-coupled flashes to eliminate the number of wires I can trip over. I determine exposures with a Minolta Flash Meter IV, although I used the GN formula before I bought the meter.

In a home studio, floor space is frequently limited. For this reason you might consider using Bogen Magic Arms or studio light stands to support your flashes. Lightstands can telescope to five or six feet from a small base that takes up much less space than a tripod. An even better choice is Bogen's Auto-Poles that extend to over 11 feet and are designed to brace between the floor and ceiling. By mounting Bogen Magic Arms to the poles, my floor space is almost completely free. That's important when I'm trying to induce a rattlesnake to strike and would like to have some running room!

SAVANNAH MONITOR (CAPTIVE), McClure, Pennsylvania. 200mm F4 macro lens, 1/250 sec. at *f*/16, manual flash, Fuji Velvia

This shot came about by accident as the lizard moved from its original position to one in which, when I looked at it head-on, it looked fabulous!

ALLIGATOR SNAPPING TURTLE (CAPTIVE), McClure, Pennsylvania. 100mm F2.8 macro lens, 1/250 sec. at *f*/8, manual flash, Kodachrome 64

This turtle was in an aquarium, but by placing some tree roots on the outside of the tank behind the turtle, I created the illusion that the turtle was among the roots.

Although I seldom use a tripod's center column when in the field, I do use one in the studio, because it enables me to keep the tripod legs at their minimum length and allows me greater speed in adjusting for height when I'm ready to change my perspective. I can raise the camera by just one turn of the center-column's lock instead of adjusting three separate legs. The short duration of the flash provides the necessary sharpness because the tripod is only a support.

I set up aquarium shots in a similar way. Instead of a black background, I use a greenish- or tannish-colored square of posterboard, a piece large enough to cover the back of the tank. Because light reflects at the same angle that it strikes a surface, a flash unit mounted on the camera hotshoe would emit light that reflects straight from the aquarium glass back into the camera lens. You can eliminate these reflections by taking the flash off the hotshoe, holding it away from the camera, and aiming it at the tank at a 45-degree angle. In fact, for most setups, I use three flash units, two on either side of the tank and a third on top for overhead lighting.

Small aquarium tanks and most public aquariums are usually photographed with just one off-camera TTL flash. In public aquariums, you'll probably have to handhold the flash or have someone help you because there are too many people around to permit the use of a tripod and lightstand. Be sure to angle the flash so that the light doesn't reflect into the lens. You can minimize distortion and reflections in the background by placing the camera lens against the tank glass. If you can't do this, carry along a large square or circular piece of black cardboard with a hole cut out for your lens. The black mask will eliminate reflections the glass may pick up from you or the background. You won't have to do this when photographing a tank at home because you can dim the lights in the room or hang a black cloth between the camera and the tank to eliminate the reflections ambient light causes.

Small subjects can be hard to find in the viewfinder when they're freely swimming inside an aquarium. You can reduce the amount of area you need to cover by restricting your subjects movements. I slip panes of glass into grooves I've cut into my tank's plastic frame. Typically, I'll cut grooves spaced one, two, and four inches from the front to accommodate specimens of different widths. You can safely confine a tadpole within a one-inch space inside a tank. But a small turtle that must surface to breathe requires the full four inches for freedom of movement.

A final point about studio shoots. If you're cooperating with a friend who keeps animals as pets or for exhibits, maintenance and care perhaps won't be your concern, but you must give proper care if you are responsible. Don't even consider collecting an animal for home studio if you don't know its life requirements: what it eats, the moisture it requires, and its tolerance to disturbance or to being handled. The activity of cold-blooded animals, such as amphibians, reptiles, fish, insects, and spiders, depends on temperature. These animals are active when warm and still when it is cold. Don't ever refrigerate and *absolutely never even consider* temporarily placing

an animal in a freezer to chill it into a torpid, more manageable state; this can sicken or kill your subject. If that is not convincing enough, cold animals look droopy and unnatural when chilled. Cold-blooded animals are not heat tolerant, either. They can overheat and die if kept in the sun or under bright lights.

Fortunately, reptiles, amphibians, and fish don't have to eat daily, and food might be unnecessary if you keep a specimen for only one day. But some small mammals, such as shrews or deer mice, eat surprisingly large quantities of food. Field guides, wild-pet care books, animal rehabilitators' guides, and other sources contain pertinent information on animal care should you decide to learn about certain animals. I urge you to do extensive research before you even think about shooting an animal in the studio!

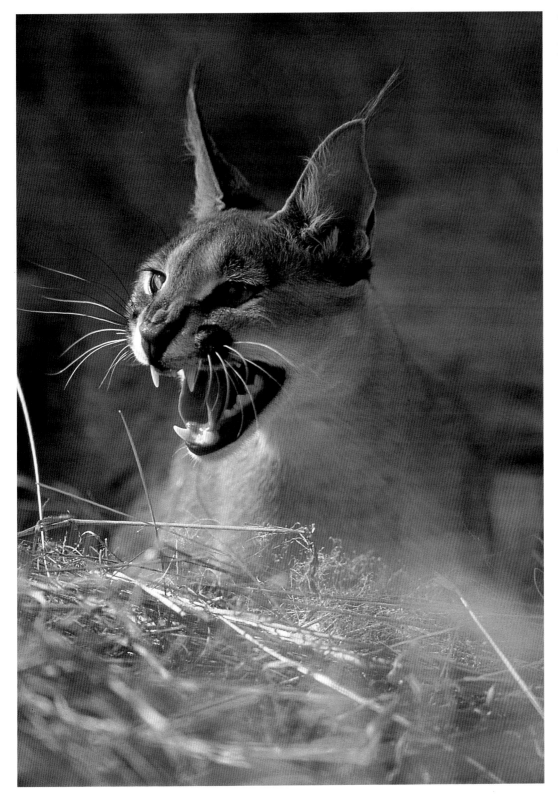

CARACAL (CAPTIVE), Okinjima, Africa Trust, Namibia. 300mm F2.8 lens, 1/250 sec. at ƒ/6.3, Fujichrome 100

This lynx-like caracal was a pet, free to come and go as it pleased but usually living inside its owner's home.

Finally, collecting of many animals is illegal. In some areas, all backboned animals—including all fish, amphibians, reptiles, birds, and mammals—are protected by law. You may need to have a hunting or fishing license, or a special collector's permit, to have any of these animals in your possession. Almost all birds are protected by international laws and cannot be kept except by a licensed rehabilitator or exhibitor.

GAME RANCHES AND ZOOS

Ironically, photographers in the United States or Canada have a better chance of photographing predatory animals in undeveloped, third-world countries than in their own. For example, in India I've filmed several tigers in just one trip; in Africa I typically photograph four or five leopards on each safari. Yet in North America, I've seen cougars just one time (a mother with two large cubs a quarter mile away). And I'm not alone. I think most wildlife photographers would agree that photographing cougar, lynx, gray wolf, and a few other predators is nearly impossible to do in the wild. We'd all love to, but the animals are either too scarce or too wary to make this possible.

A practical and very satisfying way to film these elusive predators is at a game ranch specializing in these captive animals. Although some consider this "nature cheating," there are few options for photographers who don't have the time or resources to wait at a waterhole, or to bait or use a game call in the hopes of getting a predator within camera range. And, of course, there are dangers in trying to film wild predators in this manner. Waiting at a waterhole could keep a predator from water if it knows you're there; baiting could habituate a predator to hand-outs, or create an association with man through scent; and game-calling could cost valuable calories for a predator taxed to find food and tricked into traveling unnecessary distances. The real issue, as I mention in the preface, is in the labeling or captioning of the slides.

At game ranches, you or a small group can rent one or several species for photography. A trainer handles the animal in an open setting if the animal is sufficiently tame or in a large natural enclosure. This opportunity can cost $75 to $300 per person per day, depending on the number of photographers involved and your choice of subject. The experience is unique, and the images you can obtain are otherwise unavailable. There are a few game ranches specializing in this business throughout the United States. Photography magazines frequently carry their ads, and many workshops and tours (my own included) visit them regularly.

Although most wildlife photographers hope to visit exotic foreign countries to photograph animals, few are lucky enough to have the opportunity. Zoos are wonderful

SNOWY EGRET CHICKS, St. Augustine Alligator Farm, Florida. 300mm F2.8 lens, 1/125 sec. at f/11, TTL flash at -1, Fujichrome 100
A variety of herons and egrets nest within feet of the boardwalk at this tourist facility, providing one of the best wild-bird nest opportunities available anywhere.

settings for encountering lions, leopards, rhinoceroses, and the like. Zoo photography can be fun and satisfying. By visiting several zoos and picking the best exhibits each has to offer, you can amass a wonderful portfolio of exotic species.

Many zoos now exhibit animals in open, moat-protected enclosures. Although there are no wires or bars to contend with, the area around the animal may be busy or unnatural. Bare ground, lawn grass, or background clutter can ruin the effect you wish to achieve. Use the longest lens possible to minimize this. Concentrate on doing close-up portraits, rather than capturing animals in their habitats. The latter framing won't be effective or look natural, anyway, unless you're filming in an aviary. Birds in aviaries can look very natural. Still, you

must watch for and try to crop out the bird bands or multicolored rings with which keepers tag individual birds. Sometimes a bird perches in such a way that its legs or the rings are hidden. Use a shallow depth of field to eliminate background wire. You might also need a fill flash for illumination because screens and plastics cover many aviaries, making it too dark for slow-speed films.

Unfortunately, many animals and birds are displayed behind wires, bars, or glass. If you must shoot through these, place the lens as close to the cage as possible and shoot wide open. The limited depth of field should make reflections, fences, and bars disappear. Always pick a shaded section of fencing because bright, sunlit areas create a fuzzy, unattractive glare, just as a flash can. When using flash, position it so that its light doesn't strike the same wires or bars through which you're pointing the lens. I usually hold the flash up high and to the side of my camera's position, and if I have someone to help, I shade the cage area in front of the lens. Paying attention to these details pays off.

OPOSSUM (CAPTIVE), Rehabilitation Center, New Jersey. 200mm F4 macro lens, 1/250 sec. at *f*/8, manual flash, Kodachrome 64

I filmed this young opossum a few days before it was released back to the wild. Rehabilitation centers are a great place to find subjects.

APPLICATION:
RECORDING A NATURAL HISTORY

A few years ago, I had the chance to record nearly the entire growth and development of a clutch of Eastern screech owls rescued when a logger unknowingly cut down the birds' nest tree. Working with the rehabilitator, I was able to recreate the birds' nesting environment—the logger was so guilt-ridden he brought along the 100-pound section of tree housing their nesthole.

As the birds grew and were introduced to the natural prey they would later hunt, I filmed their crude attempts at capture, as well as their successes. Perhaps most satisfying were the days following their release when the owls, still accustomed to us, would allow our close approach or even fly near to investigate. That didn't last long, and within 10 days of release the birds had dispersed, although we still see one of the birds now and then.

EASTERN SCREECH OWL BABIES (CAPTIVE), McClure, Pennsylvania. 100mm F2.8 macro lens, 1/250 sec. at *f*/22, manual flash, Fuji Velvia

These screech owl babies were only a few days old and barely strong enough to hold up their heads. They are inside the nesthole of the tree they were in when it was chopped down.

EASTERN SCREECH OWL BABIES (CAPTIVE), McClure, Pennsylvania. 80–200mm F2.8 zoom lens, 1/250 sec. at *f*/16, manual flash, Fuji Velvia

The young owls often clustered together in a bundle. Here, they were placed on a limb outside their pen for a photo session.

EASTERN SCREECH OWL JUVENILES (CAPTIVE), McClure, Pennsylvania. 100mm F2.8 macro lens, 1/250 sec. at *f*/16, manual flash, Fujichrome 100

I placed a black cloth and a sumac limb in the back of the owls' pen to create a natural-looking background.

EASTERN SCREECH OWL JUVENILES (CAPTIVE), McClure, Pennsylvania. 100mm F2.8 macro lens, "B" at *f*/22, manual flash, Kodachrome 64

I used a Shutterbeam and several high-speed flashes to catch the owls as they flew about their pen.

EASTERN SCREECH OWL FLEDGLING (WILD), McClure, Pennsylvania. 80–200mm F2.8 zoom lens, 1/60 sec. at *f*/4, Fujichrome 100

Once they were strong fliers and accustomed to eating a variety of foods found in the wild, the owls were released.

RESOURCES

Bogen Photo Corporation
565 East Crescent Avenue
P.O. Box 506
Ramsey, NJ 07446-0506
www.bogenphoto.com
Accessory items, including the Bogen Magic Arm, Bogen 3021 tripod, various monopods, Bogen Auto-Pole, and clamps for studio, flash, and field use. Also the American distributor for Gitzo tripods, including the lightweight carbon-fiber models.

Daniel Poleschook Nature Photography
9225 North Palmer Road
Spokane, WA 99207-9711
Manufactures the Stable Windowframe Mount II, a rock-solid lens support for use in cars, and the Action Head Teleflash System, a teleflash that increases flash output by as much as 5.7X the GN.

Image 1 Stop
P.O. Box 743
Calvert City, KY 42020
Computer database program to organize, track, and locate images, as well as label and number slides; provides scientific names for most North American species and allows sales records to be organized and managed.

Johnny Stewart Game Calls
P.O. Box 7594
Waco, TX 76714-7594
Provides tapes of a variety of birds and mammals for bird and predator calling, and manufactures a high-quality game caller for their use.

Kinesis Products
5875 Simms Street
Arvada, CO 80004
www.KinesisGear.com
Manufactures a heavy-duty camera-carrying belt system— essentially, a gadget bag on your hips. Also makes a fine-quality beanbag for use with the Groofwin Pod.

L. L. Rue Enterprises
138 Millbrook Road
Blairstown, NJ 07825
www.rue.com
Offers the largest and most diverse assortment of accessories for the outdoor photographer, including Gitzo tripods, the Groofwin Pod, the Ultimate Blind, and a complete selection of nature and wildlife photography books.

Lowepro
3171 Guemeville
Santa Rosa, CA 95401
www.lowepro.com
Manufacturer of several high quality, sturdy photography backpacks and gadget bags, including the Lowepro Photo Trekker AW, a photo backpack that doubles as a gadget bag and conforms to carry-on dimensions for most airlines.

McDonald Wildlife Photography, Inc.
73 Loht Road
McClure, PA 17841
www.hoothollow.com
Photography workshops, as well as photo tours and safaris to various destinations in the United States, Africa, and the Falkland Islands led jointly by Joe and Mary Ann McDonald. Also distributes the Visual Echoes teleflash bracket. Limited edition prints are also available of the photographs appearing in this book.

NANPA
North American Nature Photography Association
10200 West 44th Avenue
Wheat Ridge, CO 80033-2840
www.nanpa.com
An association of amateur and professional nature photographers, editors, stock agents, and outdoor-oriented people interested in promoting education, ethics, and awareness in the field of nature photography.

National Photo Traveler
P.O. Box 39912
Los Angeles, CA 90039
A bulletin that covers specific information on selected destinations of interest to photographers throughout North America.

Nature's Reflections
P.O. Box 6531
Rescue, CA 95672
Offers two gimbal-type mounting systems for telephoto action photography, a teleflash system offering an increase of three or four times a flash's GN, and the Portablind (a portable photo blind).

PHOTOnaturalist
P.O. Box 621454
Littleton, CO 80162
www.photonaturalist.com
Designed and sells the Chroma-Zone Exposure System™ reference cards to determine a subject's color tonalities. An excellent reference to acquaint yourself with middle tones of various colors.

PHOTOSOFT
P.O. Box 209
Marlboro, NJ 07746-0209
www.photosoft.com
Offers a database program (PhotoExplorer) that organizes, tracks, and locates images, as well as labels and numbers slides. The program can also transport images via e-mail and organize slides into slide shows.

Really Right Stuff
P.O. Box 6531
Los Osos, CA 93412
www.reallyrightstuff.com
For quick-release plates, including a vertical and horizontal bracket for the Nikon F5, for dovetail-style monoballs like the Arca Swiss and Foba; macro-photography focusing sliders and braces; flash arms that couple directly onto a large lens' tripod mount; and flash extender posts to eliminate red-eye, useful with the Visual Echoes teleflash bracket.

The Saunders Group
21 Jet View Drive
Rochester, NY 14624
www.saundersphoto.com
Offers the Lepp II Macro Flash Bracket, useful for TTL closeups with two flashes, and the Scopepak, a photo backpack designed for long lenses including a 600mm.

Skyline Camouflage, Inc.
184 Ellicott Road
West Falls, NY 14170
For a variety of camouflage apparel.

Tiffen
90 Oser Avenue
Hauppauge, NY 11788
www.tiffen.com
Manufacturer and distributor of tripods, support systems, and filters. Makes extremely high-quality glass filters, color filters, and a Warming Polarizer Filter.

Vested Interest
1425 Century Lane, Suite 100
Dallas, TX 75006
www.vestedinterest.com
Manufactures the roomiest, most comfortable photo vests on the market today, and will custom make vests to specifications. The magnum and the Khumbu will accommodate four camera bodies in the front two pockets, and the Khumbu can be fitted to carry a 600mm telephoto. Also makes rain covers for lenses of up to 600mm in length and beanbags for the Groofwin Pod.

Warren and Sweat Treestands
P.O. Box 440
Grand Island, FL 32735
For high-quality and safe treestands, ladders, and steps for getting into trees. The climbing treestands provide the easiest and safest means to ascend a limbless tree. The treestands can easily be adapted for use as a photo blind.

Wild Eyes Photo Adventures
894 Lake Drive
Columbia Falls, MT 59912
For predator photography of wildlife models, including most North American species, such as cougar, lynx, bobcat, gray wolf, red fox, badger, otter, and more.

Woods Electronics, Inc.
14781 Pomerado Road, Suite 197
Poway, CA 92064
Manufactures and sells the Shutterbeam, a camera/flash tripper that is activated by either breaking an infrared beam or by sound.

INDEX